The Painters of the Wagilag Sisters Story 1937-1997

Wally Caruana
Nigel Lendon

Editors

National Gallery of Australia

Edited, designed and produced by the Publications Department
of the National Gallery of Australia, Canberra.
Designed by Kirsty Morrison.
Edited by Karen Leary.
Colour separations by Pep Colour.
Printed by Inprint Pty Ltd.

Distributed by:
Thames and Hudson (Australia Pty Ltd),
11 Central Boulevard, Portside Business Park,
Port Melbourne, Victoria 3207, Australia.

Thames and Hudson Ltd,
30–34 Bloomsbury Street, London WC1B 3QP, UK.

Thames and Hudson Inc,
500 Fifth Avenue, New York, NY 10110, USA.

Cataloguing-in-Publication data
The Painters of the Wagilag sisters story, 1937–1997.
Bibliography.
ISBN 0 642 13068 X
1. Aborigines. Australian - Northern Territory - Arnhem Land - Art -
Exhibitions. 2. Art - Northern Territory - Arnhem Land - Exhibitions. 3. Art.
Australian - Aboriginal artists - Exhibitions. I. Caruana. Wally. 1952-. II
National Gallery of Australia.
759.9942950749471

This catalogue is published on the occasion of the exhibition
The Painters of the Wagilag Sisters Story 1937–1997 held at the
National Gallery of Australia, Canberra, 13 September to 23 November 1997.

Curators and consultants
Wally Caruana is curator of Aboriginal and Torres Strait Islander art,
National Gallery of Australia.

Albert Djiwada is the traditional owner and senior indigenous consultant
to the exhibition.

Nigel Lendon is Reader in Visual Arts at the Canberra School of Art,
Australian National University.

Djon Mundine is the senior curator at the Museum of Contemporary Art,
Sydney. Previously, he was the art adviser for Central Arnhem Land.

WARNING
It is customary in Aboriginal communities not to mention
the name or reproduce images of the recently deceased.
All such mentions and images in this book have been
reproduced with the express permission of the appropriate
authorities and family members. Nonetheless care
and discretion should be exercised in using this book within
Arnhem Land.

(cover) **Paddy Dhathangu** Liyagalawumirr/Malimali *Wititj (Olive Python)* 1983
from the series *The Wagilag Sisters Story*

Contents

The structure of this catalogue and the exhibition is the result of extensive consultation between the curators, the artists and landowners and their *djunggayi* or custodians over the course of several years.

The Narrative of the Wagilag Sisters and Wititj the Olive Python binds together clans and groups who have ownership of the different parts of this story. Nonetheless, precise distinctions are maintained between artists' origins and their ownership of or responsibility for territory and the associated spiritual properties and narratives, all of which are reflected in art.

The exhibition, therefore, is made up of two sections: the work of artists of the Liyagalawumirr clan and related artists from Central Arnhem Land, and that of artists belonging to the clans of Eastern Arnhem Land. Within the first section, the sequence of works is based on the clan membership of the artist and on his or her site of conception, an important feature of individual Aboriginal identity. In the second section the sequence of works is based on the artists' clan membership and the relationship of each clan to the Liyagalawumirr.

As part of the encounter with the works of art, the reader and viewer is therefore invited to recognise the relationships of each artist to their clan and group and, within this structure, to trace the chronology of the historical developments these works reveal.

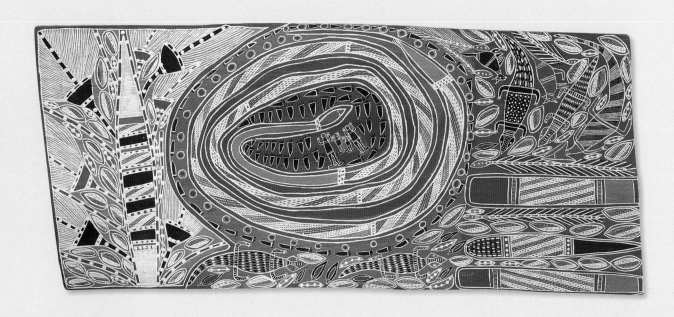

Paddy Dhathangu Liyagalawumirr/Malamali (with Dorothy Djukulul) *The Wagilag Sisters Story* 1983

Director's Foreword

It is with great satisfaction that I am able to write a few words of introduction to the catalogue of the exhibition **The Painters of the Wagilag Sisters Story 1937–1997**, the last foreword I am to write in my term as Director of the National Gallery of Australia. During this time Aboriginal art has grown in prominence in the public arena and within the programs of the National Gallery. The fine and extensive collection built during the stewardship of the National Gallery's founding Director, James Mollison, has been developed and enhanced. This very exhibition is based upon some of the strengths of the National Collection. The Loti and Victor Smorgon Gallery at the very entrance to the building now houses the permanent collection of Aboriginal and Torres Strait Islander art, graced as it is by the installation of *The Aboriginal Memorial* 1987–88.

The *Memorial* reflects the close relationship between the National Gallery and the artists of Central Arnhem Land, a relationship which is strengthened by this exhibition, focusing as it does on one of the major Arnhem Land Creation Stories which finds its culmination in the region. The exhibition also enhances the relationship between this institution and the artists of Eastern Arnhem Land whose contribution to the project is significant.

Indeed, it has been the process of close cooperation and consultation between the curators and all the artists, landowners and custodians that has made **The Wagilag Sisters** such a significant exhibition. My special thanks go to Albert Djiwada, Joe Djembangu, Trevor Djarrakaykay, Gawirrin Gumana and Dula Ngurruwutthun, to mention a few of the leading protagonists in this project.

The curators have worked assiduously and imaginatively over a period of seven years to bring this exhibition to fruition; Djon Mundine, Nigel Lendon and Wally Caruana were ably assisted by Susan Jenkins, Avril Quaill and Hilary Hoolihan. My thanks go to them as well as to the lenders and the numerous people, within the National Gallery and elsewhere, who have made valuable contributions to this project.

The scope of **The Painters of the Wagilag Sisters Story 1937–1997** gives us the opportunity to experience at first hand the transmission of artistic traditions from one generation to the next; reinforcing the knowledge and beliefs of the past, while revealing their relevance in the present.

Finally, I would like to dedicate this exhibition to the memory of Paddy Dhathangu who was at the core of this project at the very beginning: through his art he, as with indigenous artists in general, has enriched the cultural heritage of all Australians.

Betty Churcher AO
Director
July 1997

Artists of Central Arnhem Land

Djunggayi (Custodians)	Lilipiyana from Gatatangurr freshwater	Walkurwalkur from Mirarrmina freshwater	Malimali from Ditjirama freshwater	Durrurrnga from Guruwana salt water	Related clans
Daynganggan Daygurrgurr/ Gupapuyngu 1892–deceased	**YILKARI KITANI** **Liyagalawumirr** **1891–1956**				
Dhawadanygulili Daygurrgurr/ Gupapuyngu 1900–1976		**DAWIDI** **Liyagalawumirr** **1921–1970** **(Yilkari's brother's son)**			**Gimindjo** Mandhalpuy 1915–deceased
		PADDY DHATHANGU Liyagalawumirr c.1915–1993 (Yilkari's son)			
Joe Djembangu Gupapuyngu born c.1935 (Manybunharrawuy's husband)		**Philip Gudthaykudthay** Liyagalawumirr born 1935		**Namiyal Bopirri** Liyagalawumirr born 1927	
		ALBERT DJIWADA **Liyagalawumirr** **born 1938** (Yilkari's son)		**Yambal Durrurrnga** Liyagalawumirr born 1936 (Nanytjawuy's brother)	
Jimmy Yangganiny Ganalbingu 1949–1989 (Dhathangu's sister's son)		**Daisy Manybunharrawuy** Liyagalawumirr born 1950 (Dawidi's daughter, Djembangu's wife)		**Neville Nanytjawuy** Liyagalawumirr born 1942 (Yambal's brother)	**Peter Minygululu** Djinba/Mandhalpuy born 1942
				Kathy Yawirr Djambarrpuyngu born 1955 (Yangganiny's widow)	**Djardie Ashley** Wagilag born 1950

Artists of Eastern Arnhem Land

Djunggaya (Custodians)	Rirratjingu clan		Gälpu clan	Marrakulu clan	
	Mawalan Marika *c.*1908–1967	**Mathaman Marika** *c.*1920–1970 (Mawalan's brother)			
Gawirrin Gumana *Dhalwangu* *born 1935*	**Wandjuk Marika** 1930–1987 (Mawalan's son)		**Mithinarri Gurruwiwi** *c.*1929–1976	**Durndiwuy Wanambi** *c.*1936–1996	**Welwi Wanambi** 1935?-1974
	Dhuwarrwarr Marika born *c.*1946 (Mawalan's daughter)		**Djalu Gurruwiwi** born 1931	*Gundimulk Wanambi* *born 1957* *(Durndiwuy's daughter)*	**Motu Yunupingu** Gumatj born 1959 (Durndiwuy's widow)
	Banduk Marika born 1954 (Mawalan's daughter)	**Yalmay Yunupingu** born 1955 (Mathaman's daughter)		**Wolpa Wanambi** born 1970 (Durndiwuy's daughter)	

Legend

The names of the artists in the exhibition appear in bold type.

The names of the main artists appear in upper case, bold type.

The names of contributors to the catalogue whose work is not represented in the exhibition appear in italics.

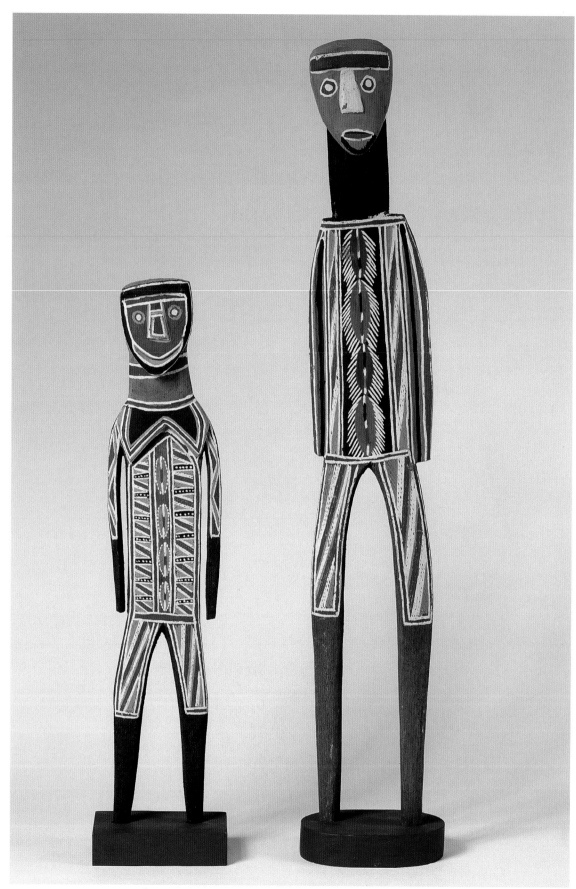

Plate 1. **Dawidi** Liyagalawumirr/Walkurwalkur *The Wagilag Sisters* 1965

Wititj the Olive Python and the Wagilag Sisters

The Narrative of the two Wagilag Sisters is a Creation Story with wide significance for the Dhuwa moiety among the Yolngu of Central and Eastern Arnhem Land.[1] The Narrative relates the encounter between human and animal ancestors, who in the process create and make sense of their world and its creative forces. It provides the basis for key aspects of Yolngu social life and its rituals, as expressed in ceremony and song, as well as in the laws relating to authority, kinship, territory and, significantly, marriage. It also tells of the flooding of the earth in the first monsoon.

The story covers the territory of several clans, and in particular the waterhole named Mirarrmina on the Upper Woolen River in the land of the Liyagalawumirr.[2] This is the home of Wititj the Olive Python, one of the most powerful of ancestral figures. Accounts of the story vary with context and narrator, but the following details occur in most versions.

Two Sisters, the older of whom has a child, the younger is pregnant, are fleeing their home in the south east. They are being followed by clansmen. The Sisters reach Ngilipidji, or the Stone Country of the Wagilag clan, from where they get their name. As they continue on their travels they encounter animals, plants and country on which they confer names, in essence bringing them into being. They decide to camp in the rich and fertile country surrounding the waterhole at Mirarrmina.

According to some versions of the Narrative, one of the Sisters pollutes the waterhole, which arouses Wititj from his sleep. The younger Sister gives birth, further inciting the Snake. Unsuspecting, the Sisters make camp, build a bark hut, and try to cook the food they have caught, but things begin to go wrong — the animals and vegetables come to life and leap into the waterhole. Wititj emerges from the waterhole and creates a storm cloud with lightning and thunder to wash the Sisters into the well. The land is flooded as the first monsoon pours down its rains.

Frightened, the Sisters perform dances and sing sacred songs to deter the Python. Finally the Sisters drop in exhaustion, and Wititj is able to enter the hut and swallow them, their children and their dog.

Shortly afterwards, the great Wititj develops a terrible stomach ache. He rises into the sky above the flooded landscape, and his groans attract the attention of other great Snakes from surrounding clan estates, who also rise up into the sky. They talk to each other and discover they have different names. When asked what ails him, Wititj lies about what he has eaten, realising that he has probably eaten beings of the same moiety. Finally, the pain becomes so great that he falls to earth and vomits the Sisters. (He retains the children, who belong to the opposite moiety, the Yirritja.) When the Sisters are brought to life again by the bites of the stinging caterpillars, Wititj beats them with clapsticks (*malirri*), and swallows them again.

The Sisters' clansmen had followed them and were asleep by the triangular impression made in the ground by the Python's fall. The Sisters come to them in a dream and reveal the secrets of the sacred dances and songs they had composed in their efforts to stop the rain.

1 Aboriginal people in Central and Eastern Arnhem Land refer to themselves collectively as the Yolngu, a word which means human beings. Two moieties, which among the Yolngu are called Dhuwa and Yirritja, are the basic organisational units of Aboriginal society. All people, supernatural beings, every living thing, all inanimate objects and all phenomena are deemed to belong to one or the other.

2 Liyagalawumirr is a language group in Central Arnhem Land.

The Past 100 Years

A brief history of the artists and their art

Wally Caruana

Him [Yilkari Kitani] bin born maku [maybe] we country — I was still in the water yet, my mother didn't find me yet. He had two brothers from one Mildjingi mother. My fathers were number one singers, all three. After that I learned, and now I sing.

Paddy Dhathangu[1]

According to government records, Yilkari Kitani, the first ceremonial leader and artist in the exhibition 'The Painters of the Wagilag Sisters Story 1937–1997', was born in 1891.[2] He was born into a Liyagalawumirr family in Arnhem Land in the Northern Territory, where traditions of life and culture have developed and grown over millennia.[3] With its relatively high density of population and range of tropical environments — from the great sandstone escarpment in the west which houses thousands of rock art sites, to rivers and creeks, freshwater lagoons, jungles and forests, sandy beaches and islands — Arnhem Land is one of the richest art-producing regions of the country.

This outline of one aspect of the twentieth-century history of the artists of Arnhem Land describes a period in which their art has steadily gained a wider audience from that restricted to ceremonial and local milieux, to the first collections made by outsiders, researchers and collectors, and to the international world of art. The staging of this exhibition traces the development of one artistic tradition within the parameters of a single cultural bloc, the Yolngu. While the focus is on Central Arnhem Land, reference will be made to significant events in the east where people share some of the iconography and ceremonies relating to the Narrative of the Wagilag Sisters.[4]

The Yolngu speak several distinct languages and dialects, yet the clans of the region share similar forms of social organisation, spiritual beliefs and ceremonies. The clans are also connected through the ancestral narratives associated with the major creator beings who travelled across the land in the genesis ('when the world began' according to artist and current owner of the Wagilag Sisters Story, Albert Djiwada), performing creative acts at particular sites.

Among the most important Dhuwa moiety themes in Central and Eastern Arnhem Land are those of the Djan'kawu creators and that of the Wagilag Sisters. The saga concerning the creative acts of the Djan'kawu belongs to coastal saltwater clans. The Djan'kawu are commonly described as two sisters and their brother who came from the east, giving birth to the clans and establishing their cultural values and characteristics.

On the other hand, the story of the Wagilag Sisters and Wititj the Olive Python is primarily associated with the inland freshwater country. The story commences with the Honey Ancestor Wuyal at Gurka'wuy, but follows two Sisters on their journey inland, north to Ngilipidji where they speak in the Wagilag language, then on to Mirarrmina. The Wagilag Sisters story and related ceremonies connect several clans and language groups including the Wagilag, Liyagalawumirr, Djambarrpuyngu, Mandhalpuy, Gälpu, Marrakulu and Rirratjingu.

The events of the Narrative form the basis of one of the major ceremonial cycles and painting traditions in Central Arnhem Land. They herald the arrival of the first monsoon season and the flooding of the earth; more importantly, the Narrative documents the foundation of the laws of social and ritual behaviour, in particular relating to rules of marriage, and provides a means for the continued transmission of cultural knowledge. The cycle of rituals connected with the Wagilag Sisters has assumed greater significance for Yolngu since the arrival of Christianity in the region in the 1920s. The overriding purpose of the exhibition 'The Painters of the Wagilag Sisters Story 1937–1997', however, is not to analyse the restricted nature of ceremony and ritual associated with the Wagilag Sisters, but to recognise where connections are made on a public level through paintings and other art forms and how, in pictorial terms, these connections are carried from one generation to the next; indeed the exhibition covers four generations of artists.

The winds of change

In the final decade of the nineteenth century, the winds of change — those which for centuries had brought the Macassans from Indonesia and before them the Bugis[5] — had been blowing again across Arnhem Land. From the 1880s eleven cattle stations spanned Arnhem Land and, as the cattle and their owners invaded the land, clashes between Yolngu and Balanda began.[6] The cattlemen's brutality to the local Aboriginal people is remembered to this day as the 'cattle wars'.[7] By 1907 the cattle stations on Yolngu land had closed, but the impact of European presence returned with the advent of Christian missions in the 1920s.

The twentieth century dawned with an historic exchange of rituals which spread the influence of the Wagilag Sisters Narrative to the north east tip of Arnhem Land. Sometime before 1918 an exchange of ceremonies took place; it involved men of the Mandhalpuy group and the grandfather of Mawalan Marika of the Rirratjingu group.[8]

The presence of Europeans in Central Arnhem Land became permanent when the Methodist Church established a mission on Milingimbi in the Crocodile Islands in 1923. The mission was situated on the site of an important traditional meeting place which was also a waterhole associated with an ancestral Yirritja Rainbow Serpent. Here people would gather to conduct ceremonies but, until the establishment of the mission, there had been no permanent population at Milingimbi.[9]

Fig. 1
Painted panels from bark dwellings, Goyder River, 1926. Photo: G.H. Wilkins

In 1926 the English explorer G.H. Wilkins became the first to record bark paintings in Central Arnhem Land; his photographs show naturalistic images painted onto the sheets of bark used as walls for temporary shelters in the Goyder River region (fig.1).[10]

From 1926 to 1929, the American W. Lloyd Warner carried out the first anthropological study of the local peoples, whom he dubbed the Murngin, with particular reference to their social systems and cycles of economic and ritual exchange. Warner also collected the art of the region, including bark paintings

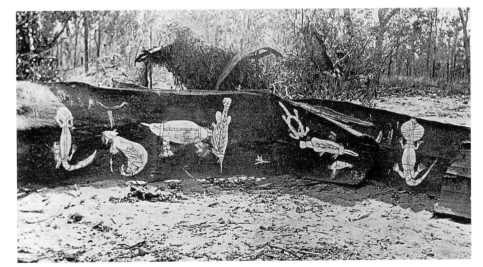

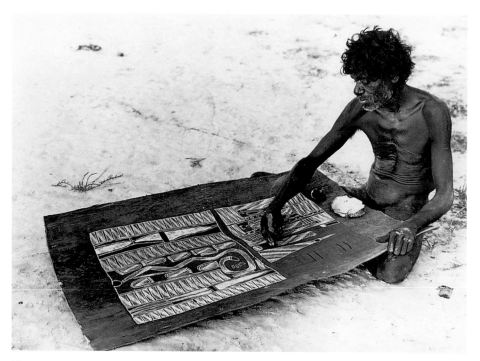

and weavings which are now distributed amongst several museums in Australia.

During 1932 and 1933, at Caledon Bay on the north east tip of Arnhem Land, trouble flared when a group of Japanese trepang fishermen trespassed on Yolngu land and threatened Yolngu women. In the ensuing skirmishes a number of Japanese and white Australians were killed, prompting the federal government to plan a punitive expedition against the Yolngu. These events led to the establishment of a mission by the Reverend Wilbur Chaseling at Yirrkala in 1934, and to Melbourne anthropologist Donald Thomson petitioning the government to send him to the area to find a peaceful resolution to the conflict. Thomson first arrived in Arnhem Land in March 1935 and was soon able to win the trust of the Yolngu to secure the peace.

Fig. 2
Yilkari painting *Wagilag Dhäwu (Wagilag Story)*, 1937
Photo: D.F. Thomson
Courtesy of Mrs D.M. Thomson

Thomson calculated the population of the Crocodile Islands and Goyder River area at approximately 400 people out of an indigenous population in Central and Eastern Arnhem Land of 1500.[11] Thomson's anthropological studies were embellished by his superb photographic records — he constructed bark-walled darkrooms in the field to process the sensitive glass plates before the chemicals could deteriorate in the humid heat. By the time of his second field trip from June 1936 to October 1937, Thomson had developed an interest in the theme of the Wagilag Sisters and the associated ceremonies, and he commissioned works of art; the painting *Wagilag Dhäwu (Wagilag Story)* 1937 (fig. 2 and plate 8), by Yilkari, is the oldest known work on the subject in existence.

During the war years Thomson returned to Arnhem Land to form the Special Reconnaissance Unit as a guerilla force, of which Daynganggan was a member, to resist the threat of Japanese invaders. The Second World War is still regarded by Yolngu as a significant historical marker; the war came to northern Australia and to Arnhem Land in particular. In 1942 the Royal Australian Air Force upgraded the airstrip on Milingimbi, which became a target for enemy bombing, and the local people (including Yambal Durrurrnga and Neville Nanytjawuy) were evacuated to Elcho Island. The mission on Milingimbi was bombed in 1943 resulting in loss of life and several casualties among the Yolngu.[12] Albert Djiwada recalls the bombing and subsequently escaping with his family to set up camp at Thomson's headquarters at Gatji some fifty kilometres inland.[13]

Fig. 3
Members of the Special Reconnaissance Unit instructed in aircraft recognition aboard the *Aroetta*
Photo: D.F. Thomson
Courtesy of Mrs D.M. Thomson

The post-war era

The immediate post-war period witnessed an expansion of scientific interest in the Aboriginal peoples of remote areas. In 1946–47 the anthropologists Ronald and Catherine Berndt worked at Milingimbi and at Yirrkala where they issued artists with coloured crayons and drawing paper with which to illustrate their ancestral narratives (fig. 4). The Berndts subsequently made important collections of bark paintings and sculptures. Mawalan's bark

painting *At Muruwul [Marwuyu], home of the Wititj Python* (plate 91) and his figures of the two Wagilag Sisters (plate 81) date from this period.

The Berndts were followed in 1948 by Charles P. Mountford and the American–Australian Scientific Expedition to Arnhem Land which went to Gunbalanya (Oenpelli), Yirrkala and Groote Eylandt, visiting Milingimbi on the way. The scope of the expedition was an all-embracing study of natural history and ethnology, and the collections of art made by Mountford in each place are broad in their range of subject matter.[14] Two works from this expedition feature in the exhibition: Mawalan's *The Wawilak Sisters* (plate 82),[15] and the ceremonial image showing figures wearing headdresses, *Yolngu with ceremonial objects* (plate 9), now known to be the work of Yilkari.[16]

Milingimbi mission: An art house

In the 1950s, under the patronage of the Reverend Edgar Wells at Milingimbi, local artists were encouraged to make paintings and artefacts for sale to raise funds for the mission, much as the Reverend Chaseling had done at Yirrkala. The result took local art into the wider public domain on a scale not seen before.

Several exhibitions of Aboriginal art were staged in the 1950s. 'The Australian Aboriginal Art: Arnhem Land Paintings on Bark and Carved Human Figures', organised by the Berndts and held at the Art Gallery of Western Australia in 1957, was the first to identify individual artists and stylistic traditions. The exhibition included work from Western and Eastern Arnhem Land, but none from the Milingimbi region. Nonetheless Mawalan was represented by several works including an untitled painting 'associated with the sacred Wawilak cycle'.[17]

In 1956 Karel Kupka, the Czech–French collector, had made the first of his several field trips to Arnhem Land. Kupka's interest in Arnhem Land art was aroused when he saw a painting of the Wagilag Sisters by Yilkari (fig. 11) which photographer Axel Poignant had collected on his 1952 visit to Milingimbi.[18] Kupka put together collections of bark paintings and sculptures for the Musée national des Arts d'Afrique et d'Océanie in Paris and the Museum für Völkerkunde in Basel.[19] Much of Kupka's personal collection is now part of the National Collection in the National Gallery of Australia. Two works in 'The Painters of the Wagilag Sisters Story 1937–1997', collected by Kupka on his first journey, were exhibited in 'Kunst der Uraustralier' at the Basel museum in 1958: Yilkari's *Mardayin ceremony* (plate 10) and Dawidi's *Dhapalany ga bathi (Itchy Caterpillars with nest)* (plate 52) both from 1955 and 1956.[20] The exhibition also featured works by Daynganggan. The popularity of the exhibition resulted in its extension by two months.[21]

The 1950s was a decade of transition. Yilkari died in 1956 and Paddy Dhathangu assumed ritual responsibility, while Dawidi was coached into becoming the main Liyagalawumirr artist in the public arena by his *djunggayi* (custodians and ritual partners of the opposite moiety) Djawa and Dhawadanygulili (fig. 9 and plate 3).

This period saw a marked escalation of interest in Aboriginal art for its artistic value rather than as an addendum to ethnography. The interest came especially from overseas, partly due to the fact that, after Africa and New Guinea, Australia was regarded as the last frontier in the collection of so-called primitive art.[22] A succession of collectors visited Arnhem Land.

Fig. 4
Mawalan and Wandjuk Marika,
Wawilak narrative, 1947; crayon on paper;
115.0 x 74.0 cm.
Photo: John E. Stanton and the Berndt Museum of Anthropology, University of Western Australia, Perth

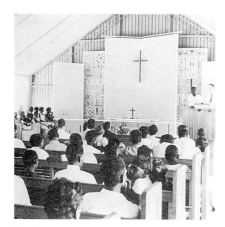

Fig. 5
Yirrkala mission church with painted panels on either side of the altar, 1963. Photo: Ann E. Wells

These included the American physician Stuart Scougall who, with the Deputy Director of the Art Gallery of New South Wales Tony Tuckson and collector Dorothy Bennett, made a series of collections, one of which is housed at the New South Wales gallery.[23] Kupka made several more trips, and other prominent collectors included the Americans Edward L. Ruhe, Louis A. Allen and Jerome Gould. Prominent among Australian collectors were J.A. Davidson, who visited every year and often supplied the American collectors, and Helen Groger-Wurm, who collected works on her anthropological field studies from 1965 to 1970.[24]

From 1961 the management of art production on Milingimbi became increasingly organised under the guidance of Alan C. Fidock, a school teacher at the mission who was to remain on the island for ten years. The work of Arnhem Land artists became a regular feature of touring exhibitions of Aboriginal art in Australia and overseas. Artists such as Dawidi and later Dhathangu, and the Yirrkala-based Marika family artists Mawalan, Mathaman and Wandjuk, regularly featured in such exhibitions. In 1960–61 the exhibition 'Australian Aboriginal Art', arranged by the state art galleries of Australia, toured the nation, while Tuckson, through Qantas Airways, organised a tour of the Scougall collection to Tokyo, Auckland, San Francisco, Montreal and Tehran.[25] The private collection of Dorothy Bennett toured Japan in 1966 under the title 'Art of the Dreamtime'. While she was living in Japan, Bennett received a request from Mawalan to return to Australia to act as his agent.[26]

Back in Arnhem Land, Ngangalala was established in 1963 as a mainland outpost for the mission at Milingimbi. At Yirrkala, in the meantime, the community elders, worried by the unchallenged influence of the Christian mission and the threat of mining, decided to paint two panels illustrating major ancestral narratives of the region, to be placed on either side of the altar in the mission church. The panels were executed by two groups of artists according to moiety affiliations; Mawalan Marika led the Dhuwa moiety artists, who included his brother Mathaman, his son Wandjuk, and Mithinarri Gurruwiwi, in the painting of the Djan'kawu ancestral saga (fig. 5).

Also in 1963, Yirrkala presented the first petition on bark to the federal Parliament in Canberra when a mining company sought to establish a bauxite mine in the region. The petition was presented as evidence of Yolngu land ownership in one of the first legal battles for the recognition of Aboriginal land rights. Prominent among petitioners were members of the Rirratjingu and Marrakulu clans on whose land mining was to occur. The petition's form of paintings on two sheets of bark underscored the significance of art practice within the totality of Yolngu culture — the painted image as a document of history and a title deed to land. The outcome of the proceedings did not favour the Yolngu at the time.[27] Nonetheless, the significance of the petition lies in the fact that Aboriginal people relied on their spiritual knowledge and traditional laws — and art — in negotiating their position in relation to white Australia. Another bark petition, submitted in 1968, bore an image by Durndiwuy Wanambi of Wuyal standing on a hill, Nhulun, around which was built the mining town of Gove.

Dhathangu and the rise to prominence of Ramingining art
Dawidi passed away in 1970 and the mantle of senior artist, who also held the position of ceremonial leader, passed to Paddy Dhathangu. Like Dawidi, he had initially been taught to paint by Yilkari.

By 1971 the population of Milingimbi was estimated at 852 and the sale of art brought $22,000 to the mission, which included twenty-six male artists — the women were not counted.[28] By 1977 the township of Ramingining was built, and the local art centre, Ramingining Arts and Crafts, was established with Peter Yates as the first art adviser, followed by Ian Ferguson. The art centre took over the role that the mission had played in organising, promoting and exhibiting the work of local artists. In 1979 Djon Mundine took up the post of art coordinator or adviser for Milingimbi and Ramingining, and later that year artists from the latter community were the first indigenous Australians to be invited to exhibit at the Biennale of Sydney.[29] Also in 1979, an exhibition of Milingimbi art held at Monash University in Victoria featured the work of Albert Djiwada and Joe Djembangu.

In the early 1980s the artists of Central Arnhem Land, based around the townships of Milingimbi and Ramingining, began to establish themselves in the public domain of art. Exhibitions of their work became more frequent: from Yilkari's *Mardayin ceremony* (plate 10), in 'Ozeanische Kunst: Meisterwerke aus dem Museum für Völkerkunde', Basel, in 1980, to contemporary Ramingining artists' participation in the Australian Perspecta in Sydney and at the São Paulo Biennial in Brazil. In 1983 Philip Gudthaykudthay was the first Ramingining artist to hold a solo exhibition, at the Garry Anderson Gallery in Sydney. From this exhibition the National Gallery of Australia acquired two bark paintings depicting the artist's country at Gunyungmirringa rendered in a regular grid of *miny'tji* or clan patterns.[30]

Mundine moved to Ramingining in 1983. That year an exhibition featuring the work of Dhathangu, Jack Manbarrarra and David Malangi at the Collectors Gallery (Aboriginal Arts and Crafts) in Sydney was, in effect, the genesis of the current exhibition, for it was here that the National Gallery acquired Dhathangu's series of fifteen bark paintings and a *yidaki* (didjeridu) (plates 22, 24–38) in which the artist elaborated on the theme of the Wagilag Sisters in greater detail than could be achieved on a single sheet of bark. In effect, such exhibitions proved a watershed in the presentation of Aboriginal art in commercial art galleries; each artist had the opportunity to create series of works on a single theme to provide the viewer with a more detailed and intimate understanding of the nuances and complexities of the narratives which were the subject of the paintings, while simultaneously familiarising the viewer with the particular hand of each artist — the idea at the core of the National Gallery's 1986 exhibition 'My Country, My Story, My Painting' featuring Dhathangu's Wagilag series.[31]

In 1984 a collection of works of art from Ramingining executed over a period of three years was acquired by the Power Institute of the Faculty of Fine Art at the University of Sydney. Exhibited under the title 'Objects and Representations from Ramingining', the show included works by Dhathangu, Philip Gudthaykudthay, Djardie Ashley, Neville Nanytjawuy and Yambal Durrurrnga. The modernist approach to the display of Aboriginal art which then prevailed characteristically gave primacy to the individual work devoid of its contextual references. This exhibition's curatorial approach was holistic in terms of context, while respecting the value of each individual piece. The collection was subsequently transferred to the Museum of Contemporary Art in Sydney, where it was shown again in 1996 with the introductory title of 'The Native Born'.

Meanwhile in 1986, two *yidaki* by Durndiwuy Wanambi and Dhathangu featured in the National Gallery's exhibition 'Painted Objects from Arnhem Land', and a year later

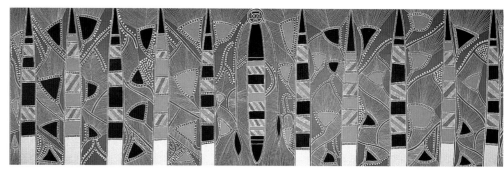

Dhathangu was commissioned by the Holmes à Court Collection to paint a mural at the Darwin Performing Arts Centre (fig. 6). The mural depicts a series of *wurrdjarra* (Sand Palms) flanking a ritual object bearing the visage of Dhathangu's father Yilkari, an image also found in his *Father totem c.*1969 (plate 58). With David Malangi, Dhathangu also executed a mural at the Darwin post office showing details of the Wagilag Sisters Narrative.

1988 and beyond

By 1987–88 Ramingining Arts and Crafts had 150 artists on its books, male and female, and the annual return for the sale of art grew to over half a million dollars in 1989–90.[32] The artists of Ramingining and Central Arnhem Land were establishing themselves in the world of art and their confidence led to the development of their most audacious public work to date. In 1987 a group of senior artists led by Dhathangu embarked on a project to mark the impending bicentenary of European settlement in Australia. For indigenous people the bicentenary represented 200 years of invasion, oppression and the attempted destruction of a race; nonetheless Aboriginal culture had survived and was thriving. The artists of Ramingining, therefore, sought to commemorate all the indigenous people who, over two centuries, had lost their lives defending their land. At the same time, they wished to demonstrate the resilience of Aboriginal culture and to provoke a change of attitude within the Australian population. Thus *The Aboriginal Memorial*, in the form of 200 painted hollow log coffins symbolising each year of European presence, came into being (fig. 7).

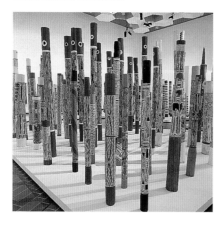

Dhathangu and the other leading participants required the *Memorial* to be displayed prominently in a public place where it would survive for the benefit of future generations of Australians. The National Gallery of Australia agreed to fund the construction of the *Memorial* and, after its first public showing in 1988 at the Sydney Biennale,[33] it was brought to Canberra, where it is now permanently housed in the first room of the Gallery, symbolically at the beginning of the visitor's journey through the collections. Apart from Dhathangu, among the forty-three artists who contributed to the project are Gudthaykudthay, Yambal Durrurrnga, Nanytjawuy and Djardie Ashley. The images painted on the hollow logs by the first two mentioned refer to the Wagilag Sisters story.

The year 1988 proved decisive for Ramingining artists; the exhibition, 'Dreamings: The Art of Aboriginal Australia', mounted by the South Australian Museum at the Asia Society Galleries in New York in that year, was the catalyst for the American collector John W. Kluge to commission a large collection of paintings and sculptures thematically based around the clan territories of the Arafura Swamp.[34] In 1988–89 the Museum of Mankind in London also commissioned a collection of bark paintings including one of Wititj the Olive Python by Gudthaykudthay.

In 1992 Ramingining Arts and Crafts gave way to Bula'bula Arts which was established as an incorporated body and artists cooperative, complete with a new building inaugurated by the National Gallery's founding director, James Mollison (fig. 8).

Also in that year Paddy Dhathangu was awarded an Emeritus Fellowship by the Australia Council in recognition of his contribution to the arts in Australia. Sadly, Dhathangu's visit to Canberra on his way home from collecting the award was also the first and only occasion that he saw the *Memorial* in its permanent location in the Gallery; Dhathangu passed away in March 1993, having witnessed and participated in many of the critical events in the public engagement with Central Arnhem Land art.

Fig. 8
Bula'bula Arts, Ramingining, 1994
Photo: Nigel Lendon

In Europe, abiding by the conventions for the display of so-called primitive art, ethnographic museums still maintained a monopoly on showing Aboriginal art, thus reflecting attitudes that denied indigenous art its contemporary relevance. This was to change with the breakthrough exhibition 'Aratjara: Art of the First Australians', which toured three European museums of modern art in 1993–94.[35] The exhibition featured works by Mawalan and Wandjuk Marika, as well as Gudthaykudthay's *Warrala Warrala* 1987 (plate 62), and Daisy Manybunharrawuy's *Wagilag Creation Story* 1990 (plate 5).

The National Gallery of Australia's collections and exhibitions

The National Gallery's policies for collecting Aboriginal and Torres Strait Islander art originate in the recognition that indigenous Australian art is the oldest continuing tradition of art in the world and that it is one of the two major art traditions operating within Australia today. The Gallery opened its doors to the public in 1982, during a time of burgeoning interest in Aboriginal art. Other public museums in Australia housed earlier major collections; consequently, the National Gallery formulated a policy to document and represent the continuing and evolving traditions of Aboriginal and Torres Strait Islander art in light of the dynamic nature of indigenous artistic practice reflecting a diversity of experience. The National Collection is intended, therefore, to reflect the various themes, contexts and artistic motivations present within the art of indigenous Australians where prominent subjects in each stylistic region are often based around particular ancestral narrative cycles such as those of the Wagilag Sisters.

Notwithstanding the representative nature of the collection, there are areas of specialisation of which the bark painting collection is one. Add to this the fact that the collection also represents, in some depth, the major individual figures in indigenous art such as Dawidi, Dhathangu and Gudthaykudthay, and the foundation for an exhibition such as 'The Painters of the Wagilag Sisters Story 1937–1997' had been laid.

In 1989, the year after *The Aboriginal Memorial* project, the National Gallery held its first major survey exhibition 'Aboriginal Art: The Continuing Tradition'. This included over 500 works displayed along thematic and stylistic lines. One room was dedicated to the Wagilag Sisters theme and included several works in the current exhibition by Dawidi, Dhathangu and Gudthaykudthay; Djardie Ashley's *Ngambi, spear points* 1986 (plate 78) and related works by Mawalan, Wandjuk and Banduk Marika, Mithinarri and Durndiwuy were displayed elsewhere.

Subsequent to this exhibition, the National Gallery planned a series of focused exhibitions: these included 'Flash Pictures',[36] an investigation of the aesthetics of painting; and 1993 saw the first of two monographic exhibitions of indigenous artists, 'The Art of George Milpurrurru', followed in 1994 by 'Roads Cross: The Paintings of Rover Thomas'. Whereas these exhibitions concentrated mostly on recent art, the Gallery has also held exhibitions of historical Aboriginal work. In 1987, the work of Dawidi, Mawalan and Mithinarri was featured in 'Ancestors and Spirits: Aboriginal Painting from Arnhem Land in the 1950s and the 1960s'. The exhibition 'Aboriginal Artists of the Nineteenth Century', in 1994, looked at the emergence of artists such as Tommy McRae (1830–1901) and William Barak (c.1824–1903) at the frontier with European colonisation in the south east of the continent. In 1996 'Papunya Pictures: The First Ten Years' celebrated the development of the painting tradition in the desert community of Papunya, in the twenty-fifth year since local artists confronted the public domain for the first time.

The developments in indigenous art in the twentieth century have, to a greater or lesser degree, depended on the responses to dramatically changing social and political circumstances, such as those faced by McRae and the Papunya artists. In an era of great change, it seemed timely to examine the development of a tradition sustained over successive generations of artists. By 1991, discussions had commenced between the National Gallery and Bula'bula Arts, and with Dhathangu in particular, concerning a focused exhibition on the theme of the Wagilag Sisters; the existence of Yilkari's 1937 painting of the *Wagilag Dhäwu (Wagilag Story)* (plate 8) provided a starting point while the National Collection contains numerous works on the theme by senior artists. To present the development of a single tradition of art-making over the best part of the twentieth century, it has proved necessary to locate many works which had been dispersed across the globe. The prospect of rediscovering paintings and objects which had left the community decades ago appealed to the artists and their families. After Dhathangu's death, consultations continued with Djiwada, Yilkari's younger son and the current senior owner of the ancestral Narrative, and Joe Djembangu, the senior *djunggayi*.

Just over a hundred years after Yilkari's birth, the result is 'The Painters of the Wagilag Sisters Story 1937–1997'.

1 Paddy Dhathangu, in an interview with Djon Mundine, Ramingining 1991.
2 *Northern Territory of Australia Government Gazette*, 1957, Welfare Ordinance 1953–55, Register of Wards.
3 'Liyagalawumirr' is the term used by a Dhuwa speaker, a Yirritja speaker would say 'Liyagalawumirri'.
4 In Eastern Arnhem Land the Wagilag are usually referred to as the Wawilak.
5 Macassan and Bugis trepang fishermen from the island of Sulawesi in modern-day Indonesia regularly visited the coast of Arnhem Land for perhaps 600 years until the early twentieth century.
6 Balanda, the Yolngu term for non-Aboriginal people, was introduced by the Macassans from Indonesia — the term is an adaptation of the Dutch word used in Indonesia for white people.
7 Djon Mundine, *The Native Born* (in press).
8 See Malawan's account of the acquisition of the story in his grandfather's time in Nicolas Peterson, 'Notes for archival version of the Djungguwan', unpublished field notes, 1966. The focus of the Mandhalpuy version of events concerning the Wititj is Marwuyu waterhole, and not Mirarrmina. As a result, most Rirratjingu images of Wititj relate to Marwuyu.
9 Djon Mundine, *The Native Born* (in press).
10 Captain Sir (George) Hubert Wilkins MC, *Undiscovered Australia* (1929), p. 185.
11 Donald Thomson, *Donald Thomson in Arnhem Land* (1983), p. 78. In light of the more recent population studies, including Noel G. Butlin, *Our Original Aggression* (1983), this estimate may be somewhat conservative.
12 Djon Mundine, *The Native Born* (in press).

13 Albert Djiwada, interview with Nigel Lendon, Yathalamarra, Arnhem Land, 1994.

14 Arnhem Land was selected for the expedition as it was virtually unknown to non-Aboriginal people.
See Charles P. Mountford, *Art, Myth and Symbolism* (1956), p. ix.

15 Ibid, p.280, plate 88A.

16 Ibid, p.388, plate 126D, *The serpent-men, [Wititj] and Gadjalan.*

17 Ronald M. Berndt & Catherine H. Berndt, *The Australian Aboriginal Art* (1957), p. 13.

18 Kupka's introduction to Aboriginal art took many forms; the Australian painter Carl Plate (1909–1977) also
encouraged his interest (Nigel Lendon pers. comm. 1991). Kupka's interest stemmed from a belief that he had
discovered the origins of art; see Michèle Souef, 'Avant-propos Karel Kupka (1918–1993)', in Dussart,
La Peinture des Aborigènes d'Australie (1993), pp. 9–16.

19 The Museum für Völkerkunde und Schweizerische Museum für Völkerkunde is now the Museum der Kulturen.

20 Illustrated in *Kunst der Uraustralier (Art of the Australian Aborigine)*, Basel: Museum für Völkerkunde und
Schweizerische Museum für Völkerkunde, 1958, foreword by Alfred Bühler, text by Karel Kupka.

21 Michèle Souef, in Dussart (1993), pp. 9–16.

22 The American collector Louis A. Allen hints at this in his rationale for collecting Aboriginal art; he writes of 'making
direct communication with old men who had been part of [the Stone Age] culture' and who were believed at the time
to be at the threshold of the extinction of Aboriginal culture. See Louis A. Allen, *Time Before Morning* (1976), p. 4.

23 Tuckson's interest in Aboriginal art was also stimulated by Axel Poignant who had sent him some Arnhem Land
bark paintings in 1952; Margaret Tuckson, personal communication with Nigel Lendon.

24 Groger-Wurm's collections are now in the National Museum of Australia, Canberra, and the Museums and Art
Galleries of the Northern Territory, Darwin. Durndiwuy's *Gundimulk ceremony ground with Wuyal and Dhulaku (Euro)
at Yanawal* (plate 92) was collected by Groger-Wurm in 1967.

25 Stuart Scougall, *Australian Aboriginal Bark Paintings: A Brief Survey* (1963).

26 Dorothy Bennett, oral history deposited at the National Museum of Australia, Canberra.

27 The case, Milirrpum and Others (plaintiffs) and NABALCO Pty Ltd and the Commonwealth of Australia (defendants)
went to the Supreme Court in Darwin; No. 341 of 1968. See also Nancy M. Williams, *The Yolngu and their Land*
(1986).

28 Djon Mundine, *The Native Born* (in press).

29 The artists were David Malangi, George Milpurrurru and John Bunguwuy, who exhibited at the third Biennale
of Sydney, 'A European Dialogue'.

30 Wally Caruana (ed.), *Windows on the Dreaming* (1989), p. 87.

31 'My Country, My Story, My Painting: Recent Paintings by Twelve Arnhem Land Artists' was shown at the then
National Gallery's Drill Hall Gallery at the Australian National University.

32 Djon Mundine, *The Native Born* (in press).

33 'From the Southern Cross', the Fourth Biennale of Sydney.

34 Djon Mundine (in press). The Arafura Swamp is at the junction of the Glyde and Goyder Rivers, some thirty
kilometres from Ramingining. See also P. Sutton (ed.) *Dreamings: The Art of Aboriginal Australia*, (1988).

35 The exhibition was organised by the Kunstsammlung Nordrhein-Westfalen in Düsseldorf and the Australia Council,
and travelled to the Hayward Gallery in London and the Louisiana Museum in Denmark.

36 'Flash Pictures by Aboriginal and Torres Strait Islander Artists' opened at the National Gallery, Canberra, in 1991
and later toured Australia.

A Narrative in Paint

Nigel Lendon

Any exhibition of paintings proposes several unique experiences to the viewer: the opportunity to encounter each work face to face; to recognise the similarities and differences between works, and how these function across time and space; and to engage with the consciousness of the individual artist, through the medium of the work and the touch of the artist's hand. The experience of an exhibition is an accumulation of all these things, and more, that in the body of an exhibition one learns to see each work differently by the inflections of context established between works, as each contributes to the framework by which others might be understood.

In the case of 'The Painters of the Wagilag Sisters Story 1937–1997' a number of things are occurring which are without precedent. We are all — Aboriginal and non-Aboriginal viewers alike — seeing for the first time the pictorial accounts of a creation narrative as it has been related by four generations of Yolngu artists, since almost the time of the first white inhabitation of their land.

The theme of this exhibition is at the same time both narrow in its focus and for the Yolngu, extraordinarily broad in its implications. The core of the exhibition is based upon a concentration on the paintings which depict the full Narrative of the Wagilag Sisters and their encounter with Wititj the Olive Python, in the *wangarr*, the ancestral past. For many groups and families in Central and Eastern Arnhem Land this provides a unifying set of principles which, in conjunction with each individual's other ancestral inheritance, simultaneously orders and makes sense of everyday life.

The scope of 'ownership' and custodial responsibility for the Narrative is reflected in the historical relationships between the various groups and families. As Albert Djiwada explains it, totems, places and songs are intricately inter-related:

> We all have to sing, people from Mirarrmina, all the people, Lilipiyana mob, Durrurrnga mob, Mänyarrngu mob, we all have to sing, Mandhalpuy, Balawuy, one Wititj, one song, *manikay*. And we are all Liyagalawumirr, but I'm Lilipiyana, Malangi's Mänyarrngu, Yambal's Durrurrnga, Minygululu's Balawuy.

> That's why, as Durndiwuy [said], that's Liyagalawumirr country there at Gurka'wuy, but maybe we not all own it, maybe someone else, maybe a Gälpu mob, or maybe other Liyagalawumirr people, but we don't own him, right? We got Liyagalawumirr country, but maybe someone else is using it, that country, or ceremony. But it's Liyagalawumirr country, as Durndiwuy [said]. But we can say that there's a lot of Liyagalawumirr country, owned by Durrurrnga mob, Lilipiyana mob, Mänyarrngu mob, only all based on Wititj, you know.[1]

In this sense, the structure of relations between families and clans and the understanding of a Yolngu history are critically related to the actions and authority of a person's forebears. The historical aspect of any given thing or event is as much a matter for immediate concern and interest as the ideas and responses of the current generation. And this is just as relevant

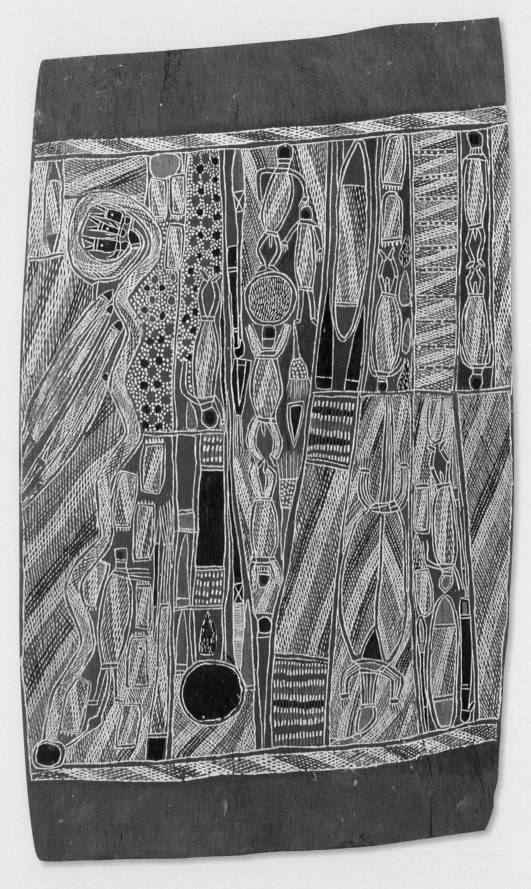

Plate 2. **Yilkari Kitani** Liyagalawumirr/Lilipiyana *Wagilag Dhäwu (Wagilag Story)* 1951

to the way in which painting is 'performed' as it is to any other aspect of ritual and social life. Painting, in this context, is crucially a performance of knowledge, inheritance, and the assertion of authority.

'Rich with history'[2]

For the Yolngu, the Western convention of seeing — that is, to see a painting from the past as if it effects some historical closure — has little meaning insofar as all art exists simultaneously in the present and in the past. Time and space collapse towards each other within the frame of reference of the painted image.[3] The currency of past experience or the affirmation of knowledge and authority, and thereby access to the time and space of the ancestral beings, are all liable to be invoked in any number of circumstances. Thus the presence of a bark painting from the past is no more than a confirmation that things have always been so. In another deeper sense, the evidence of the paintings before us is an affirmation and clarification of the sense in which the actions of the ancestral figures remain with us in the present. This exhibition is also a tangible demonstration of how the reverence accorded to the authority of previous generations (whether from Djiwada to Dhathangu to Dawidi to Yilkari, or Gundimulk and Wolpa to Durndiwuy, or through Dhuwarrwarr and Banduk to Wandjuk to Mawalan), is here seen to be present, tangible, and a value embodied in the works themselves.

The preparation of this exhibition has provided the senior landowners and *djunggayi* (managers or custodians) with an opportunity to trace and reconstruct a different pathway along which a Yolngu sense of history may be experienced. This has happened as a consequence of the way these people have structured their engagement with outsiders — in this case, by painting their story in all its complexity, selling the paintings, and seeing them disappear to the outside world. In the absence of significant durable examples of material culture — by contrast to the rock art galleries of the escarpment country to the west — the Yolngu of the centre and east have few precedents for keeping a visual record of the lives and actions of their forebears. Apart from a reliance on oral history and visual memory, this is a context where most things are ephemeral, largely as a result of the harsh climate and the tradition of a semi-nomadic lifestyle. It was not until the 1930s with the production of bark paintings as commodities or items of trade with the outside world, that a record began, spontaneously, to be kept. Now, through the circumstances which have lead to this exhibition and publication, the outside has brought these pictures back.

The changing circumstances of engagement with the world beyond the boundaries of Arnhem Land, the increasing numbers of visitors, the experience of travel, and the development of a market economy has had inevitable consequences for the place of art and the role of the artist. Over the past sixty years this has brought about a process of adjustment and modification to the imagery, but more crucially to the public interpretation of these works and the protection of knowledge. Here the status of a bark painting as a public manifestation of a sacred narrative is not in question.[4]

Outside the restricted setting of senior men with the relevant authority and knowledge, the ways in which a painting may be publicly interpreted now differ from the past. Restrictions are applied through a complex process of translation and accounting for the layered meanings of an image in response to the proliferating audience. These the artists now recognise are a consequence of the curiosity and admiration of the outside world.

This exhibition represents 'generations' ambiguously, for in one sense the sixty-year span of the tradition is but two generations: Albert Djiwada is Yilkari Kitani's son. In art historical terms, however, the show represents at least four generations of painters, with a number of sub-sets working simultaneously. In addition, within Yolngu society such categorisations are complicated by the moiety system. Everything has its place within either the Dhuwa or Yirritja moiety, and everything is linked by kinship to everything else. As they grow up, people learn their own complex relationship and responsibilities to other people and places, and thus to the totemic figures which give them life and order their behaviour in the world. As it applies to the successive senior painters celebrated by this exhibition, the term 'generation' dissolves into a matrix of interrelationships.

A key characteristic of this particular painting tradition is the process of the acquisition of knowledge through the role of the *djunggayi*, who carries managerial or custodial responsibility for a person's land and the related stories and ritual through that person's mother's clan. Thus although the Mirarrmina story is Dhuwa — and is owned by the Liyagalawumirr speaking people — it was the senior Yirritja ceremonial leader Dhawadanygulili who taught Dawidi, as he assumed the senior Dhuwa artistic role in Central Arnhem Land in the 1960s. The interval following the death of a leader often sees a number of senior men of the other moiety producing paintings 'on their mother's side', thereby maintaining the momentum of the tradition and reaffirming its vitality. In art historical terms, it is this cross-moiety influence at the moment of generational transition which appears to give this tradition its extraordinary dynamism. This mechanism also allows contemporary Yolngu to project backwards from the material evidence presented by the work in this exhibition towards its predecessors, as Albert Djiwada explains:

> To you, old Yilkari, he painted this first. No, the system doesn't work like that, has to come out from *djunggayi*. I think they painted it first, because when you say to me that Yilkari, he painted the first one, uh uh, he had permission from his *djunggayi*. They learn it from their father, and they had to tell permission to my father, Yilkari …[5]

Significantly, the person who assumes the role of the ceremonial leader, who may have previously been known more for their prowess as a singer, dancer, or a painter or maker of objects, now also acquires the added responsibility of painting the full account of the primary narratives to which their country refers. This creates the circumstances in which an artist's distinctive style, and the various factors which constitute their individual way of representing a narrative, contribute to each painter's performance of their authority.

In Lloyd Warner's fieldwork experience in the 1920s he recorded that bark paintings were used in the Ngulmarrk ceremony, and later Ronald and Catherine Berndt made similar references to this ceremonial function;[6] and there are records from the 1920s of paintings on the inside of bark shelters in the Goyder River region.[7] However the increasing number of requests from outsiders (starting with Warner, the Reverend Wilbur Chaseling and Donald Thomson in the 1920s and 1930s) has caused the production of paintings on bark as we now know them to become an increasingly important part of the material culture of the Yolngu.[8] From their first contact with Europeans, who regarded bark paintings as objects of ethnographic interest (Thomson in particular recognised the value of using the paintings as a stimulus to Yolngu elucidation of their cosmology), it was but a short step for the Yolngu to recognise that the demand for these artefacts provided a potential avenue for establishing trading relations with the outside world. Gradually, through the interest of enlightened

mission staff (particularly Chaseling, the Reverend Edgar Wells, the Reverend Gordon Symons, lay missionary Douglas Tuffin and Alan C. Fidock), a significant market for bark paintings was established. From the mid-1950s collectors and dealers were making regular annual visits to Arnhem Land and increasing numbers of paintings began to be sent to southern and international outlets for sale or as the result of commissions. Important collections were formed through successive contacts with anthropologists and missionaries, often acting on behalf of collectors or through consignments to dealers, and later arts advisers, through which the developing characteristics of the works themselves can now be traced.

While none of the paintings collected by Warner in the 1920s can definitively be identified as relating to the Wagilag Sisters Narrative, this exhibition draws on these early holdings to span almost the entire history of the collection of bark paintings from Central and Eastern Arnhem Land. The selection of paintings therefore widens the sense of the evolution of painting on bark as a significant medium, relevant both within Yolngu communities — its growing didactic role — as well as in its recognition by the artists as a form of communication with the outside world. Thus within the historical span of this exhibition we find the beginnings of a new role for painting to address multiple audiences, both Yolngu and Balanda, near and far.

To understand the significance of this medium — the 'bark painting' — it is necessary to recognise its references to other forms of imagery within Yolngu culture. For outsiders, bark painting has emerged as the most visible manifestation of Yolngu imagery and, possibly, in recent decades it has become the most prolific form of painting altogether. Within Yolngu culture however, the practice of painting on bark is grounded on other modes of image-making: on body painting, but also on paintings on hollow logs, on other sculptural or functional objects used in ritual, as well as the *molk*, the designs made on the surface of the ceremony ground. The specific ceremonial and ritual significance of these latter forms provides the source for the public manifestations of the many narrative representations which now make up the rich range of Yolngu visual arts.

In all of these manifestations, the key reference point is the way imagery is articulated in relation to and by the body. In this we find the basis of the crucial conceptual distinction to be made between the representation of the human form as the predominant theme of Western visual conventions, and the Yolngu conception of the body as the actual substrate of painting.[9] For boys, from the moment of their *dhapi* (circumcision ceremony) — for which the child is elaborately painted — each individual experiences the idea of painting as being intimately connected with the space, the physical reality, of his own identity. Thus the equivalents of Western concepts of space, location, perspective and world-view are all centred on the individual's situation within his or her specific place in a constellation of social and totemic relationships.

'Painted literature'[10]

In the paintings in this exhibition one finds not only the explicit elements of the story of the encounter between the Sisters and Wititj the Olive Python, but also an allegorical potential for deeper interpretation. At this level, the paintings refer to reciprocal tests of powers — on the one hand, of the women, who (through their irregular behaviour) precipitated the laws relating to marriage and social structures, and invented ceremonies in response to the threats of the *bäpi* (the great Snake) — and on the other, the power of the

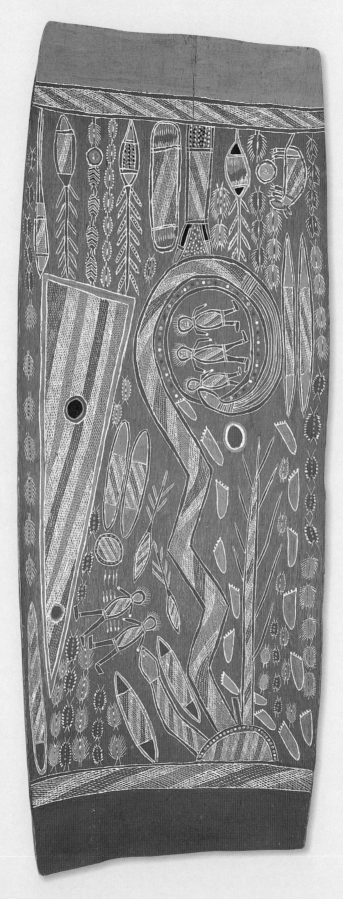

Plate 3. **Dawidi** Liyagalawumirr/Walkurwalkur (with Dhawadanygulili) *Wagilag Creation Story* 1960

bäpi, who, when the equilibrium of its existence was disturbed, summoned the first monsoon (and in the process created the seasons), and established (again by transgression) the proper relationship between the moieties. This allegorical dimension of the Narrative is revealed in other ways through ceremonial enactment of the events of each episode.

The interpretation of pictorial space provides a common access point for an understanding of the place of paintings within a Yolngu cosmology. One might start with the question of the orientation of a bark painting: how should we look at it? Bark paintings and body paintings share a common process in that both are painted on a horizontal plane, and then viewed on the vertical (as when a person stands up), even though many of the elements may also refer to the topographical figures of ground designs or a planar perspective of objects seen from above.

In the remainder of this essay I want to focus on what is at stake when the dynamic characteristics of this painting tradition are considered. While the artists and the Yolngu interpreters are always at pains to establish the ground rules for such a discussion — to establish continuity and stability, the characteristics of what we call a 'tradition' — at the same time the evidence of the eye confirms the existence of dynamic factors within their mode of representation.[11] They provide a multitude of formal possibilities within the determining sense of order and stability that Yolngu ideology demands. Thus while paintings from the past may demonstrate formal differences, for the Yolngu they demonstrate with equal force that things are as they have always been: the authority of their forebears is confirmed by the painting as a record of the performance of that authority. The Yolngu concept of tradition admits the actuality of individual variation and innovation as a proof of its continuing vitality and authenticity, passed from leader to leader through the successive generations.

Six key works by the artists who have successively held the primary responsibility for representing the Mirarrmina story — artists of the Liyagalawumirr language group and their *djunggayi* — will serve here to indicate how the potentiality of individual modes of representation of the Narrative evolves, and the characteristics of each generation's particular 'style'.

From the first known example of the narrative form of the imagery by Yilkari (plate 8), collected by Donald Thomson in 1937, one finds a number of elements which are common to all subsequent paintings on the same theme. While other images may refer to the Narrative in part or indirectly, those which can be described as the 'core' narratives always show the great Snake, Wititj, emerging from Mirarrmina, and encircling the Sisters and their children. Other elements refer to the sequence of the other events encompassed by the full account of the story.

Footprints tracking around the image of Wititj represent the dances performed by the Sisters in their attempts to repel the great Snake's advances. The triangular ceremonial ground represents the imprint of the great Snake when he fell from the sky. This element, which shows internal circular forms representing the Snake's heart and cloaca, is repeated as a ground sculpture in funeral ceremonies, in which case the circular forms acquire different functions and meanings. The lines of *dhapalany*, the itchy caterpillars, are ubiquitous in this and other images and objects, and their relationship to each element provides different keys to their specific part in this particular narrative.

In the paintings of the 1950s and 1960s different aspects of the Narrative are shown in distinctive ways by each artist: separate episodes are depicted within the image, and the sequential aspects of the key elements (for example. the multiple representations of the Sisters and the great Snake, as well as the latter's alternate embodiment in male and female guise) emphasise the narrative function of the painting in more literal ways.

Following the death of Yilkari in 1956, Dawidi assumed the rights to paint the full Narrative. Dawidi's versions of the Narrative of the early 1960s involve a greater precision and the simplification of forms, along with an increased density and the complication of the pictorial space. In addition, one sees a more literal depiction of the sequence of events and inclusion of other elements of the Narrative, for instance the inclusion of *wurrdjarra*, the Sand Palm which is associated with Mirarrmina. These pictures also include the new forms of the rain cloud, occasionally a second ceremonial ground, the stars and moon, the Sisters' dog, multiple representations of Wititj and the Sisters, and other innovations. As well, other elements in the 1937 image (the spearthrower, spears, other triangular forms representing stone spear heads, and clan patterns representing country) re-appear in these and later images by Dawidi, Dhathangu, and others.

The differences between the paintings of this tradition reveal how the process of change occurs. The complex narrative images also exist in relation to other imagery which focuses on individual symbolic/totemic elements or combinations of elements of the Narrative. These, due to the multivalent nature of the meaning of each element in different conjunctions, connote different nuances of meaning. The understanding of these meanings is, of course, dependent on the ritual knowledge of the narrator or viewer, and the audience to whom these are addressed. In isolation they may assume a different order of representation.

'Same, but different...'[12]

In the Narrative paintings by Yilkari, who represents the first generation of painters encountered by European visitors to Arnhem Land, the elements are compacted into a distinctive pictographic field, constructed with a cellular division of space (plates 2 and 8). The mosaic of elements and emblems packed into the overall pictorial schema is much like a cross-section of a living organism.

A pictorial structure such as this addresses the viewer through multiple viewpoints, and establishes the precedent for the later representations which combine both a planar viewpoint (or rather a number of planar viewpoints at different scales) with pictorial and other visual conventions. The painting by Yilkari however derives its aerial perspective through its references to *molk*, or ground designs (the way these forms are depicted in ceremonial sand sculptures) and to body painting and objects used in ceremony, and creates a virtual inventory of forms and emblems which are related to the performance of the story.

Throughout the 1960s Dawidi, although a relatively young ceremonial leader of the Liyagalawumirr, produced an extraordinarily comprehensive body of work involving distinctive modes of depicting the complex narrative. These can be traced to the influence of his ceremonial mentor and *djunggayi* for the Mirarrmina story, Dhawadanygulili, in the years following Yilkari's death. In these paintings Dawidi employed an ambiguous spatial organisation, combining planar and atmospheric representations in a field aligned towards the viewer through the semicircular form of the waterhole. With a range of subtle

devices, Dawidi establishes a foreground and background and a clear sense of up and down within the picture, thus creating an internal structure which orders the viewer's access to the details of the story. The effect is a sense of progressive movement between the two conventions: both drawing in the viewer, almost within reach of the forms and figures represented, as well as emphasising the authoritative location of the painter/narrator. Through this compelling curvature of the space of the painting, (planar in the foreground, vertical in the background), the viewer is therefore drawn closer to the ancestral figures to which the Narrative refers.

The most complex and challenging invention in such paintings is the sense of space which incorporates the viewer. In Dawidi's painting it is the semicircular space of the waterhole at the bottom of the image — the site from which the Narrative radiates.[13] The incomplete circular form imaginatively crosses the lower edge of the painting and thereby positions the artist (and the viewer) *within* the ambiguous space to which that form refers — with all the implications that position suggests to the knowledgeable viewer. Dawidi's adoption of this device can be traced stylistically to the influence of the ceremonial leader Dhawadanygulili.[14] In their joint painting of 1960, *Wagilag Creation Story*, can be found the first known example of this distinctive new way of depicting the story from which Dawidi developed his particular style (plate 3 and fig. 9).

For the Liyagalawumirr artist, this particular symbolic space is the equivalent to the centre of the universe, from which perspective maximum authority may be exercised. Therefore, the optimum vantage point to enter the scene of the Narrative is to straddle the frame at the point of access to the space of ancestral time — the waterhole. These paintings seek to do more than simply depict an event. For different reasons, the artist invents pictorial devices which draw the viewer into the scene and into the different realities it represents.

Fig. 9
'Artists' workshop' in Milingimbi, southern camp, 1960. Dawidi, second from left, and Dhawadanygulili are shown painting *Wagilag Creation Story* (plate 3)
Photo: Karel Kupka

This sense of enveloping space suggested by such devices within Dawidi's paintings is also consistent with the way in which the Yolngu subject experiences other forms of painting. In body painting, from the time of a subject's *dhapi*, for example, the body is literally the substrate of the painting of the complex clan designs. Thus in bark painting, by an extraordinary conceptual transposition, the knowledgeable subject may both enter the space of the painting from the outside or, drawing on restricted knowledge and experience of body painting, the subject may experience it from within.

Some years after Dawidi's death in 1970, the rights to paint the Narrative in his manner were inherited by his daughter Daisy Manybunharrawuy and her husband Joe Djembangu who, being Yirritja, assumes the rights from his mother's side.

The first accounts of women painters possessing the authority to paint such stories

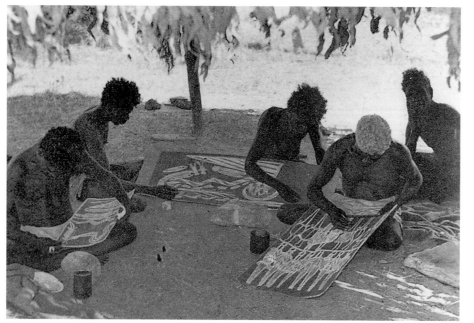

28

dates from the late 1950s: the three daughters of the Rirratjingu clan elder Mawalan (Banygul, Dhuwarrwarr and Banduk Marika) are recorded as learning through assisting their father. As Dawidi's first-born child, Manybunharrawuy acquired the rights to paint the Narrative of the Wagilag Sisters in her father's style through a similar process.

In her paintings, often produced in collaboration with her husband Djembangu, we see a clarification and elaboration of Dawidi's style. Djembangu is also the senior *djunggayi* and thus has the right to paint the story independently. A comparison of their two paintings (plates 4 and 5) reveals the literal intention of the planar viewpoint of the central section of the painting: within their hut, lying down asleep (about to be eaten) the orientation of the figures of the Sisters and their children can be either up or down — they are, after all, lying on the ground. In the paintings of the full Narrative by Manybunharrawuy one finds the continuity of her father's 'classical' representation of the Narrative modified by the characteristics of her individual style.

In contrast, the other significant Liyagalawumirr artist who began to paint the story of the Wagilag Sisters in the 1960s, Paddy Dhathangu, depicted the Narrative through constant variations on the theme. With his *märi* Dawidi,[15] Dhathangu shared the Dhuwa ritual and ceremonial authority throughout the sixties, and with this authority came also the rights to paint the full Narrative, although the specific source of his style is not so clear. Examples from the late sixties show the development of a different mode of representation from that of Dawidi, in which Dhathangu's approach to the depiction of figures and forms in space is through an emphasis on their bodily presence.

Characteristically, he turns the bark rectangle sideways and arranges the participants in the story, the elements of the landscape and the ceremonial emblems, to fit within the boundary of the new format (plate 6). This mode of depiction creates a distinctive vantage point which gives emphasis to the corporeal and enveloping form of the coiled Wititj. While his depiction of the Snake is often more energetic than his predecessors, certain motifs (for instance, the palm tree and the dilly bags full of bush tucker) are painted with a characteristic rhythmic structural patterning that distinguishes Dhathangu's work.

The 'embodied' space of these paintings, their corporeal quality, arises partly from the artist's pragmatic necessity to arrange the bodies of the figures and animals and other forms within the available space. On one level the space of these paintings is articulated as a function of the need to adjust the bodies and objects within the boundary of the bark; as a consequence this presents the images and forms close up, on the same scale as painted on the human body.[16]

Following Dhathangu's death in 1993, Albert Djiwada assumed the ritual authority for the Mirarrmina story as the senior songman for the Liyagalawumirr and the oldest living son of Yilkari. He resumed painting in 1994, reviving his early 1980s style of representing the story. In Djiwada's style we find a multiplicity of icons presented in profile, dispersed across a distinctive regular pictorial background of *rärrk* (cross-hatching). In these works the forms of the minor elements do not align necessarily with the major forms of the Snake and the figures, nor with a sense of foreground and background, but are shown floating against the *rärrk* and across the painting's boundaries. The poly-iconic structure of his paintings allows an inclusive and flexible approach to representations of the details of the story and makes references to other visual forms derived from the ground designs of related

Fig. 10
Dawidi explaining the Wagilag Story to Malcolm Douglas, Milingimbi, 1967
Photo: David Oldmeadow

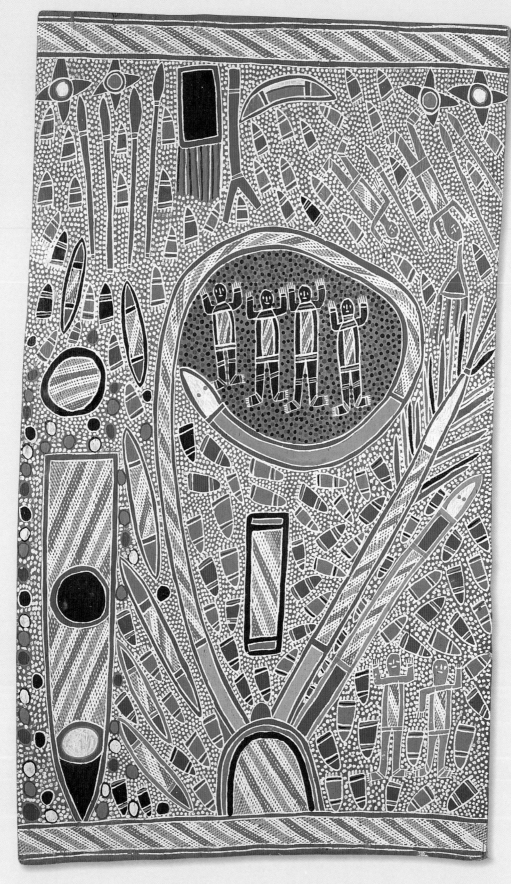

Plate 4. **Joe Djembangu** Gupapuyngu *Wagilag Creation Story* c.1980

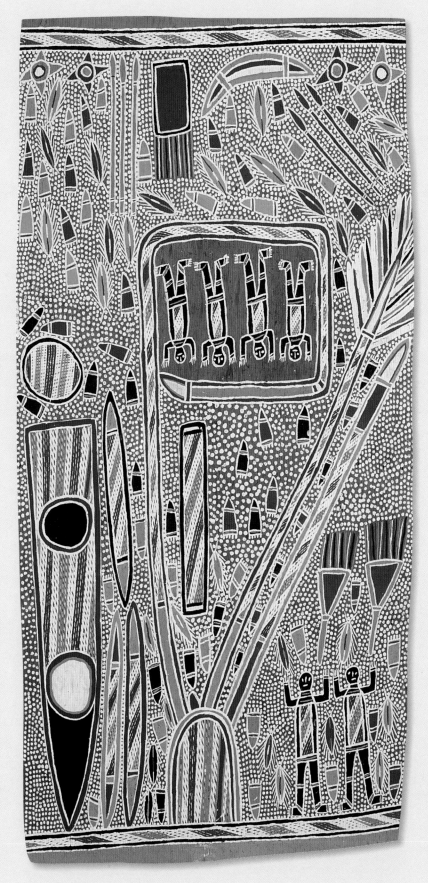

Plate 5. **Daisy Manybunharrawuy** Liyagalawumirr /Walkurwalkur *Wagilag Creation Story* 1990

ceremonies. Thus we find the inclusion of the constructed *wänga* (bark hut) and *dindin* (paperbark water carrier) (plate 7), elements not previously seen in the paintings which precede Djiwada's own representations of the Narrative.

Through examples like these we recognise an historical process in the development of the Narrative paintings, building up to a complex spatial repertoire both through the capacity for invention, which is evident in the way the tradition has evolved, as well as the influences of external pictorial conventions. One example is the formal complexity of the multiple viewpoints in such paintings. This apparent paradox is entirely consistent with the sense in which a multiplicity of ways of reading or explaining natural and social phenomena is fundamental to the Yolngu system of knowledge. This system is inherently multivalent and variable, dependent on who is interpreting what, and for whom, and the degree to which 'meaning' may or may not be enunciated. The polysemic nature of these paintings thus enables the protection of meanings without necessarily restricting either their exposure to the gaze of outsiders or their content to the communication of 'outside' meanings.

Some forms of pictorial innovation, which may be said to animate the Narrative in a quite individualistic manner, pose a different set of questions. This draws attention to the potential for such visual innovations to have primarily an aesthetic intention; to intensify the reading of the more conventional symbolism; or to articulate the artist's authority in the expanded frame of reference of the new social arenas now addressed by the work.[17]

The development of new conventions of pictorial space (for example in the ambiguous curvature of space as seen in Dawidi's paintings, or the floating effects of those by Djiwada) provides a clue to the new communicative functions of painting within the historical span of this exhibition. This occurs both internally, in relation to the changing role of bark paintings as a didactic medium, and externally, in response to the interrogation of visiting Balanda, and their explicit search for 'epic' stories (from the time of Karel Kupka, Stuart Scougall and Tony Tuckson). It is also possible to interpret these new spatial conventions as both a way of structuring the relationship of the viewer (and by implication, the artist) to the subject matter, and of enhancing that experience through innovative activation of the forms of the image.

Such instances of formal change may also be interpreted as a manifestation of the enhanced social status acquired through the developing role of the painter within Yolngu society.[18] The development of a recognisable personal style occurs, not only through the demonstration of a particular array of forms and symbols each painter may own, but also through the development of a signature style in terms of technique and articulation of the material qualities of a painting to depict forms and space.

The formal language of this art reveals how certain conventions have been established through which the tradition has been passed from generation to generation. An iconographic approach to the modes of figuration and abstraction, in which are combined the various representations of the different episodes of the stories, suggests how these more complex narrative pictorial accounts establish unique ways of representing the world and the artist's relationship to it.

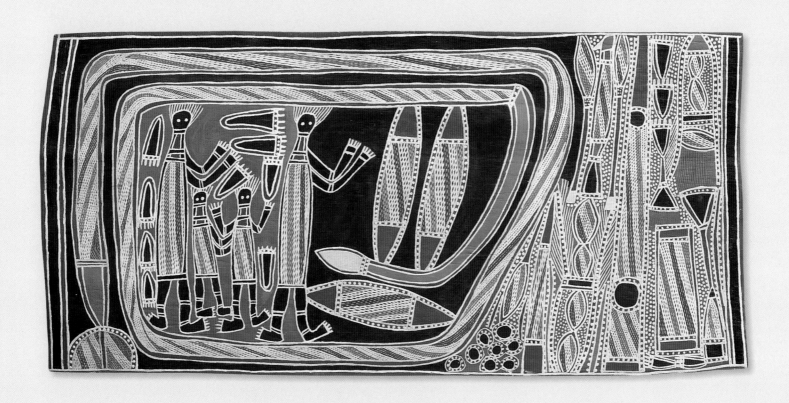

Plate 6. **Paddy Dhathangu** Liyagalawumirr/Malimali *Wagilag Dhäwu (Wagilag Story)* *c.*1980

'Plenty of stories under the ground'[19]

Other paintings in this exhibition describe specific episodes in the Narrative. They appear to have an added significance beyond amplifying a particular aspect of the Narrative, in that they also have the capacity to provide linkages to other ceremonies and stories. In such paintings the Narrative is implicit rather than explicit. The explanatory power of such imagery increases with the potential of each element to carry multiple meanings or a higher order of knowledge and a greater degree of abstraction.

Such combinations of totemic forms represent both a different order of abstraction and an elaboration of the forms, objects and events referred to in the more literal Narrative paintings. In an important sense it is the artist's understanding that such further dimensions of the content of the Narrative are already contained within the more literal depictions, awaiting the right circumstances or an appropriate level of ceremonial knowledge to be triggered.

As if to illustrate Marshall Sahlins' paradoxical dictum that 'tradition is the distinctive way that change proceeds',[20] the thrust of this essay has been to explore the dynamic character of a particular painting tradition. For the Yolngu, however, the prime characteristic of what I have referred to as 'tradition' is the capacity of narratives such as the Mirarrmina story to invoke the constancy of the ancestral past, albeit through a dynamic and variable mode of representation, while at the same time affirming the authority of forebears and their ancestral antecedents.

Within the paintings in this exhibition, one particular icon consistently grounds the Narrative in the events that occurred at Mirarrmina in the ancestral time of the *wangarr*. The representation of the waterhole, the locus of the greatest concentration of spiritual power, offers a constant reminder of the way these paintings are expected to engage the viewer. While in earlier images the waterhole was conventionally shown as a black circular form, in the paintings of Dawidi, Manybunharrawuy and Djembangu it is a semicircle bridging the foreground edge of the painting. In Djiwada's paintings this particular form of the waterhole, the great Snake's *wänga*, or home, is ambiguously also the representation of the *gurndirr*, the termite mound, as well as the entrance to the bark shelter, the *wänga* which was first built by the Sisters to shelter from the rainstorm. In other representations, for instance Gimindjo's *Wititj and Bardipardi (Rock Wallaby) at Marwuyu* (plate 66), the significance of the waterhole is intensified by showing it and its surroundings as a vortex, stressing its symbolism as the site of ancestral power, and a point of access to the world beneath the ground.

Throughout this exhibition, the multiplicity of associations invoked by the black circle is a constant reminder of the immense significance of Mirarrmina as the site of ancestral power for those associated with the Narrative of the Wagilag Sisters. As a form, the black circle has also an extraordinary metaphorical potential, for the surface of a waterhole is both a mirror, reflecting back the gaze of the outsider, and an interface, a symbolic point of access to the space of the *wangarr*, under the ground.

The surface of a painting may also be thought to represent an interface — a boundary between inside and outside meanings, or between the secular and sacred realms of human activity. In addition, the material qualities of the painted representation of the black circle

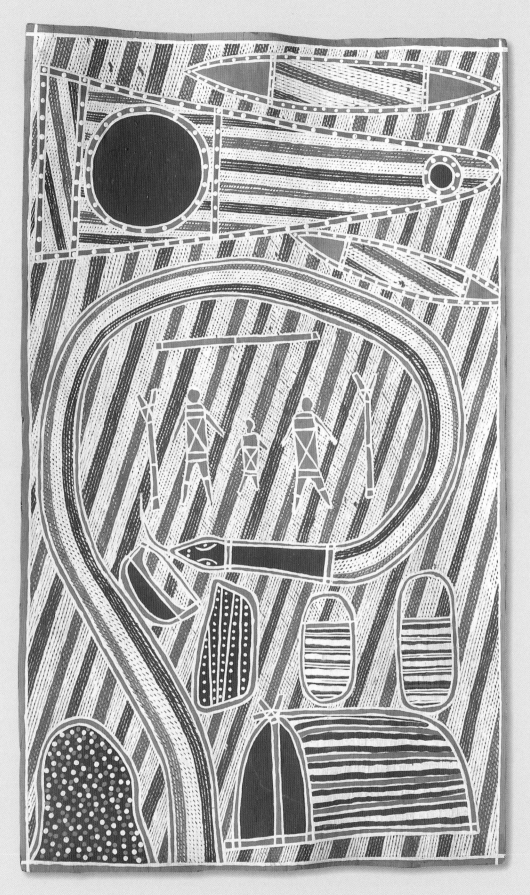

Plate 7. **Albert Djiwada** Liyagalawumirr/Walkurwalkur *Wagilag Dhäwu (Wagilag Story)* 1995

have the potential to bring us close to its most striking analogy — the skin of the painted body, glistening, shining, anointed with pigment, the figurative ground itself.

The micro-structure of paintings such as these is also loaded with meaning: the pigment has specific associations with the land and specific identities, qualities, and significance — both separately and together with other elements and qualities. Thus the material itself has a heritage of meanings, dependent on the particular constellation of references released in the performance of the artist's unique capacity to produce a particular image. Matter is transformed by the touch of the artist, which is reciprocated in the actions of the viewer.

With bark paintings, interpretations of the potential significance of different conventions of form and space need always to be grounded on the compelling material qualities of the medium itself, which leads to a distinctly different mode of perception. The importance of non-pictorial ways of seeing may be reinforced through the association between the material, the bark, which is peeled from the trunk of the tree, and the form of the painted hollow-log coffin, with all the spiritual associations this engenders. Such an appreciation of the material qualities of the form of a bark painting, along with the performative and bodily associations with other forms of Yolngu visual imagery, is a necessary balance to the tendency of Balanda to limit visual analysis to comparisons with outside conventions of perspective-based pictorialism.

Within the culture of the Yolngu the role of painting is established through a reiteration of origins, of place, of ownership, authority, and identity through the rendition of a particular narrative. Painting therefore fulfils a function in the description of belief systems, as a way of interpreting the natural and social worlds. Inasmuch as these are inseparable concepts for the Yolngu, painting also serves to activate sacred and secular accounts of nature and culture. In the recognition by the Yolngu of the painter's 'ownership' of a repertoire of images, and the identification of individual signature styles, painting also serves to confirm the structures of social life, and as a consequence the social status of the painter, far beyond the mere capacity to produce artefacts for a market.

1 Author's interview with Albert Djiwada, David Malangi and Joe Djembangu, 12 November 1994.
2 'Gälpu are like rich people … Rich, with history', Djalu Gurruwiwi and Manany, from the video 'Gälpu people sing Wititj *manikay* for Liyagalawumirr people', April 1997.
3 See Geoffrey Bardon, *Papunya Tula: Art of the Western Desert,* Melbourne: McPhee Gribble, 1991, p. 134. Here Bardon's comments on the multivalent character of Western Desert art are relevant: 'In the Western Desert paintings, the images do not provide a mere graphic equivalent of spoken words, thereby attaching themselves to the temporality implicit in the ordinary syntax of a sentence. Quite to the contrary, and importantly: time has become space.'
4 From all the many bark paintings considered by the Yolngu owners and their consultants for this exhibition, only one was withheld from public view. As Yambal Durrurrnga once commented when a curator asked whether a particular painting should be restricted: 'No, this was painted for people to look at', [Dick] Yambal Durrurrnga, personal communication, 1994.
5 Albert Djiwada, 1996.
6 See Ronald M. Berndt & Catherine H. Berndt, *Arnhem Land: Its history and its people* (1954); and R. Berndt et al, *Australian Aboriginal Art* (1964).
7 Captain Sir (George) Hubert Wilkins, *Undiscovered Australia* (1929).
8 In its present form, bark painting appears to be a relatively recent development within Yolngu culture. The production in large numbers of small portable paintings on bark for a commodity market has effectively resulted in a new secular 'medium' of communication with the outside world. In the creation of this painting tradition, the distinctive form of this medium, a pictorial field created in ochres, natural pigments and binders on the smooth inner surface of a rectangular piece of the stringybark tree (*Eucalyptus tetradonta*), refers to the many prior modes of painting which predate this development, including paintings on the inside of bark huts, bark paintings used in ceremony and body painting.

9 See author's essay 'The Meaning of Innovation: David Malangi and the Bark Painting Tradition of Central Arnhem Land', in J. Kerr, D. Losche & N. Thomas (eds), *Reframing Aboriginal Art* (forthcoming).

10 Karel Kupka coined this term to describe these paintings in *Dawn of Art* (1965), p. 109.

11 For an account of the stability of Aboriginal notions of tradition, at odds with some of the suggestions of this essay, see P. Sutton (ed), in *Dreamings: the art of Aboriginal Australia* (1988), pp. 46–49.

12 'Same, but different' is the most common Yolngu translation of variation within a stable cosmology. See Luke Taylor (1987), 'The Same but Different': Social Reproduction and Innovation in the Art of the Kunwinjku of Western Arnhem Land.' Ph.D. Thesis, Australian National University.

13 See my later discussion of the way in which the contemporary painter Albert Djiwada refers to the semicircular form ambiguously as both the waterhole, the entrance to the bark hut (*wänga*), and as the termite mound *gurndirr*, which are all alternative references to the underground 'home' of the Wititj.

14 The transition from Dawidi painting in the 'style' of Yilkari to the 'style' of Dhawadanygulili can be traced to the painting episode photographed by Kupka in 1960. See Kupka (1965), p. 38b.

15 In this context, *märi* is the subject's classificatory grandfather. In different circumstances one's *märi* can be either paternal grandfather or his sister, or maternal grandmother or her brother, all of which are the same moiety as the subject.

16 In his own words, it's a big story, and there's not enough room to fit everything in: 'There's no room for the house for these two women. There's nothing wrong with the painting, but there's no room to put the house in,' Dhathangu, 1992.

17 The precedent for this approach to the study of form is Howard Morphy's account of the function of *bir'yun* (brilliance) in the painting tradition of the Yirrkala region. See Morphy, 'From Dull to Brilliant: The Aesthetics of Spiritual Power among the Yolngu,' in *Man*, vol. 2, no. 1, 1989, p. 189.

18 See author's essay in J. Kerr, D. Losche & N. Thomas (eds), *Reframing Aboriginal Art* (forthcoming).

19 Robert Gural Lilipiyana (Yilkari-3), personal communication, 1995.

20 From his paper at the Australian National University/National Library of Australia conference, 'Reimagining the Pacific', 1996.

Central Arnhem Land

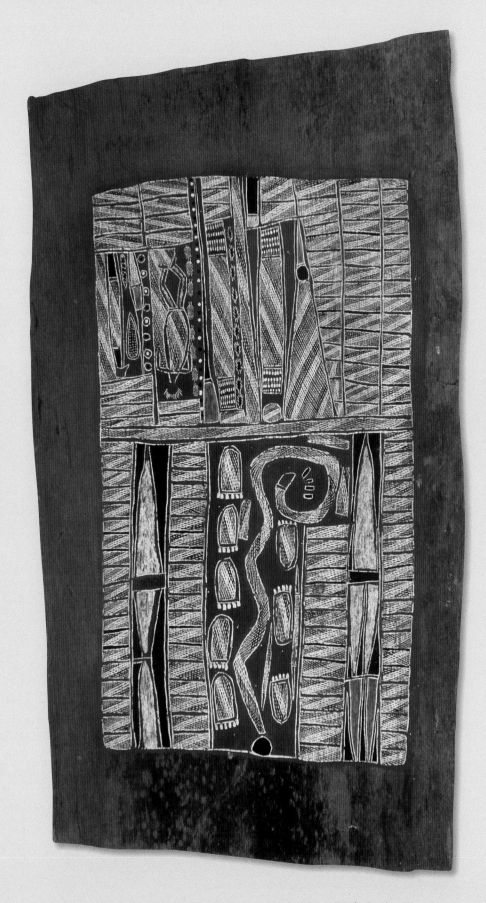

Plate 8. **Yilkari Kitani** Liyagalawumirr/Lilipiyana *Wagilag Dhäwu (Wagilag Story)* 1937

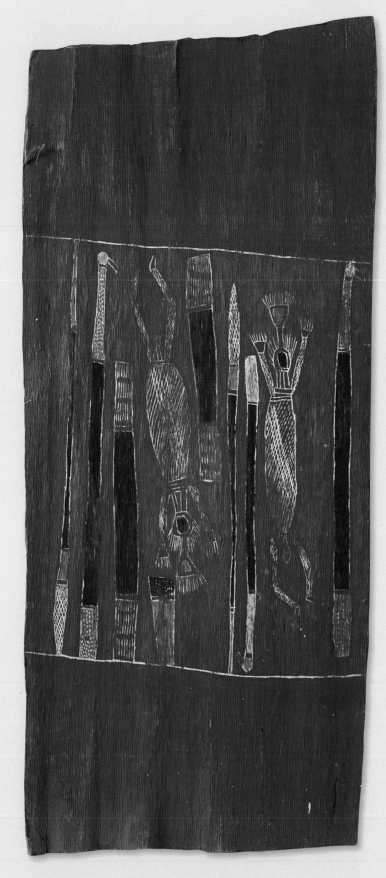

Plate 9. **Yilkari Kitani** Liyagalawumirr/Lilipiyana *Yolngu with ceremonial objects* 1948

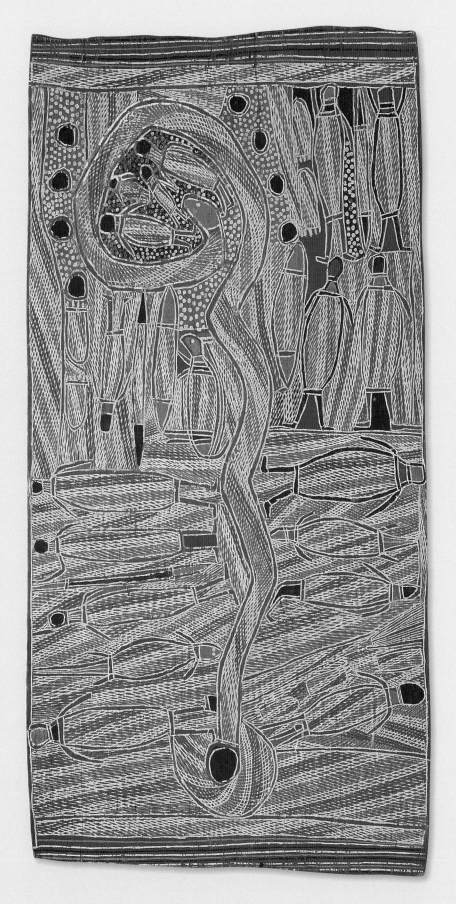

Plate 10. **Yilkari Kitani** Liyagalawumirr/Lilipiyana *Mardayin ceremony* 1955–56

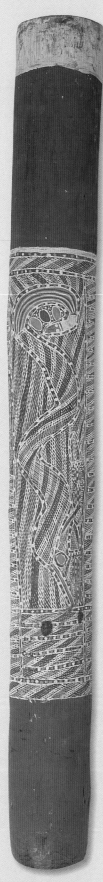

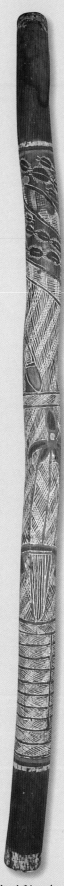

Plate 11. **Yilkari Kitani** Liyagalawumirr/Lilipiyana
Gurrurdupun 1949

Plate 12. **Yilkari Kitani** Liyagalawumirr/Lilipiyana
Yidaki (didjeridu) showing Wititj and Djarrka 1940s

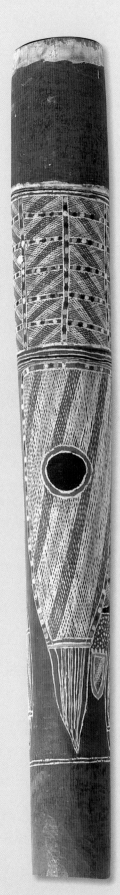
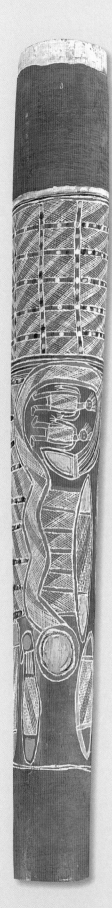

Plate 13. **Dawidi**, Liyagalawumirr/Walkurwalkur *Gurrurdupun (hollow log coffin): Wagilag Creation Story with Waltjarn (rain)* 1960 (front and back)

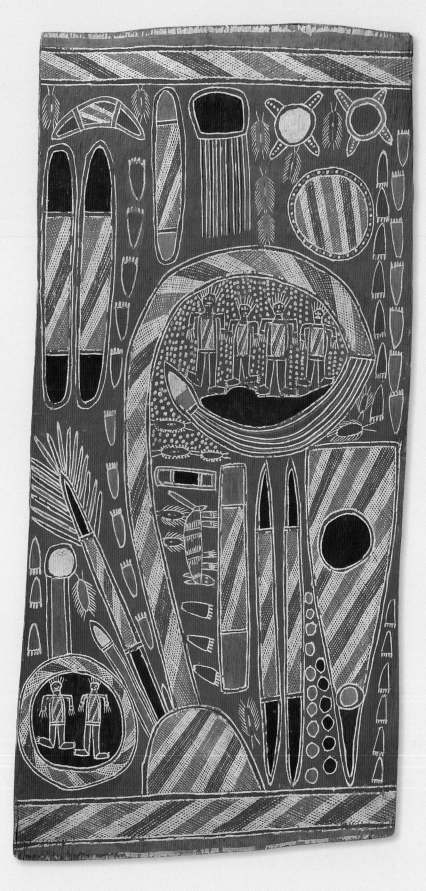

Plate 14. **Dawidi** Liyagalawumirr/Walkurwalkur *Wagilag Creation Story* 1963

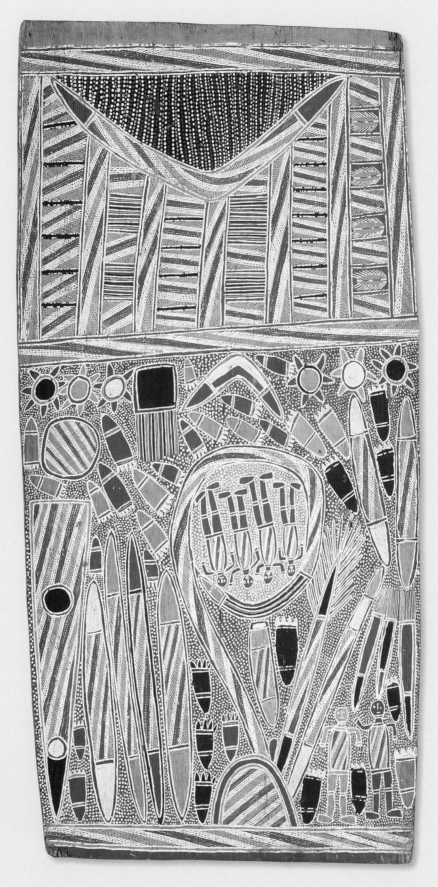

Plate 15. **Dawidi** Liyagalawumirr/Walkurwalkur *Wagilag Creation Story and the thundercloud before the first wet season* 1965

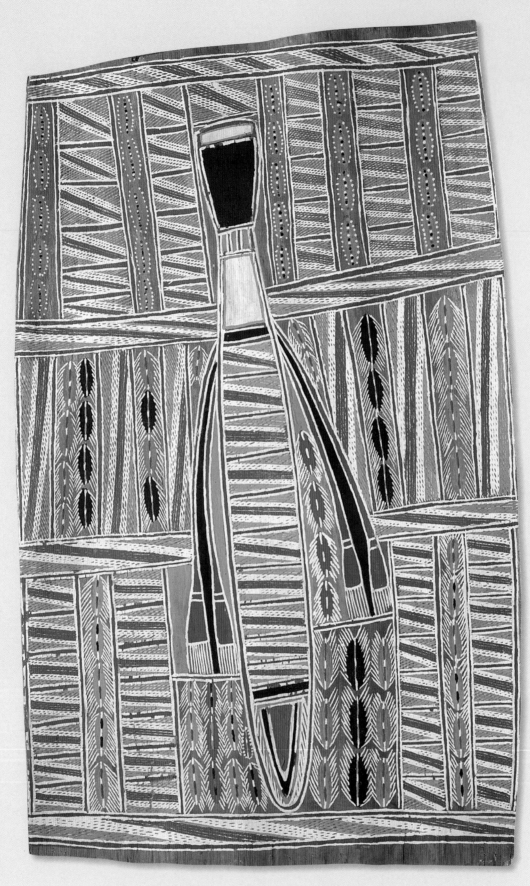

Plate 16. **Dawidi** Liyagalawumirr/Walkurwalkur *Wagilag painting (Elder Sister)* 1966

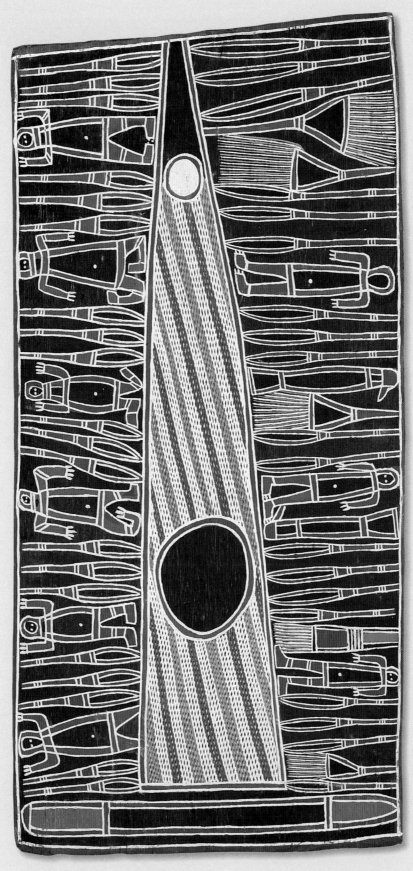

Plate 17. **Dawidi** Liyagalawumirr/Walkurwalkur *Molk ga Yolngu ga ngambi ga wurrdjarra ga manga ga malirri*
(Ground design with Yolngu, spear heads, sand palm fronds, spears and clapsticks) 1968

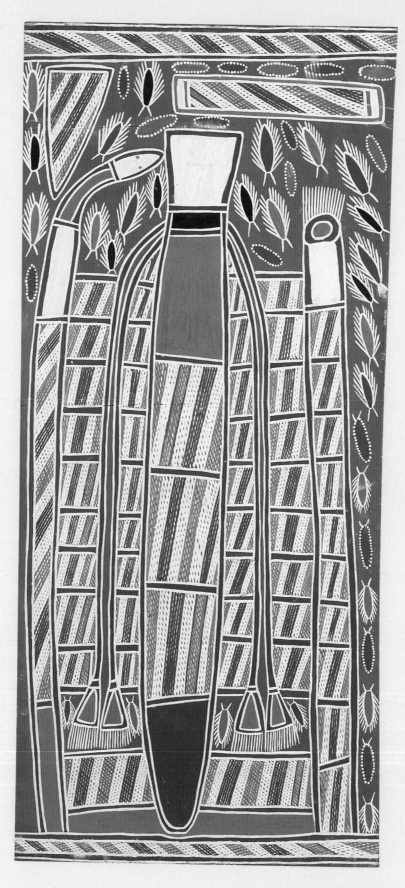

Plate 18. **Daisy Manybunharrawuy** Liyagalawumirr /Walkurwalkur *Girri' (Wagilag ceremonial emblems)* 1991

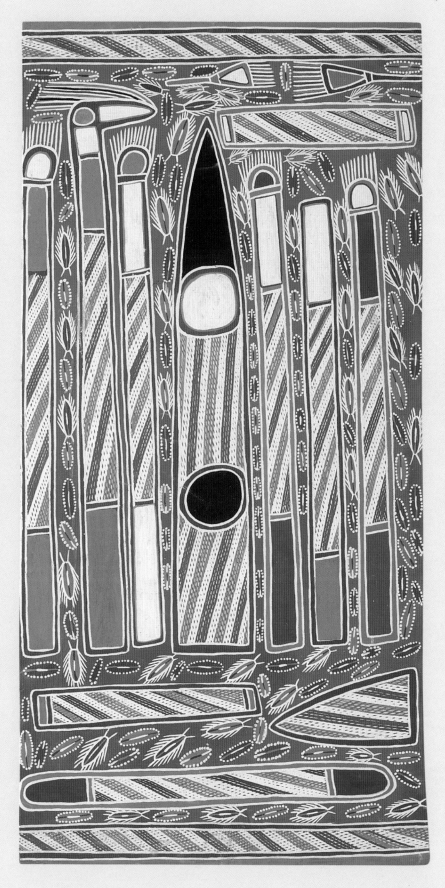

Plate 19. **Daisy Manybunharrawuy** Liyagalawumirr /Walkurwalkur *Girri' (Wagilag ceremonial emblems)* 1991

Plate 20. **Dawidi** Liyagalawumirr/Walkurwalkur *Wadjiwadji (emu feather fans) c.*1965 (detail)

Plate 21. **Dawidi** Liyagalawumirr/Walkurwalkur *Nguja, feathered head ornament* 1965

The Story of the Wagilag Sisters[1]

Paddy Dhathangu

I'll give you my story right now? Right now? You want my story. I'll give it to you right now [plate 22].

These important two are here and their two children here. There are these two mothers here, that's their footprints there, and here is Wititj python. There's no room for the house for these two women. There's nothing wrong with the painting, but there's no room to put the house in.

These two women made a bark house, and this is the Wititj here. All right?

There's two *bilma* [clapsticks]. Everybody calls these things *bilma*, but really in my language they're called *malirri*. So they have two names, *malirri* and *bilma*. And this here is called a *dhorna* [digging stick].

These two women brought this and used it to dig yams. These two women brought all these things and carried them with them; *bilma*, *dhorna*, yam as they travelled from Borroloola way. And this you know *djabakalang* [blue-tongue lizard] and this one *mirriwa* [frill-necked lizard] and this one here *riny'tangu* [blood yam] and these two; where's the other one? Oh, only one. All right, this one dog called Wulngarri, those two women brought him from a long way. These two killed blue-tongue, goanna, everything.

These two came through Ngilipidji, hunting all the way. And this dog, he saw these animals and said, 'Hey Sisters, we got blue-tongue here, we got goanna here, we got good food'.

These *dhapalany* [stinging caterpillars] sit on the bushes and leaves and sometimes on the *warraw'* [traditional bush shade with branches and leaves on the roof]. When anyone goes hunting and we go past and get that caterpillar on us, and later when we get home we start to itch and scratch from these caterpillars. These two Sisters were itchy from these caterpillars. We sing a song about this *dhapalany*. Maybe later I'll sing it for you. And this large bark has all [these] little laws or little barks on it; everything comes out of this one.[2]

And this here *dhorna*, the two Sisters used it to dance with when they got to Mirarrmina. They started to cook their food there when they camped. They cooked these bush vegetables and *wan'kurra* [bandicoot], which are left out of here, and this blue-tongue. They all ran into the water then, this *riny'tangu* ran into the waterhole.

So all this food ran from the camp into the bush and jumped into the waterhole. This Mirarrmina waterhole is near the Woolen River.

Then a small cloud, not a big one, a small cloud came up and started to make rain. It came from the spit of the Wititj, and the frightened women began to dance to stop it,

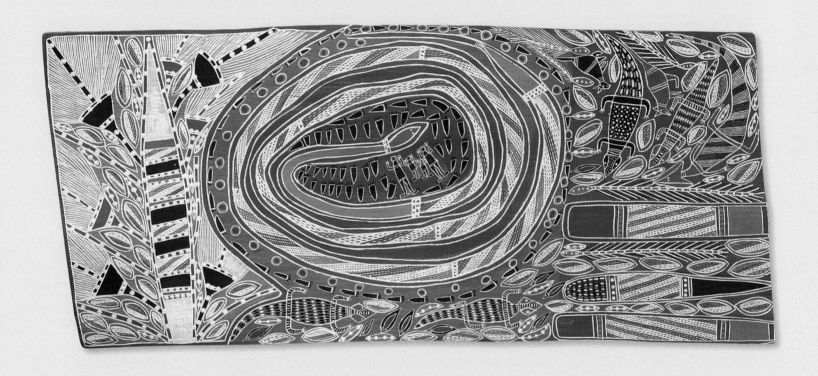

Plate 22. **Paddy Dhathangu** Liyagalawumirr/Malimali (with Dorothy Djukulul) *The Wagilag Sisters Story* 1983 from the series *The Wagilag Sisters Story*

but it still kept raining. They sang those songs like we sing today. Like I sang for my dead son at Galidjapin. This my [Creation Story] too now, and my country.

They began singing.

One Sister sang and the other used the didjeridu. One of these *wangarr miyalk* [spiritual women] sang and the other played the didjeridu and they both took turns to dance singing '*gaypa, gaypa, gaypa*' and hitting the ground with their *dhorna* as they danced.

And this one at this end called *wurrdjarra* [Sand Palm]. These here are their *malirri* and *dhorna* and this is their footprints as they danced, singing '*gaypa, gaypa, gaypa*' If we have ceremonies today, like the Ngulmarrk, women can dance like that.

So this one here, that Snake, spat out this cloud. And from this little cloud came the big rain, and the women kept singing to stop the rain. One trying hard first, but stopping, then saying 'You now, Sister'. So they tried for a long time but this rain kept coming from just this little cloud and then when they fell asleep the Snake began to creep closer.

I didn't have room to put the ant-bed in he crept up on. Then he curled around their home, bark shelter, I didn't have any room to put that in. Then he went inside and swallowed them. He swallowed one, then he swallowed one, then he swallowed one, then he swallowed one. He swallowed the mothers first, then the two babies, then the dog and all their house, food and things.

And this here Sand Palm, *wurrdjarra*, when these Sisters were camping this was their food. These two women — I don't really know where they started from — somewhere on the Borroloola side and Roper River. They came to Ngilipidji where they make the stone spears. This is a Wagilag place. I don't know what language they spoke before, but after they got to Ngilipidji they spoke Wagilag. I speak Liyagalawumirr.

I'm an old man but I know all this story.

These two women came there and started to make fire and cook their food and make their shelter, when all of a sudden their food jumped up and ran into the waterhole. They couldn't understand what was happening. That *riny'tangu* ran off too.

Oh, yes. Oh yes, I forgot — that's not the end! After that Wititj ate them, he stood up straight in the sky and he began to feel stomach pains because he ate the wrong things; the wrong side, his own moiety. They were all Dhuwa, the women and the Snake. That Wititj ate and killed those two Sisters and their children and all the animals and food.

Well, another Snake from Warramiri [clan] side, he sang out, and another Snake from Marwuyu, David Gulpilil's country,[3] he heard the noise and the conversation of the other Snakes, he asked:

'What are you doing there, what happened?'

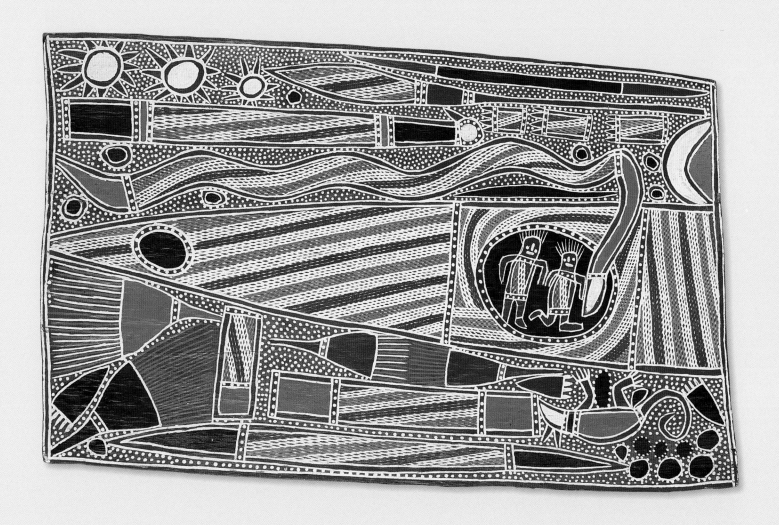

Plate 23. **Paddy Dhathangu** Liyagalawumirr/Malimali *Wagilag Dhäwu (Wagilag Story)* 1969

'Yes,' he said. 'I ate two women and ... baby and ... dog.'

The two Snakes talk together from Marwuyu and Mirarrmina, that's Mandhalpuy [clan] and Liyagalawumirr country [respectively]. And this is a true story, no bullshit.

Another Snake, in the salt water country, you know Liwukang and Burramarra [old men from Galiwin'ku], this is [their] mother ['s Creation Story], that [other] Wititj, [from] a long way away in the salt water country. Bararrngu *matha*, different language but we understand it.

'What did you eat?' the Wititj said. 'What did you eat?'

Well, the Wititj were here, at Marwuyu, and there, at Golumala, Golumala country.

He said, 'What did you eat?' '*Guya*, or fish, true God, *lalu* [parrot fish].'

The other Snake ask again, 'What did you eat?'

'Yes, fish, *guya*, fish!'

'You're no good,' from Marwuyu and Marrangu [clan] side, they say. 'You've been spoiling yourself, your body.'

I see from there now, somebody were asking again, the Marwuyu Snake, 'What about you, what did you eat?'

'*Yaka* [no], I ate Yolngu,' said the Snake at Mirarrmina. 'Yes, Yolngu I ate, two women I ate.'

'You're rubbish!' somebody called out from one of the other places.

'You're no good, we never eat that, you're a bad man,' the Snakes from all the different places said.

And the Marwuyu, the Snake said, 'Granny you are no good, *märi*, you're rubbish.'

He fell crashing to the ground [in disgrace]. He left his shape in the ground and then went back into the waterhole where he lives today. And now all the Yolngu that come from that country sing those songs and dance those dances that they did to try to stop the rain. They sing Ngulmarrk, Marndayala, and Djungguwan and Mardayin. The two Sisters carried all these things; *bilma*, *mirndirr* [dilly bags], *mangal* [spear throwers], and they wore the *maytjka* and *lindirritj* [special headbands].

This is a true story, it was painted by my father. I'll show you a photograph [fig 2]. This is a sacred and true story.

The Mirarrmina Snake did a terrible thing. If you go somewhere, and they ask you about the Wagilag Sisters, you can tell the story, you got it from me, it is a true story from my father, and I belong to that country, Mirarrmina. My country, Mirarrmina. This was given to me by my father, Tjam Yilkari, nobody else, he was the number one singer for Liyagalawumirr.

There's a lot of ceremonies from these stories. And that's all for now, no more story.

1 As told by Paddy Dhathangu to Djon Mundine in 1983, referring to his narrative painting *The Wagilag Sisters Story* (plate 22) from *The Wagilag Sisters Story* 1983 series, combined with an interview with Djon Mundine recorded in 1992, and some minor amendments by Albert Djiwada in 1997.

2 A reference to all the paintings in his *The Wagilag Sisters Story* 1983 series (plates 22, 24–38).

3 David Gulpilil is a famous screen actor and traditional dancer who owns this land.

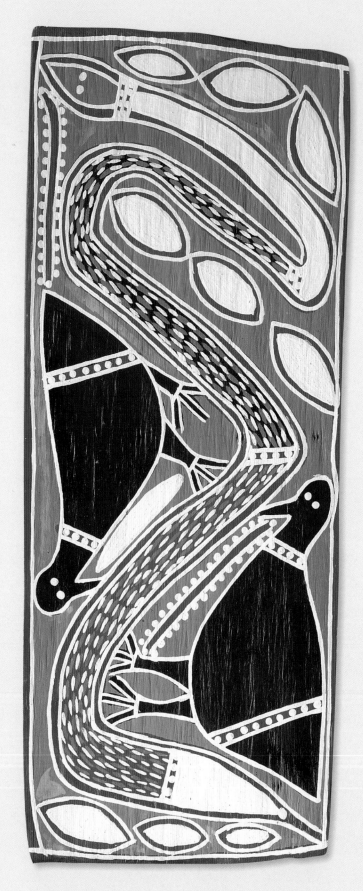

Plate 24. **Paddy Dhathangu** Liyagalawumirr/Malimali *Wäk ga Wititj (Crow and Olive Python)* 1983 from the series *The Wagilag Sisters Story*

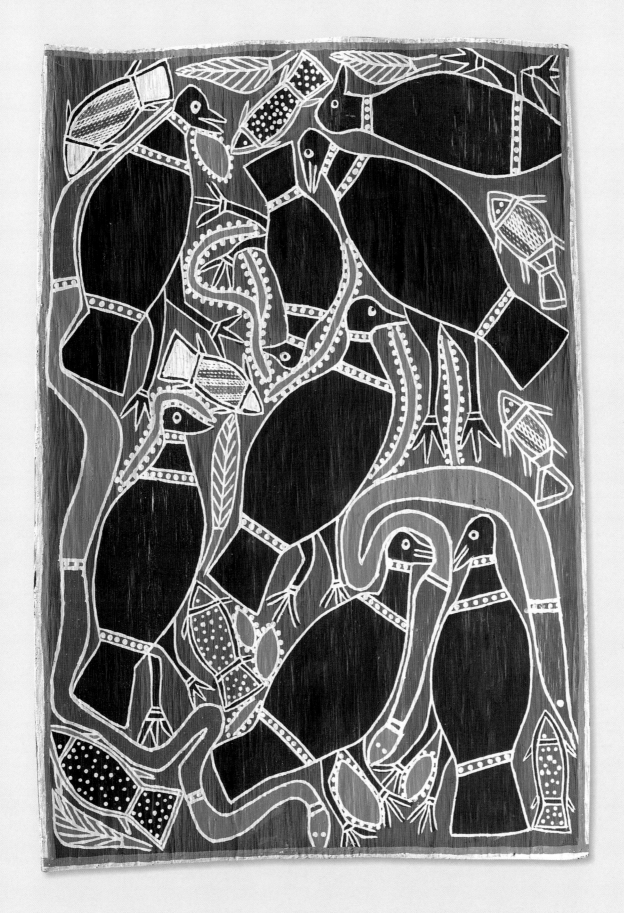

Plate 25. **Paddy Dhathangu** Liyagalawumirr/Malimali *Wäk (Crows)* 1983 from the series *The Wagilag Sisters Story*

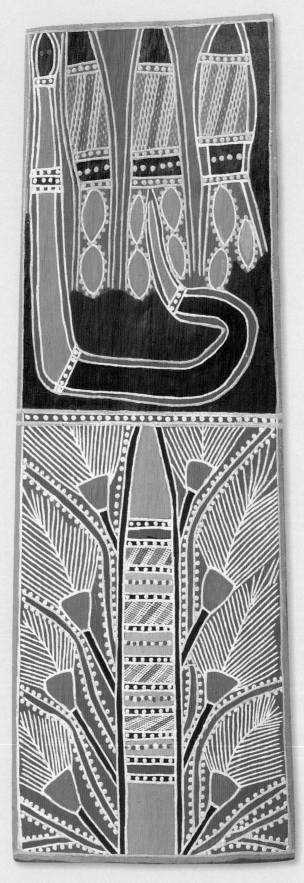

Plate 26. **Paddy Dhathangu** Liyagalawumirr/Malimali *Wurrdjarra ga Wititj (Sand Palm and Wititj)* 1983 from the series *The Wagilag Sisters Story*

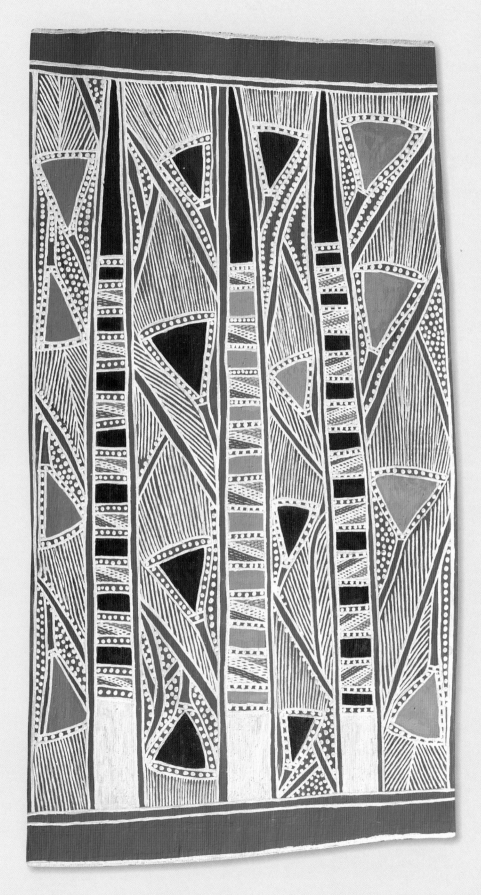

Plate 27. **Paddy Dhathangu** Liyagalawumirr/Malimali *Wurrdjarra (Sand Palms)* 1983 from the series *The Wagilag Sisters Story*

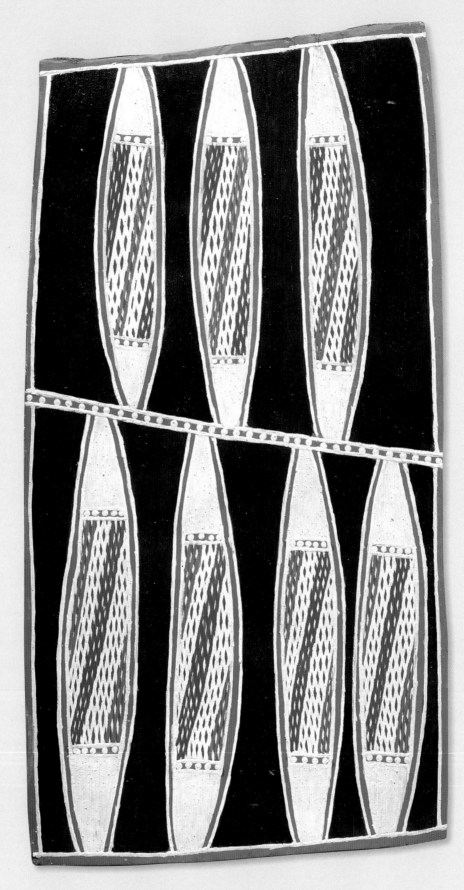

Plate 28. **Paddy Dhathangu** Liyagalawumirr/Malimali *Bilma (Clapsticks)* 1983 from the series *The Wagilag Sisters Story*

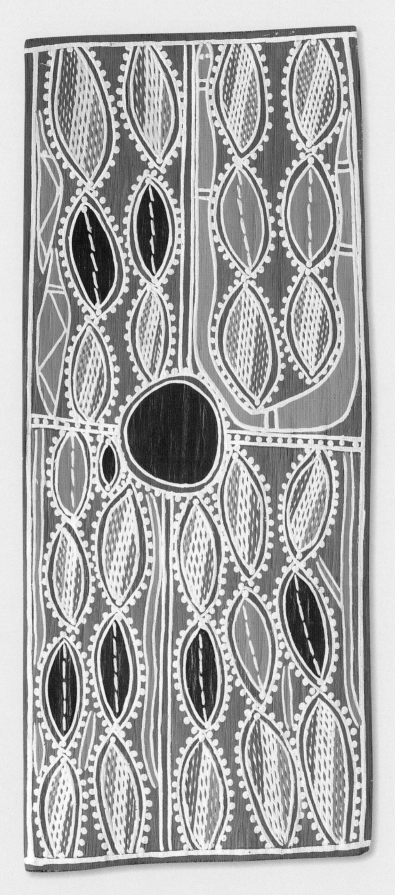

Plate 29. **Paddy Dhathangu** Liyagalawumirr/Malimali *Dhapalany (Itchy Caterpillars)* 1983 from the series *The Wagilag Sisters Story*

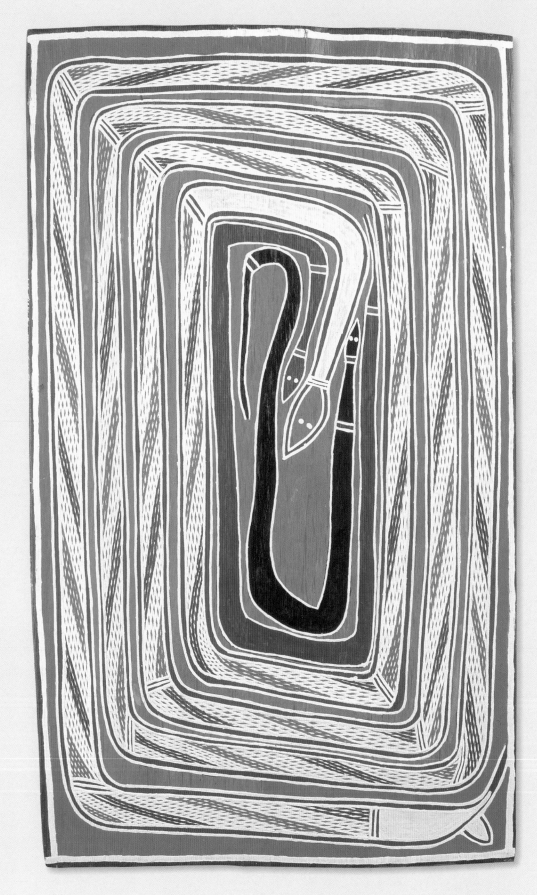

Plate 30. **Paddy Dhathangu** Liyagalawumirr/Malimali *Wititj (Olive Python)* 1983 from the series *The Wagilag Sisters Story*

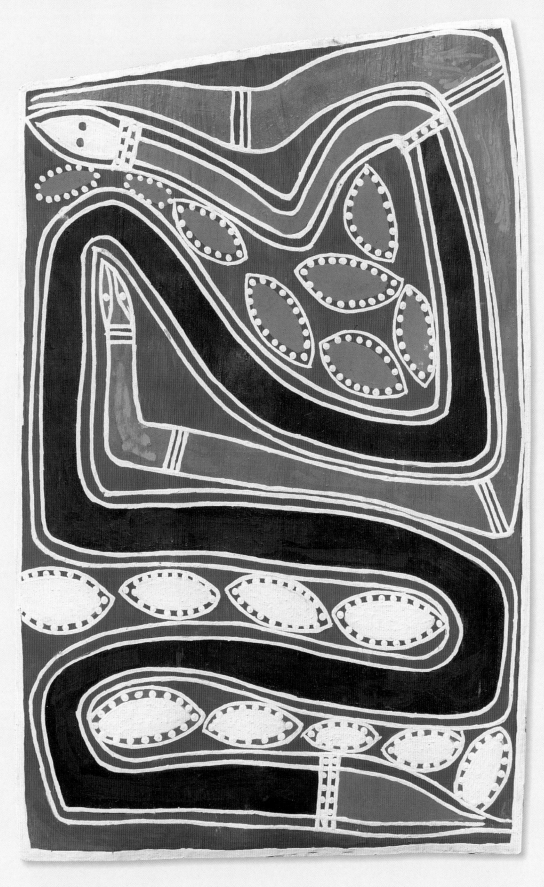

Plate 31. **Paddy Dhathangu** Liyagalawumirr/Malimali *Wititj (Olive Pythons)* 1983 from the series *The Wagilag Sisters Story*

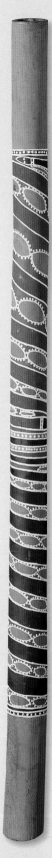

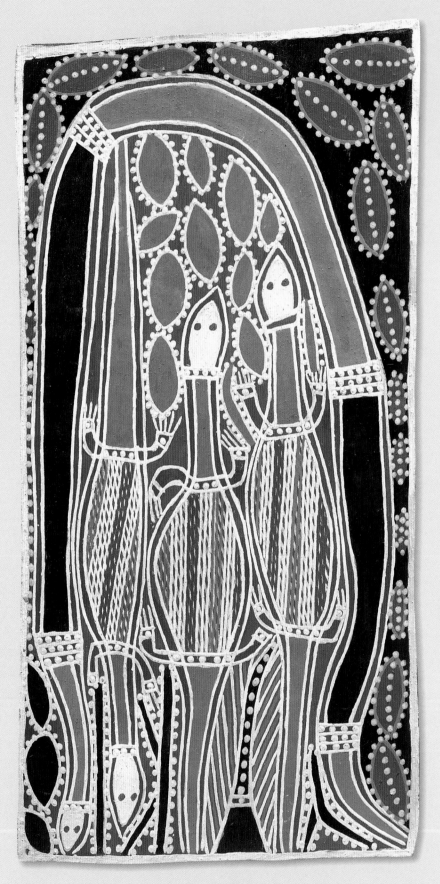

Plate 32. **Paddy Dhathangu** Liyagalawumirr/
Malimali *Yidaki (didjeridu)* 1983 from the series
The Wagilag Sisters Story

Plate 33. **Paddy Dhathangu** Liyagalawumirr/Malimali *Djarrka ga Wititj (Goannas and Olive Python)* 1983
from the series *The Wagilag Sisters Story*

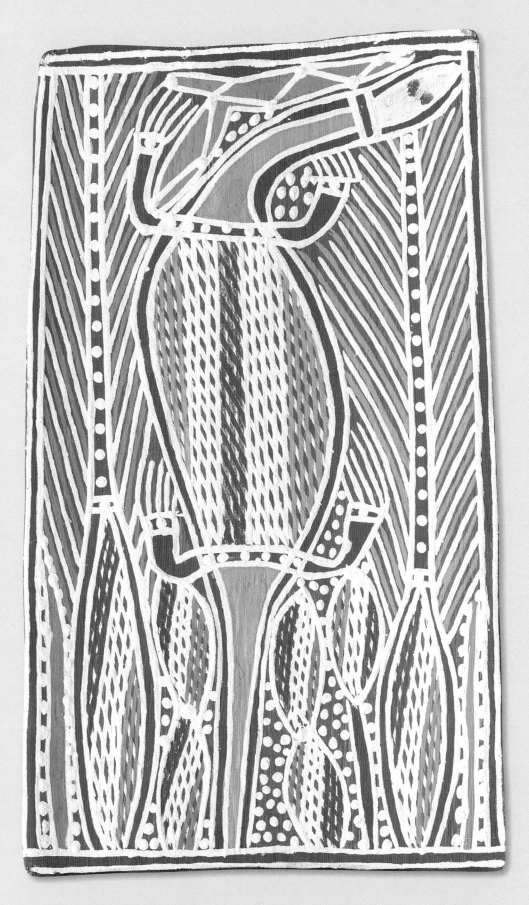

Plate 34. **Paddy Dhathangu** Liyagalawumirr/Malimali *Djarrka (Goanna)* 1983 from the series *The Wagilag Sisters Story*

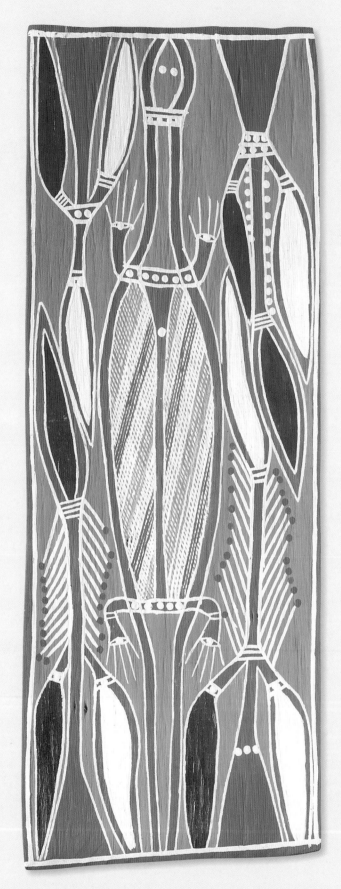

Plate 35. **Paddy Dhathangu** Liyagalawumirr/Malimali *Djarrka (Goanna)* 1983 from the series *The Wagilag Sisters Story*

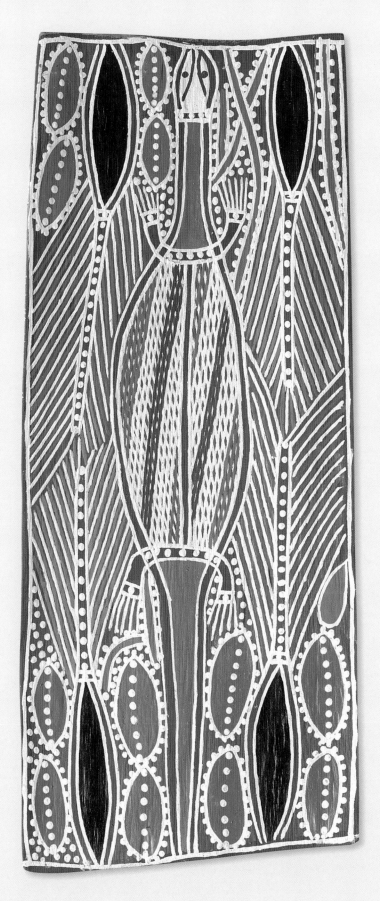

Plate 36. **Paddy Dhathangu** Liyagalawumirr/Malimali *Djarrka (Water Goanna)* 1983 from the series *The Wagilag Sisters Story*

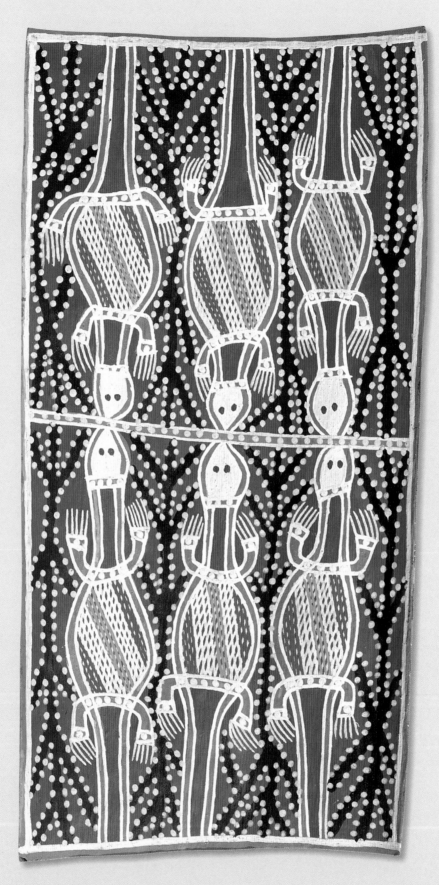

Plate 37. **Paddy Dhathangu** Liyagalawumirr/Malimali *Dhamaling (Blue-tongue Lizards)* 1983 from the series *The Wagilag Sisters Story*

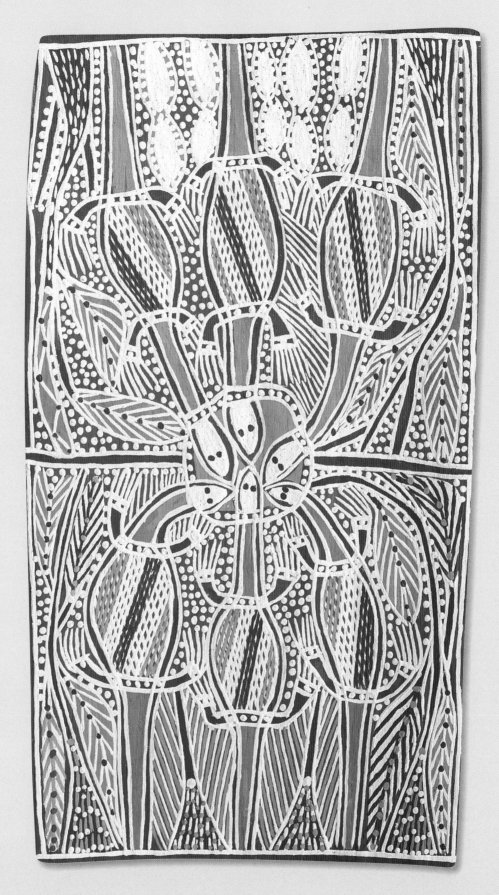

Plate 38. **Paddy Dhathangu** Liyagalawumirr/Malimali *Djarrka (Goannas)* 1983 from the series *The Wagilag Sisters Story*

The Mirarrmina Story[1]

Albert Djiwada

Our Law says when you have *yothu* [children], especially boy, the father has to hand him over to *märi* or *ngathi* [grandfathers].[2] When we become like four year old, or more, we have to go for *dhapi*.[3] Maybe five, depends on how fast you grow ... when boy [is old] enough for *dhapi*, what you call it, circumcision? We're talking about all of Yolngu *yothu*. And after *dhapi*, the Yolngu has to start to talk about how to put this boy to ceremony. Because the *dhapi*, that is the first lesson for that boy. Just like grade one when you go to school, time for *dhapi*, is first step, lesson for how to behave.

My father doesn't paint me for my *dhapi*. I think the Law says, it's the *djunggayi*,[4] my *dhuway*. My father is doing the singing, and *dhuway* is doing the painting.

[Referring to his father Yilkari's painting *Djarrka Dhäwu* (*Goanna Story*) *for Liyagalawumirr people* 1951 (plate 39), Djiwada continues:]

The real meaning for this painting? My father thought, 'Oh, I want to tell this story, to this Balanda, on the painting, just like *djorra' djäma* — the work for this book.[5] How in our history, ancestor people have been there, they were there waiting to become *mardayin*.[6] And I want to tell the story about what happened in this *djarrka* [water goanna] painting.' This is the story, this is how he painted.

In our story, these *djarrka* are like Yolngu. They were there, at the places like Mululumirr, or many other places. Well this is not really *djarrka*, but meaning of *djarrka*, because these are really meanings for ancestor people, in our story. My father thinks, 'I'll do the paintings what happened to this place'. Because these mob, in other words these *djarrka*, they are sort of like a tribe of ancestral people.

But when they put you to the Mardayin ceremony, that Wititj ceremony, that's when they have to paint the *djarrka* on the body. But not like this one here [Djiwada indicates his own painting (plate 40)]. This story, in this hollow log, is from Mirarrmina, *yindi*, very big one. When you're put into this, when you're in that ceremony, when I was a boy, when I had to, they painted me, here. And *miyalk* [women] they don't know this was inside. Today we keep it secret, they still don't know. When you see it, put it in here, they don't know what it means, it belongs to men only.

So we come from Mirarrmina, and we are the Liyagalawumirr. We are out of Wititj. That is our ancestral background. That is our story, so that's why *miyalk* call to us 'hello Wititj' — you heard this? Lena Araminba, many times, and Mary Waykingin [Neville Nanytjawuy's wife], always calling 'hello Wititj'. We are Wititj, out of Liyagalawumirr. Outside, we're Liyagalawumirr, but underneath, we're Wititj.

Fig. 11 (opposite) **Yilkari**, 1952. Photo: Axel Poignant

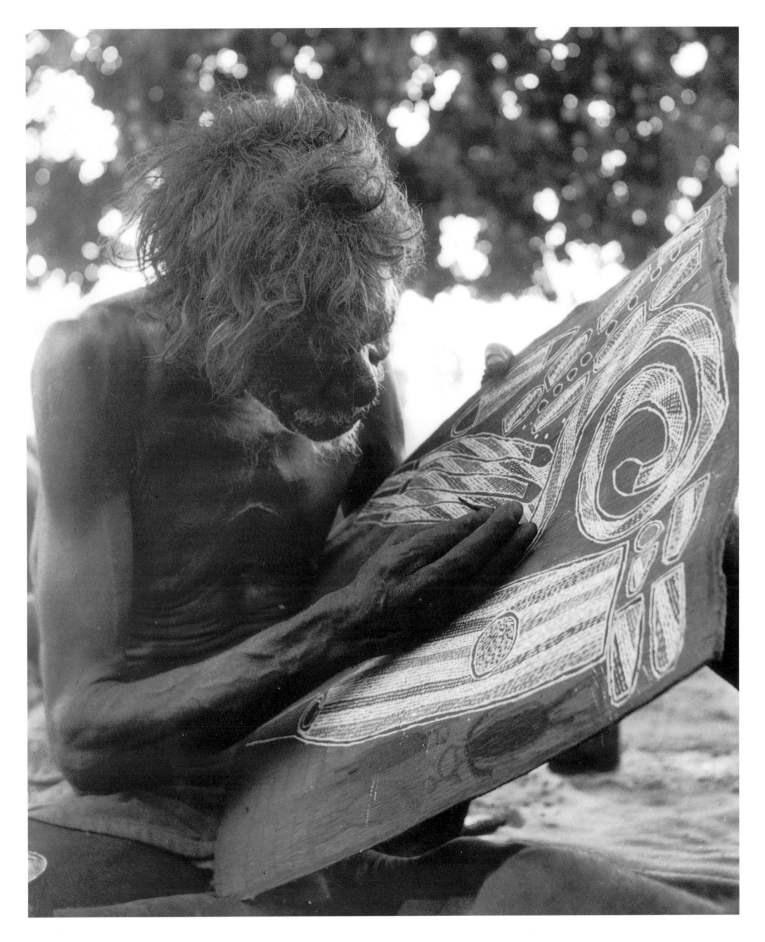

And, you see, we can say, 'Before, there was the ancestral *djarrka*, and then after that became people'. Otherwise people might say, 'Where are the people?' You can say, 'Ah, that's Wititj mob, before was the Wititj, now is the Wititj people'. But name of this Wititj was there, before the people. But now we are Wititj, here right now.

Because in our time, we used to go to school, and little bit in here [points to the painting], and more time in *djäma* [schoolwork], and little bit in here [points to the painting again], little bit. With Paddy Dhathangu, [he was] more on ceremony time, he has been in ceremony. But with me, more time in Balanda side. What I'm saying, not enough time to learn like Paddy did, he was older, like Dawidi.

And the story, now we're creating the story, we're hoping to create, the *dhäwu* [story] comes from the *djarrka*. The bottom of this represents how Liyagalawumirr mob got Djungguwan, and Ngirrgining mob got Djungguwan, Durrurrnga mob got Djungguwan, Dhaburruku' mob got Djungguwan, Mänyarrngu mob got Djungguwan, Gurralpa mob got Djungguwan, Mandhalpuy mob got Djungguwan, Garngarn mob got Djungguwan.[7]

Let's work it out this way. Everything starts to grow, at the same time, like Djungguwan here, or two Wagilag Sisters here, and Djan'kawu Sisters here, and lots of ceremonies for Yirritja people also. All together, when the world was created, and right away to me, it's like the ceremonies were born. And then they, the *djarrka*, became people in the story. So they have been sitting in the places like Mirarrmina, and many other Dhuwa places. They were there before Yolngu, and first, when we earlier talked about them, they are like *djarrka* people, same story.

These two Wagilag Sisters, I haven't heard what were the first names of these two Wagilag Sisters, when they travel from the east, before they reached Mirarrmina. Then they called themselves Garangarr and Buwaliri, but I don't know what are the real names before they reached Mirarrmina. But before they reached other side of Mirarrmina, maybe in other places they have other names. Before they reached there, before they travel in the part of Mirarrmina, maybe then they changed their name, 'Our name is Garangarr and Buwaliri'. But when they came from Ngilipidji, they had other names, which I haven't been told.

Before, they were Wagilag, and in the middle of their journey, then we don't know, [if] they're still Wagilag. Even I don't know how if they're still Wagilag, because I come from Wagilag, like Djardie Ashley. Our ceremonies join together, but he's Wagilag, and I'm Liyagalawumirr. And when the Sisters travel, they're full Wagilag, and when they reach the place Mirarrmina, there was no place called Mirarrmina before, but now, when they reached that place they named it, 'All right, we're going to name this place Mirarrmina'.

Just like two Djan'kawu Sisters, go right up, salt water way. But they make tribe, tribe, many many tribes. Here, that's Dr David Malangi's story.[8] But these two Wagilag Sisters, they named the places as they came up.

Say when the world was born, there's got to be someone in this place. This is from my thinking. When the Sisters travelled to this Mirarrmina, there must be already some

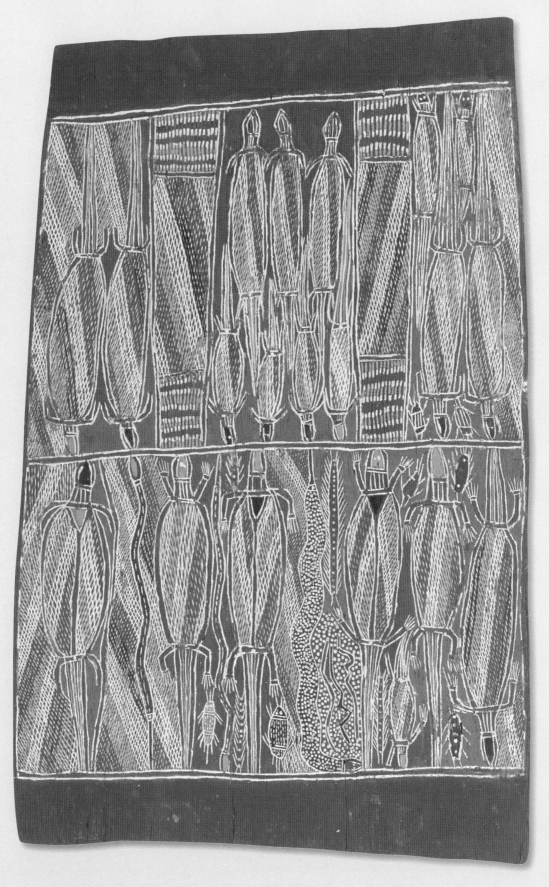

Plate 39. **Yilkari Kitani** Liyagalawumirr/Lilipiyana *Djarrka Dhäwu (Goanna Story) for Liyagalawumirr people* 1951

kind of world, when *bäpi* [great Snake] there already. And then at Mirarrmina, they were there one night, and they had one *yothu*, Yirritja. And when that *yindi bäpi* ate them, then he went back into the waterhole, then came out again, and vomited them on the *gurndirr* [flat ant bed], same name, and those cheeky ants bit them, and they began to wake. Then he broke their bones with *bilma* [clapsticks] and swallowed them again. Then he stood up, groaning, and was talking to the other *bäpi*, from Gälpu [clan] mob, and other *bäpi*. And other *bäpi*. And they have been asking each other, 'What have you ate, what have you ate?' And [the Snake from] Marwuyu asked him, 'Can you tell me true, what you really ate?' And Mirarrmina said, 'I ate two Yolngu' and fell down, and hit the ground, and made that *yindi molk* [big ground design]. And then branch it to the tribes, Guruwana, and many other little places that I haven't been told.

So Mirarrmina became like big name, from this time big name of that place, from when this *bäpi* ate two *miyalk* and the *yothu*. It's not the right way, they're both Dhuwa, of course it's not the right way, and that's why he vomited them, and then, look what happened.

I don't know, I haven't heard, what happened to them after the Wititj ate two *miyalk* and the *yothu*. Before, he called up the rain, and those two *miyalk* they had to sing, dance, and build that *wänga* [bark shelter], and then that's it. I haven't heard what happened to them. When he ate them, *bilin* [finish].

But Wititj went to become Durrurrnga at Guruwana, and there is *dharrwa dharrwa* [many, many], all them Gälpu mob, there is *dharrwa dharrwa* Wititj. *Dharrwa dharrwa* split up, from same Wititj.

But the *miyalk*, the two Wagilag Sisters, they didn't branch it up. I haven't heard where they travelled, with that *yothu*. All I heard is that when they travelled, they reached Mirarrmina, they cooked their *ngatha* [food], and evening time, this Wititj got up from underneath the waterhole, had a look at them. He said, 'I'm going to make a rain'. What happened, in the evening, when he was watching them making *ngatha*, he then spit the cloud to make that rain.

Before these two Sisters travelled here, they had one *yothu*. Now, branching out of this Mirarrmina, tribes branch it to Guruwana and to Garuma, and many other little places that I haven't been told. We are Liyagalawumirr, here at Mirarrmina, we got all the same songs, same *mardayin*.

But this one, David Malangi, he got a little bit different … he's fully Mänyarrngu, and Garrawurra. His *mokoy* [the spirit figure, Gurrmirringu], comes from Mulanga first, that's right, but now becomes Mänyarrngu, he was singing at Mulanga, other side [of the Glyde River], that country. That's Malangi, he's two clans, firstly Liyagalawumirr and then Mänyarrngu. Bottom story is Wagilag, but then they turned into Liyagalawumirr. He is Liyagalawumirr, Mänyarrngu, and then he's also joined into the Garrawurra mob, because two Garrawurra Sisters (Djan'kawu Sisters), they had a waterhole in here at Dhamala. We got to call Malangi Liyagalawumirr only because of same *manikay* [song], joined together only with the *manikay*. Gurrmirringu's [the ancestral hunter's] connection is to Mulanga,

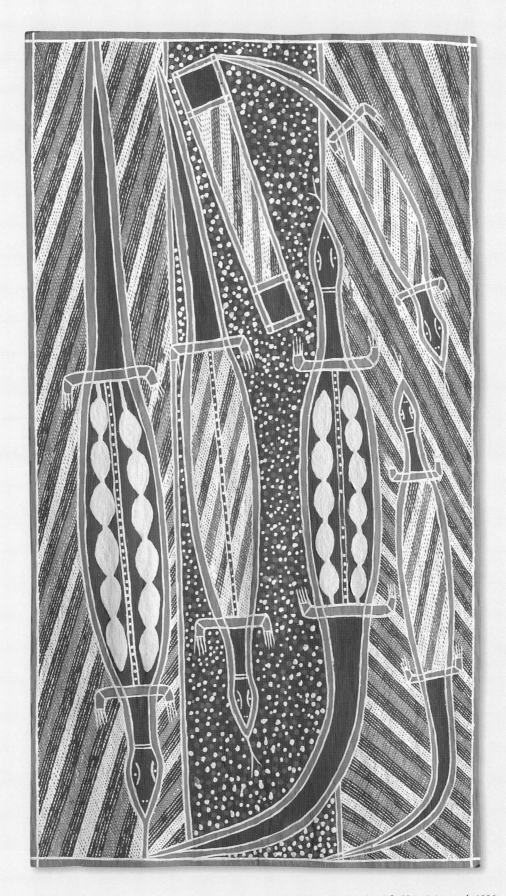

Plate 40. **Albert Djiwada** Liyagalawumirr/Walkurwalkur *Djarrka Dhäwu (Goanna Story) for Ngirrgining people* 1996

to Malarra, the fire story, which is the end of the story. He sings two *manikay*, and that Gurrmirringu *räga* [white berry bush] story is his painted *mardayin*.[9]

This *bäpi* [the Snake at Mirarrmina] travels from the country called Gatatangurr, which is the base for Wititj. This *bäpi* went hunting, and then found the two *miyalk* and the *yothu*, and ate them. Gatatangurr is the place where this ceremony stays. Maybe, say it this way … because I can tell you what I can tell you. Because … from this place Gatatangurr, this *mardayin* comes from this country, that's the bottom of the *mardayin*. Before it branches to the many many other places …

This is how it functions. The system is, for Yolngu, comes from this country, and then branches to the different clans. We all belong to here [Djiwada indicates his *Wagilag Dhäwu (Wagilag Story)* 1994 (plate 42)]. This system existed before the Sisters came. And maybe Paddy, he knows more than I do. Because I can tell you some of what I heard from *dhuway*, our *djunggayi*, Rraywala, he's dead, what I heard from him. And then my father, he passed away when I was about sixteen, eighteen years old.

[Djiwada looks at his *Djarrka Dhäwu (Goanna Story) for Ngirrgining people* 1996 (plate 40).]

This is another thing I didn't tell you about, it's the same, no matter. When we have Djungguwan, and the people have to hear from the other countries, other places, 'Ah, there's Djungguwan, coming up'. 'For who?' 'Oh, Liyagalawumirr mob.' 'Ah, that's place called Gatatangurr, or Guruwana, or the Ngirrgining mob, or Mandhalpuy.' That painting is for Ray Munyal, that one — our *märi*, that old man who died there, they had ceremony, same one, in the bushes at Gätji.

This painting's different to my father's one [plate 39]. Same story, but different way. This painting's got stones, you see, *dhumundurr*, like little round stones, all over the place, *dharrwa* [many]. And this *mardayin* came from other side, that country there, not Gätji, just here, Dandim … And this painting, it's not my *mardayin*, it's my *märi*. But for this one, the *djunggayi* is George Milpurrurru, and Jimmy Burrnyila, and many others are *djunggayi* for this ceremony.

If other Yolngu come here and they look at this painting, like when I took this to Bula'bula, they said, 'Ah, this is your *märi mardayin*, because of this *dhumundurr*'. My father, he could have painted it with the *mapu* [eggs] inside the *djarrka*, because out of that *mapu* came Burrnyila, or Milpurrurru, and many many *djunggayi*.

This is the last painting, and no more — there are too many, too many, *dharrwa dharrwa dharrwa* paintings. This story, finish, all the people died, we have to leave it. Unless Andrew Marrgululu and the other Gätji boys ask to continue this painting, 'Show us the painting, we want to get our own *mardayin*'. Well, this is the only one, which I wanted to show Andrew Marrgululu. He's seen it, they all seen it.

We can hold the Djungguwan anywhere, but this painting is because of this place, Dandim. Say Mirarrmina, I don't have to go there. But we can hold it anywhere here, long as

Fig. 12
David Gulpilil aged 12 with goanna painted on his chest
Photo: W.D. Nicol, Special Collections, State Library of South Australia

it's Djungguwan. We can hold it at Yirritja or Dhuwa land, doesn't matter, but it has to be Djungguwan for that place, not taking away from some other place.

This painting is for Ngirrgining [plate 40]. Ray Munyal, that's his *mardayin*. This *mardayin*, Ray said to me, 'Can you paint your *märi?*' This is it. Before he died. I showed him, he cried. Before he died, he cried for this. We're joined to this *mardayin*, and then, he's Ngirrgining, his tribe. And then, Dick Galpan is Dhaburruku', and they got same Djungguwan, but different way. Same *dhäwu*, but different way of painting.

I learned about paintings, but not without permission. But with the permission, we were learning. After Mr Fidock left, I been told to do the paintings. When Dawidi died, his brother Banakaka, he said to me to start doing paintings, and sometimes, singing, *manikay*, start to learn, because we're Liyagalawumirr. Mainly this Mirarrmina story, start to sing *manikay*, or have ground designs, *molk*, but also, lot of big mob story like Djungguwan story.

When we went in to Mirarrmina in Mr Fidock's time, I saw what happened to all that old *mardayin*. Because, when we went there, we saw that camp, and *dhulgu*, the big paperbark tree was there, they had to get the paperbark, to make *dindin* [water carriers]. And they had a *dhorna* [digging stick] to take the paperbark off the tree, we saw that, and we saw the camp where they were building the ground, for water to drain away, and we saw the camp, we saw the poles. Still all there. We saw where the *bäpi*, he came out of the hole, just like tracks from the grader tyre. And then, they had a camp here, and that Wititj came here, this way, and then he ate them [the Sisters], and he went back, and then tried to walk this way, and then went back and reversed. After that, back again same way, and then here.

After my father died, I went to that place Mirarrmina, and then I had to start learning to paint. When Mr Fidock came in, we have to paint for him. They taught me painting, like goanna, or tree, or flower, or anything to train with. And after Dawidi died, we have to start learning this one. Paddy was not there all the time, but he learned before because he was the oldest son.

But the Wagilag Sisters, when we do something, in ceremony, we have to paint like this stone spear, their footprints, all of them. We all have to do the same, inside. But when we do painting on bark, there is not only the paintings [from inside], and not only the same designs from the beginning. This is what I heard, you can put in anything. Anything like *wurrdjarra* [Sand Palm], *molk* [sand designs], *malirri* [clapsticks], *ngambi* [stone spear points], bushes *mala* [many bushes], Yolngu, dilly bag, digging sticks. It doesn't have to be the same every time, in the painting. You look at it from me, different. You look at it from Paddy, different. You look at it from *djunggayi* mob, different. Have to learn from both ways, from father, or *djunggayi*.

When I die, then my sons they have to learn from *djunggayi*, Djembangu, or Djarrakaykay, or Baya, or Wanimalil, Binalany. Big mob. To follow up, because you have to carry on, and then they have to learn from what they say to them. Like Banakaka when he said to me, 'You paint this Wititj and two *miyalk*, and *yothu*, and then what are you going to put, what else?' 'Oh, maybe *wurrdjarra*, or *molk*, or stone spear, or dilly bag, or *märrma*

[two] pussy cat, or *wänga* [hut], or *dindin*, or *djunggarliwarr* [conch shell], or *melkiri* [forked sticks].'

But also, see this Mirarrmina, I think I already told you. I would have been from other places, not from Mirarrmina, but because my mother and my father travelled there, and my mother had me, first son, from Mirarrmina place. I come from that *gapu* [water].

I can't do something without permission, I have to ask Djembangu or many other *djunggayi*. That's why because my responsibility is only when Liyagalawumirr die, or *dhapi*, or whatever, I carry the responsibility. I do the singing, because I learnt, and I have been taught the *manikay*. That's *manymak* [good] but without permission I can't do those *molk*, or whatever. Because for this [triangular] *molk*, *wan'tjirr* [sand designs], they got the responsibilities, if you want to use this *molk*, or this one, or this one, or this one. They make the *molk*, my job is to sing — I can't do it without permission.

This painting here, this painting [Djiwada looks at the earliest work in the exhibition, painted by Yilkari in 1937, plate 8]. I think first painting, before that, is from *djunggayi*. To you, old Yilkari, he painted this first. No, the system doesn't work like that, has to come out from *djunggayi*. I think they painted it first, because when you say to me that Yilkari, he painted the first one, uh uh, he had permission from his *djunggayi*. They learn it from their father, and they had to tell permission to my father, Yilkari, or his brother Boti.

That's why when I was learning to sing, and our *dhuway*, Mondjingu, and his brother, who died, they have to tell *yothu* to learn for our culture. They have to push, you got to come to do the singing. And Mary Waykingin, she's chief *djunggayi* for me. She got right to say can we have *molk* this one, or if she says, '*Yaka*, no, we don't want one, another one, we got the key'. *Miyalk* have it too, for public one, well sometimes a replacement, like how do I say? When men pass away, *miyalk* can take over.

Everyone sees the *molk*, we all Liyagalawumirr, we all belong to that *molk*. Paddy, he got his big *molk*, here, that one when Paddy died, we had to use this *molk*, [the Snake and waterhole] not this one [triangular form].

When I die they have to use this triangle one, *wan'tjirr*. And for this *molk* Jimmy Djelminy, Dorothy Djukulul are *djunggayi*. They have the box, they got the keys. If I want to use that, I have to ask, and they've got permission to say yes or no. When Paddy died, this Gatatangurr *molk* was finished, no more, we have to keep it in the mind. Unless *märi watangu* [owners] say so, Dorrng, Dhanyula, that's *märi* belong to them. This *molk* comes from Dhurriyula, not from Mirarrmina. But when I die, they have to use the *wan'tjirr* for the Walkurwalkur people.

1 As told by Albert Djiwada to Nigel Lendon at Yathalamarra, 24–28 August 1996 and 12–14 April 1997.

2 In the context of this discussion, the kinship terms Djiwada uses are as follows:
 Märi, in different circumstances one's *märi* can be either paternal grandfather or his sister, or maternal grandmother or her brother, all of which are the same moiety as the subject.
 Ngathi is one's maternal grandfather, of the opposite moiety as the subject.
 Ngapipi is uncle.
 Wäku is nephew.
 Gutharra is sister's daughter's son.
 Dhuway is sister's husband.
 Yothu is the word for child or children.
 Balanda is the word for someone of non-Aboriginal descent.
 Djiwada explains the significance of kinship thus: 'When my father married, he married [a woman] from this country Yathalamarra. My grandfather, mother side, is *ngapipi* for my father, and my mother is my *ngathi's* daughter, and my father was *wäku* for my *ngathi* from this country. *Ngathi* and *märi* and *gutharra* are important relations for us. *Märi-gutharra* is the mother's mother relation. My mother comes from *märi* country, Bundatheri area. My *märi* is there, otherwise I got no *märi*. You Balanda — can I say this? — Balanda got no *märi* country, but we have.'

3 *Dhapi* is the word for circumcision ceremonies.

4 *Djunggayi* means a person or persons with ceremonial authority in land belonging to the speaker's mother's clan, that is, belonging to the opposite moiety to the speaker. Also known colloquially as 'managers' or 'custodians'.

5 The painting in question was collected by Fritz Goreau, the *Time-Life* photographer who visited Milingimbi in 1951. Djiwada was responding to a question which asked what his father might have been thinking when he painted this painting.

6 *Mardayin* is the word which describes the sacred qualities associated with places, totems and sacred objects. It is also the name of an important ceremony.

7 In this context Djungguwan refers to a restricted part of a funeral ceremony related to the Mirarrmina story. Ngirrgining, Durrurrnga, Dhaburruku', Mänyarrngu, Gurralpa and Mandhalpuy are clan names; Garngarn is a site in Eastern Arnhem Land.

8 Djiwada uses the honorific to recognise the Honorary Doctorate conferred by the Australian National University in 1996.

9 See Nigel Lendon, 'The Meaning of Innovation: David Malangi and the Bark Painting Tradition of Central Arnhem Land', in J. Kerr, D. Losche & N. Thomas (eds), *Reframing Aboriginal Art* (forthcoming).

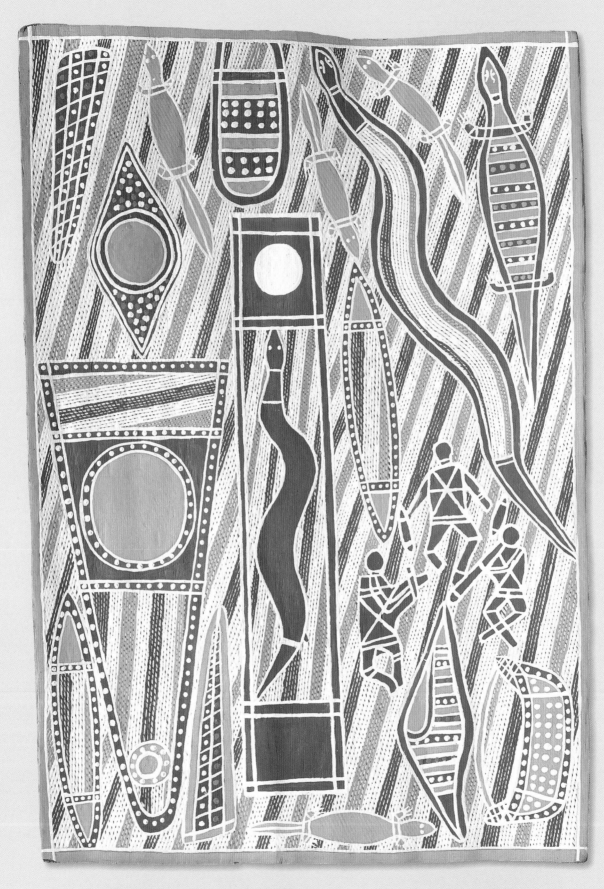

Plate 41. **Albert Djiwada** Liyagalawumirr/Walkurwalkur *Liyagalawumirr Mortuary Ceremony* 1995–96

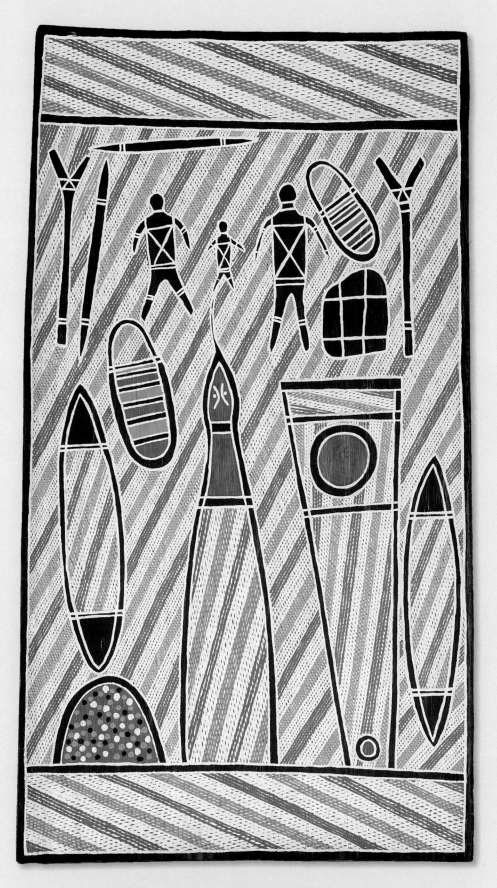

Plate 42. **Albert Djiwada** Liyagalawumirr/Walkurwalkur *Wagilag Dhäwu (Wagilag Story)* 1994

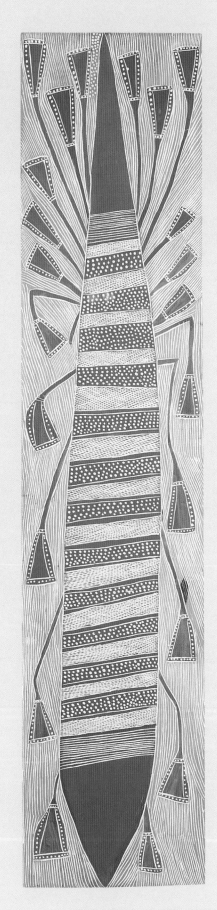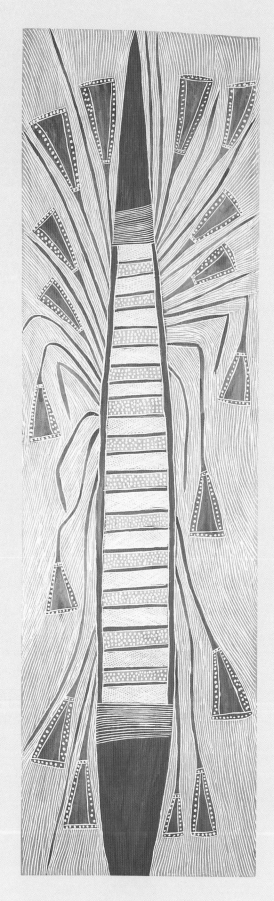

Plate 43.A and 43.B. **Philip Gudthaykudthay** Liyagalawumirr/Walkurwalkur *Wurrdjara (Sand Palms)* 1991

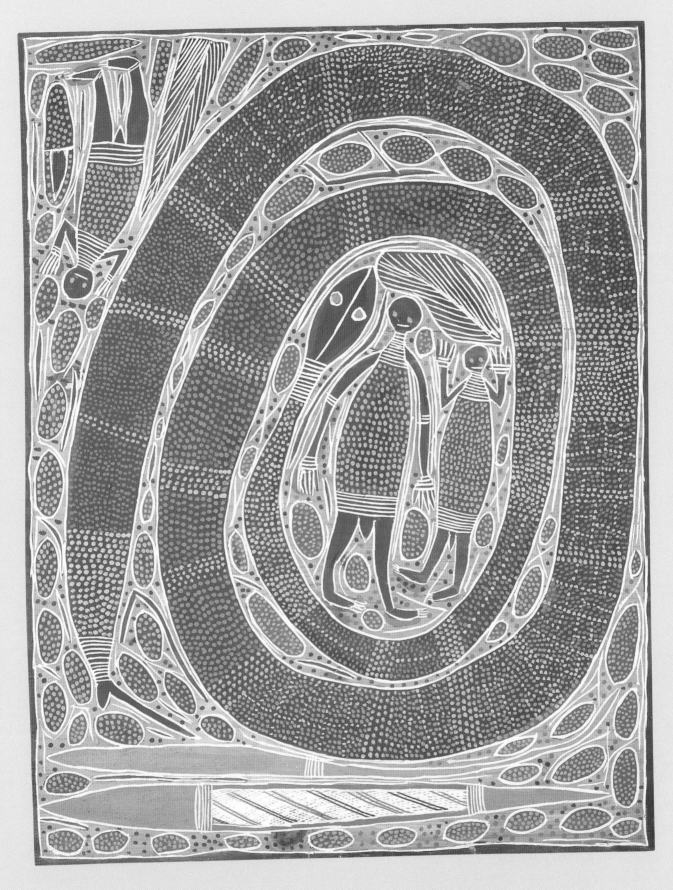

Plate 43.C **Philip Gudthaykudthay** Liyagalawumirr/Walkurwalkur *Wagilag Sisters Story* 1991

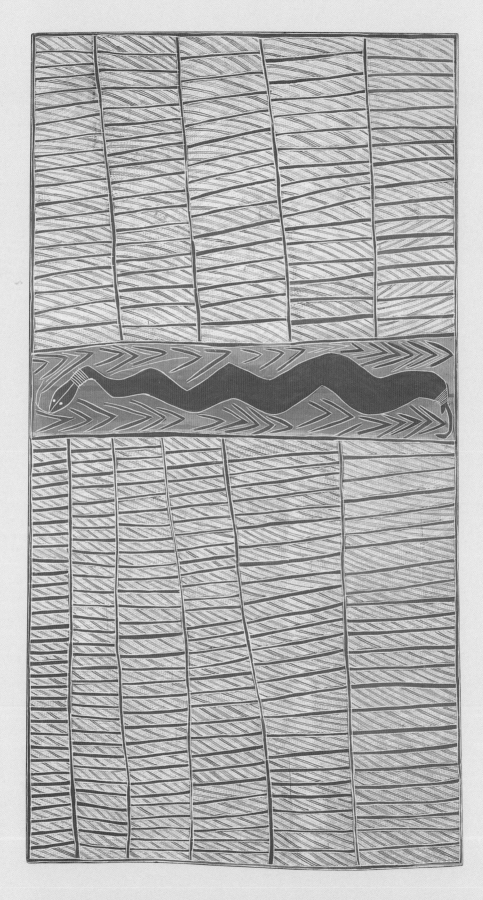

Plate 44. **Philip Gudthaykudthay** Liyagalawumirr/Walkurwalkur *Witij the Olive Python and landscape* 1991

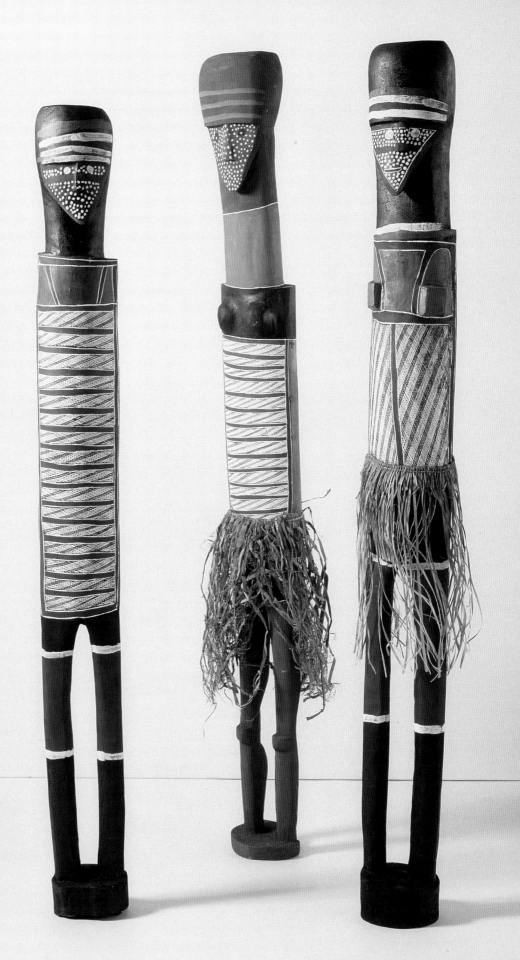

...xudthay
...lkur
...ld 1994–95

Meetings with Remarkable Men and Women

Djon Mundine

In January 1979 I took up the position of art and craft adviser for the local community in Milingimbi in the Crocodile Islands. I arrived full of nerves and optimism about what I could offer these 'bush people'. In fact, the community surprised me by being extremely similar to many 'missions' (Aboriginal settlements) found outside country towns back home in the south east of the continent. The only differences in the village of Milingimbi were that the houses were mainly adobe brick instead of fibro and timber, there were very few non-Aboriginal people, and there was no grog.

The preceding adviser Ian Ferguson, who met me at the airport, had compiled a fair body of information on practising artists, family groupings, art forms and secular and religious subject matter. My place of work, the 'art and craft shop', turned out to be the garage under a house occupied by Bobby Guwaykuway's family, with whom I soon became good friends. The staff — Kenny Djorlma, Tony Buwa'nandu (now deceased), Alfred Gungupun, and his brother Samuel Djimbarrdjimbarrwuy (now deceased) — were a group of trainees who had all just returned from a large exhibition organised by Dr Colin Bourke and Eve Fiesel at Monash University at the end of 1978. The art and craft shop was air-conditioned but we needed an outside work and storage area. My fellow workers and I tried in our amateur way to lay down a besser block floor, in the process puncturing the plastic water main and creating a major disaster. Eventually a work team of two men arrived to repair the damage, one of whom was the town plumber Albert Djiwada. They were a cheery non-assuming pair as many handymen are, and I recall their comings and goings warmly. I remember Albert's ability to grind his teeth while smiling — a skill I didn't yet have but acquired later.

Because of a lack of basic tools the job seemed to take an inordinate amount of time, but was completed such that we never had a problem with this leak again. I was surprised later when told by one of the non-Aboriginal staff that Albert was the leader of the Liyagalawumirr people at Milingimbi. What that position really meant I couldn't know at that stage.

My house was a large place on a small beach in Ngarrawundhu, or 'bottom camp', near Djiwada's home. The people who lived directly across the road, who I came to know almost like family members, were from the Gupapuyngu group. Among them was the artist Joe Djembangu, 'Big Joe', with whom I became very close friends. He and his wife, painter Daisy Manybunharrawuy, the town clerk James Gurruwanggu Gaykamangu, John Baya, and later Fred Nganganharralil (now deceased) and others visited often to 'teach me', so I could perform my role as art adviser more competently as I understood more fully the background and context of the creation of the art pieces I was handling. Their generosity of spirit remains with me to this day.

Milingimbi is famous for its woven pandanus mats, bags, baskets and other items. One day Albert Djiwada's wife Barbalene approached the art and craft centre with a message from the women's centre that the women needed to collect more pandanus to work with. The art and craft centre's Land-Rover, commandeered the next day, picked up a large group of women gathered at the women's centre. Among these were two great weavers,

Fig. 13 (opposite)
Paddy Dhathangu, 1992
Photo: Belinda Scott

Fig.14
Joe Djembangu 1997
Photo: Nigel Lendon

Dawidi's widow, Nellie Ngarridthun, and Elizabeth Djutarra, who pointed out to me the particular dye plants used and how to handle the prickly pandanus leaves.

As the first year progressed I became more aware of the incredibly intense religious and ceremonial activity being carried out concurrently with the mundane routine of modern life within the village. I was 'adopted' into a family (as everyone is) as a son by artist Manuwa, in order to incorporate me into the kinship structure which governs all Yolngu life. I came to know his son, the artist Fred Nganganharralil, and other members of the Djambarrpuyngu group. Manuwa's hand was free and expressive and he used short brushstrokes — he didn't make the long sweeping graceful lines that his son developed. When Manuwa died in this first year, I attended his extensive funeral service and was boldly confronted by the ritual mirror world which co-existed with normal daily events. Just before this time, three men — Leslie Wulurrk (a Djapu man from Yirrkala), Charlie Djota and Jimmy Yangganiny (now deceased) — who had worked at the art centre at Ramingining, came to work at the Milingimbi art and craft shop; ultimately it was they who facilitated my introduction to the Wagilag Sisters story. Wulurrk whose Djapu group are connected ceremonially to the Djambarrpuyngu, was a beautiful singer and sang quite prominently at the funeral. He made sure I attended these sessions and also took me to the *wan'tjirr* cleansing ceremony following the funeral to protect me from any possible evil associated with the death. Afterwards, my father's funeral led me to attend a number of initiation rituals associated with my neighbouring Gupapuyngu and Djambarrpuyngu families. From then on I spent more time with my neighbours generally and their rich and meaningful cultural life strongly appealed to me.

Art and ritual

One day, when a large group of people came over from Ramingining on the mainland to take part in a Marndayala initiation ceremony, I met two men who, with their families, have probably had more impact on my life than anyone except my parents. They were David Malangi, whose art work was already familiar to me through its incorporation on the one dollar note, and Paddy Dhathangu. Dhathangu was also a strong painter but less known except to real bark painting specialists. Malangi had a great sense of the ridiculous and I came to spend much time with his family; they became almost like my own family. I travelled many places with them around Arnhem Land, interstate and overseas. Dhathangu was something special. His personality effortlessly charmed everyone he came into contact with.

As part of the ceremony, related families (around a quarter of the population) gathered. Dhathangu asked for young men who were in a brother relationship to the initiates, whether they were Balanda or Yolngu, to come forward so the boys themselves could select dancers to perform at their ceremony. I didn't expect to be chosen and wasn't. I spent that night at the ceremony, during which the chosen men danced all night, then, before dawn, lit the leafy bushes tied to their thighs, sending showers of sparks into the darkness as they shook their legs.

In the following weeks, the beginning movements of a Mardayin ceremony took place in a restricted men's ground on the western edge of the town. The characteristic sounds of the ceremony punctuated the end of each working day, followed by men's voices singing well into the night.

By this time I was attending public ceremonies in 'bottom camp' regularly and had received a fair amount of instruction from my neighbours and co-workers, which they believed would increase the effectiveness of my judgement of their art. Although the ritual leaders had not thought me ready to attend a Ngarra ceremony held earlier at Milingimbi, I asked Charlie Djota to make a request on my behalf to see the Mardayin. Charlie asked me to provide a ritual payment — a number of tins of Erinmore pipe tobacco — to facilitate approval. Some days later, at the end of the day, he guided me down a dirt road, avoiding the women's restricted performing area, told me to keep my eyes down and led me into the men's ground. A lively discussion took place among the men there. I later discovered that initiates normally remain in the men's ground until the completion of the ceremony which lasts months and sometimes much longer. Some men stayed the complete period, not seeing women or children for that whole time. Running the art and craft shop was a serious enough position in the community for me to be allowed to come and go each night so I could attend to my work. Being in the ground itself was a special experience — like a men's club, a monastery and masonic lodge combined.

Though the men's ceremony ground was very close to the houses on the boundary of the town it was like being invisible to the world. We were so close to houses that one night we could hear, clear as a bell, the conversations of a Balanda fancy dress party at a nearby teacher's house, although they couldn't see us. In 1990 when a later Mardayin was held at the same place, its proximity to town allowed the garbage to be collected daily from the sacred ground.

Numbers attending each day's ritual singing and instruction varied but one small party continuously carried on the ceremony regardless of outside events; Joe Djembangu and Albert Djiwada were always there, leading the singing with their beautiful baritone voices.

Each day on our trips into the men's ground we passed a space near bottom camp where we averted our eyes — the women's ground. Each evening as the men gathered at their own area, a similar core group of women led by Nellie Ngarridthun, daughter Daisy Manybunharrawuy and others such as Elizabeth Djutarra, carried on their own essential complementary part of the ceremony in this space forbidden to men.

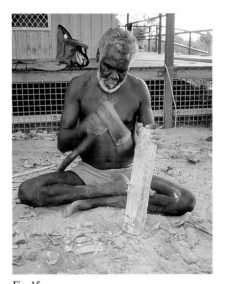

Fig. 15
Albert Djiwada 1997
Photo: Nigel Lendon

Periodically Billy Djoma, Dhathangu and other men came across from the mainland and it was on these nights that I really got to know and respect them. The complex work they carried out placed them as the most important members of the community. On one of these visits Paddy brought a magnificent large bark painting detailing the Wagilag Sisters Story, for which I paid $250. In those days this was a very high price, though nothing really given the values of such paintings today, and I wondered where to sell the piece even at cost. A group of interstate medical staff had arrived at Milingimbi as part of a dental hygiene survey of Eastern Arnhem Land and when they visited the art and craft shop and showed an interest I steered them towards the bark. Initially enamoured with the painting, they asked that it be brought to their residence later that night, however in the end they baulked at buying it after haggling over the price. The painting was eventually acquired by a visiting Ph.D student of anthropology who, though only on a scholarship salary, thought it valuable enough to 'lash out' and buy. It is included in this exhibition (*Wagilag Dhäwu (Wagilag Story) c.*1980, plate 6).

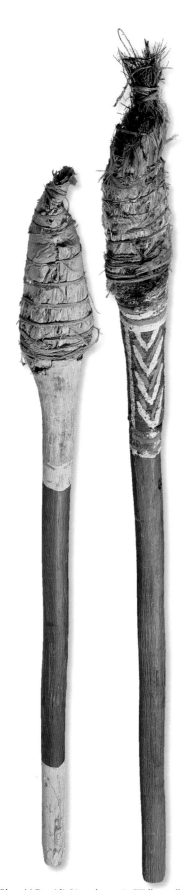

Plate 46 **Dawidi** Liyagalawumirr/Walkurwalkur
Stone-headed spear 1965 (right)
Unknown artist *Stone-headed spear* 1965

To Ramingining

Over the years I also had the opportunity to visit the community of Ramingining on the mainland, sometimes to buy art and craft. I recall my first invitation to collect some paintings in 1980: Buwa'nandu and I were dropped off at a the barge landing on the coast, and after waiting for an hour or so for a pick-up I decided to walk what I thought was a short distance to the town. Some hours and nearly thirty kilometres later we struggled into the store at Ngangalala on the Glyde River (still five kilometres from Ramingining). In fact many visitors came to town this way, including well-intentioned government officials who occasionally set out by air from Darwin to chastise the community for bureaucratic misdemeanours, only to find no-one to meet them at the airstrip. After waiting seemingly in the middle of nowhere, with the sun going down, they would head off down the bush track. An hour's trek through the heat and humidity often changed their attitude about the purpose of their visit, and by the time they reached the town they were begging for a drink of water or cup of tea.

After short periods on the mainland in 1981 and 1982, I moved there permanently in 1983 to take up the role of art adviser. At Ramingining I was introduced to a ritual life in which the activities of artists and families revolved around a cycle of major and minor rituals, including the Marndayala and Mardayin ceremonies. These took place across the landscape — from near Gapuwiyak (Lake Evella) in the east to Marrkkolidban and Mumeka towards Gunbalanya (Oenpelli) in the west. People spent certain times of the year at various places as required. Within a week of me taking up the position at Ramingining, Tommy Mulumbuk and Malangi's family took me to a Mardayin ceremony on Cape Stewart.

The house allocated to the art adviser was next to that of writer Jack Mirritji. Across the road a cement brick bungalow was home to a large number of people, run by Paddy Dhathangu and his wife. The painter Mick Magani and his son Johnny Mayarra lived there, as did Dhathangu's younger brother Alex Djirrigululu (all now deceased). These two elderly brothers often arrived on our doorstep for breakfast or tea, which we gladly shared. They were a delight to be with, either individually or together, and soon charmed our hearts. Over our meals we talked of the village activity, of their long eventful lives, the missionaries they had taught, and the ceremonial cycles that governed their yearly movements. Both were artists who were never prodigious producers but worked consistently to create sets of mostly small paintings — Alex creating fragile, sketchy animal and plant characters, and Paddy painting stronger rich colour blocks and skilfully 'jigsaw arranged' figures, boldly outlined in 'braille-thick' white borders.

Just prior to my move to Ramingining, the Yolngu people of the Crocodile Islands and the Castlereagh Bay region of Central Arnhem Land had lodged and won a Sea Closure on the waters offshore. A form of land rights, this legislation recognised that sacred sites existed offshore and extended the 'land' boundary to one kilometre beyond the low water tidal mark. This meant that although boats could journey through these waters and, in an emergency, land for water or urgent repairs, permission was required from the local traditional owners for any other visits. As part of the evidence in the submission for this Closure David Malangi had painted a spatial map representing his lands on the mouth of the Glyde River and in the waters around it. The painting revealed the landscape both physically and metaphorically as a series of inter-connected sacred sites. Each particular place represents a song in a religious narrative cycle telling of its creation and the rituals required to maintain its spiritual and environmental balance.

From this painting Malangi created a series for the 1983 'Perspecta' exhibition at the Art Gallery of New South Wales, replicating the composite map on a single large sheet of bark, covering the whole of his landscape, and a set of smaller paintings indicating a number of the individual parts. In the production of this series a discourse developed with certain major artists within the Ramingining artists cooperative, including Dhathangu, concerning Malangi's depiction of his country in this bark painting. Though competent craftsmen, most of these artists were not 'star' painters as Malangi was and had never exhibited as individuals, let alone travelled to see their shows in the larger southern centres. As Daisy Manybunharrawuy commented matter-of-factly: 'I never went to an exhibition; nobody asked me'.

To alleviate this and make outside audiences more aware of these undiscovered artists, I developed a particular curatorial practice; each year I would present an exhibition opportunity to a number of unknown artists or a group in the community which they would take up or reject. As a result, from mid-1983 Dhathangu himself began a number of single-subject paintings concerning his own Creation Story relating to the Wagilag Sisters. Each small picture covered a section of the story: showing a bird, a lizard or a snake. He was most concerned to tell the story correctly. One day he brought in a beautiful composition of a dove and yam which, for a period, took pride of place in our dining room. For a number of days he kept asking if we really liked the painting and repeatedly went over the plan of the project each time he visited. Eventually he took it back, explaining that unfortunately no matter how nice the painting was, it wasn't part of the story. A goanna and yam arrangement subsequently covered the painting and the new work took its place in the series (plate 34).

The art and craft centre was an overcrowded old demountable and our house was new but unfurnished, so we kept special pieces at home to protect them until they were sent south. In the course of their collection and Dhathangu's visits, he agreed I could take down on paper his engaging and disarmingly frank descriptions of the works, which I would read back to him for approval. He continually emphasised that these were true stories and that he was their true and rightful owner. In addition, one evening after dinner Dhathangu dictated a brief autobiography.

The artists' cooperative bought art and craft work from the local Aboriginal practitioners and arranged to sell and ship it to Darwin or more usually to Sydney, Melbourne or another southern centre. This created a liquidity ebb and flow — sometimes we had purchasing monies and sometimes not. We tried to ensure that there was always money there to purchase, however there were periods of drought. As Dhathangu's paintings came in we would try to keep monies aside so that the art piece could be kept in the set. One day, however, when he had finished the Wititj (Olive Python) 'maze' painting (plate 30), *Wititj, Olive Python* 1983 we were caught out. As Paddy needed the money urgently we suggested he sell the piece to a local non-Aboriginal community worker, advising that most probably around $100 would be a fair price. When the prospective buyer tried to haggle for a lower price saying that the composition wasn't complete because it didn't have eggs in the middle, Paddy, feeling insulted, angrily brought it back to us. From then on, if we hadn't the money to buy a piece of the series he would wait patiently for the payment.

I attempted to accumulate a similar collection of paintings associated with the Morning Star Story from my other neighbour Jack Manbarrara, a relatively unknown but expressive Murrungun painter whom I admired. Manbarrara was an engaging speaker

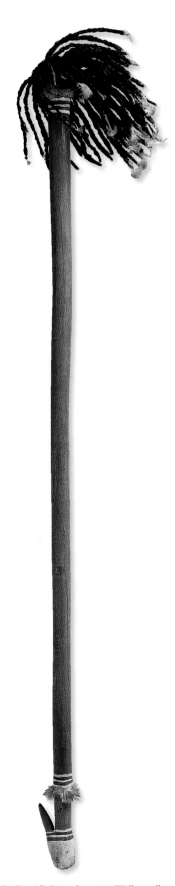

Plate 47. **Dawidi** Liyagalawumirr/Walkurwalkur
Wulambu' (spear thrower) c.1965

93

who punctuated his conversations with animated gestures and body movements. Though he completed a set of nine fine bark paintings on various song subjects and in fact was a colourful speaker, language translation problems prevented the effective documentation of the art work.

Going south

In 1983 an arrangement was made to exhibit with Anthony 'Ace' Bourke of the Collectors Gallery in the Rocks in Sydney and Dhathangu and I prepared to attend the opening. The show was to consist of the two parallel sets of paintings by Dhathangu and Jack Manbarrara and a selection of paintings by David Malangi. At the time I wanted to call the show 'Gamarrang' as all three artists were classificatory brothers with this same skin name, however it was decided that no-one in the audience would understand this name.

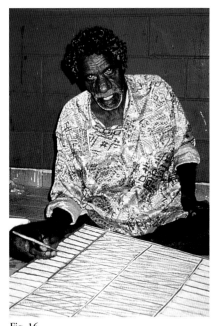

Fig. 16
Philip Gudthaykudthay 1997
Photo: Nigel Lendon

In Ramingining the most frustrating and delightful events often occurred unexpectedly. As I hurriedly packed the art work for the Sydney exhibition late one night, when I thought I must be the only person awake in the whole town, I was first interrupted by Philip Gudthaykudthay ('Pussycat') who wanted to put some finishing touches to a hollow log bone coffin before it was packed. After the paint dried, the artist Tony Djikululu came through the door to engage me in a long conversation which delayed me — but I found it difficult to complain as he told me over and over how he and other artists were worried about my financial and personal situation and how they enjoyed me working for them. Djikululu was a very competent artist, though he was known more locally for his singing and dancing skills. Painting only a couple of times a year at the most, he was sometimes assisted by his wife Namiyal Bopirri. She took on a fuller role after Djikululu suffered an incapacitating stroke in later years, and she branched out as a solo artist after his death in 1992.

Sometime after midnight, in what became a common practice, we carried the art work in the back of our Toyota truck and with Paddy set off in the night for Darwin from where a plane would take us and the art work south. Paddy was very excited about the show and about travelling as he had not been outside the Northern Territory before.

On our first night in Sydney we were able to attend a performance of *The Dreamers,* a play by Western Australian Aboriginal playwright Jack Davis, which Paddy enjoyed very much. The play, concerning the dreams and aspirations of an Aboriginal family in Western Australia, centres on the visitations of the grandfather's spiritual ancestor while he sleeps. After the performance we met Jack himself and a young Ernie Dingo, who explained how the cast became inspired in its performance after seeing Dhathangu in the front row.[1]

The exhibition was a great success, both in terms of public reaction and the fact that the National Gallery of Australia acquired the complete set of Dhathangu paintings (plates 22, 24–38) and several of the larger works by Malangi. Against the growing practice of exhibitions devoid of authenticating text, Dhathangu's paintings were hung with a mounted copy of his dictated comments alongside. The text, being the artist's own statements placed the quotations in a different positive context. The set of paintings became the core of the present exhibition.

On this trip to Sydney we also carried a collection of paintings by Gudthaykudthay, a truck driver who worked with Johnny Mayarra, and who lived in a house ringed with pawpaw trees near the centre of town. Gudthaykudthay was a consistent painter, producing a steady stream of work. He confused and delighted us with the tonal progression he created

by skillfully changing the number of coloured *rärrk* (cross-hatching) lines across his compositions, from honey gold to blood red whilst others glimmered with silver white. He responded to our interest in his preoccupation with the 'abstract' grid pattern of the Liyagalawumirr country in his paintings. Gudthaykudthay painted long hours after each day's work to complete a series for a solo exhibition at the new and prestigious Garry Anderson Gallery in Sydney, sometimes working into the night cradling a torch on his neck to see the brushstrokes. With this scene I was reminded of Vincent van Gogh, as the story goes, painting the stars in the night sky with candles on his hat, geographically and historically a world away.

Gudthaykudthay's exhibition was ahead of its time in the way it presented Aboriginal art: a single artist, and the composition of the work seen as almost abstract paintings. The show was hung without authenticating wall text and many were simply labelled Landscape no. 1, no. 2 and so on. The exhibition was opened by Pat O'Shane and several pieces were acquired by the National Gallery of Australia.[2]

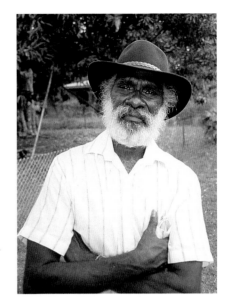

Fig. 17
Yambal Durrurrnga 1997
Photo: Nigel Lendon

Upon our return from Sydney, Paddy was able to purchase a second-hand Land-Rover. Over the years we made many journeys with groups of Ramingining people in this vehicle to attend ceremonies. Some people like Dhathangu and Djiwada organised themselves efficiently with food, water, bedding and other 'camping' essentials, others threw themselves almost completely on the generosity of their hosts. These groups invariably included Nellie Ngarridthun and Elizabeth Djutarra but on other occasions the complete Malangi family — seemingly the whole of Yathalamarra outstation. On one trip with Gudthaykudthay, Djiwada and Dhathangu, we travelled to attend a Mardayin ceremony close to Gunbalanya in Western Arnhem Land, where our group had to converse in a form of Kriol in order to be understood. Each trip seemed to contain some interesting incident besides the amazingly powerful ceremonies witnessed. There was an occasion when a woman passenger in my truck gave birth to a baby girl near the Blyth River on the return trip from a ceremony at Djabolbol in the west.

Dhathangu was to travel to exhibitions in southern cities many times after his initial exhibition in 1983. His set of Wagilag Sisters paintings were exhibited several times at the National Gallery of Australia and, in the 1989 exhibition 'The Continuing Tradition' they were placed in a section flanked by paintings of fellow Liyagalawumirr artists Dawidi and Gudthaykudthay. Following this exhibition the National Gallery sponsored preliminary research both in Australia and overseas, and subsequent visits to Ramingining and Yirrkala from 1992 to consult with Dhathangu and other artists regarding a Wagilag Sisters exhibition — the result is this exhibition.

Many of these events seem a long time ago and I was hesitant to write an account such as this until now. I did not want to write some form of colonialist memoirs. Paddy is dead now and many other people have died who took part in this story. Each had a profound influence on me — they taught me how to eat, walk, and how to talk to and relate to people. Public perceptions of Aboriginal art have changed dramatically in the period since Paddy's painting of 1983 to the present, let alone in the decades since his father Yilkari's time in the 1930s. Gudthaykudthay is now probably the most prolific painter of this group. It is pleasing to see Albert being recognised and how the paintings by Paddy are being honoured and revitalised in this important time for Aboriginal people and for Australia.

1 Ernie Dingo is an actor and television personality.
2 Pat O'Shane was Australia's first Aboriginal barrister (1976) and magistrate (NSW Local Court 1986).
 In 1994 she was appointed Chancellor of the University of New England, NSW.

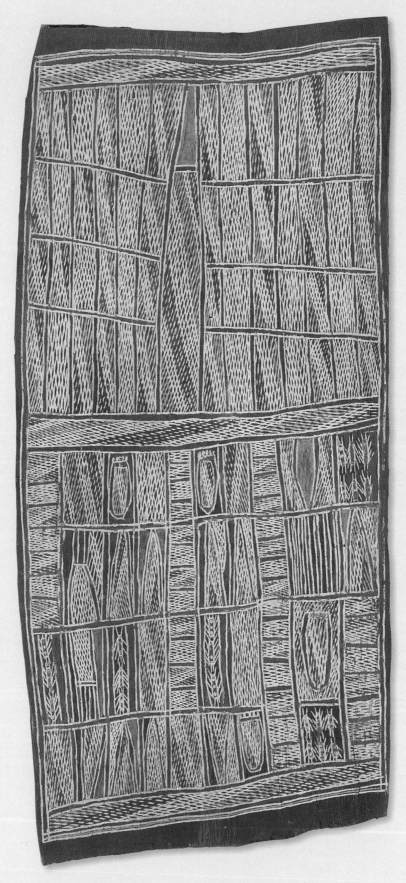

Plate 48. **Yilkari Kitani** Liyagalawumirr/Lilipiyana *Mardayin Dhäwu* c.1957

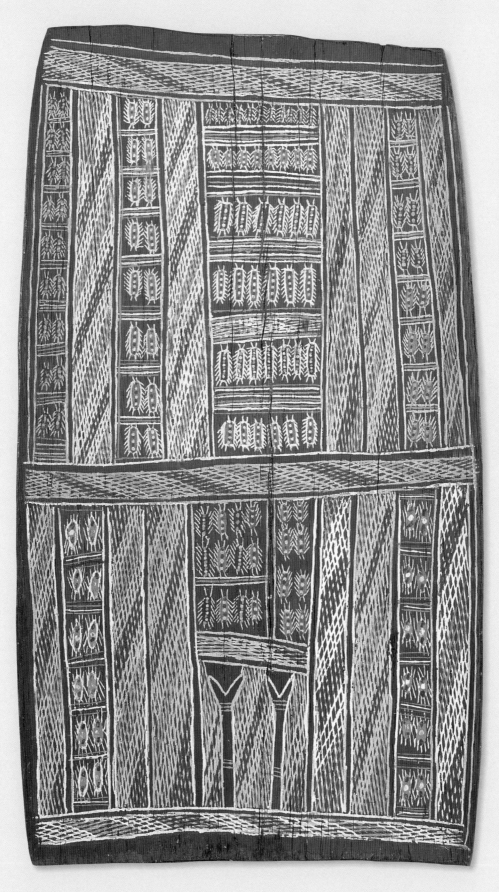

Plate 49. **Dawidi** Liyagalawumirr/Walkurwalkur *Dhapalany ga melkiri (Itchy Caterpillars with forked sticks)* 1960

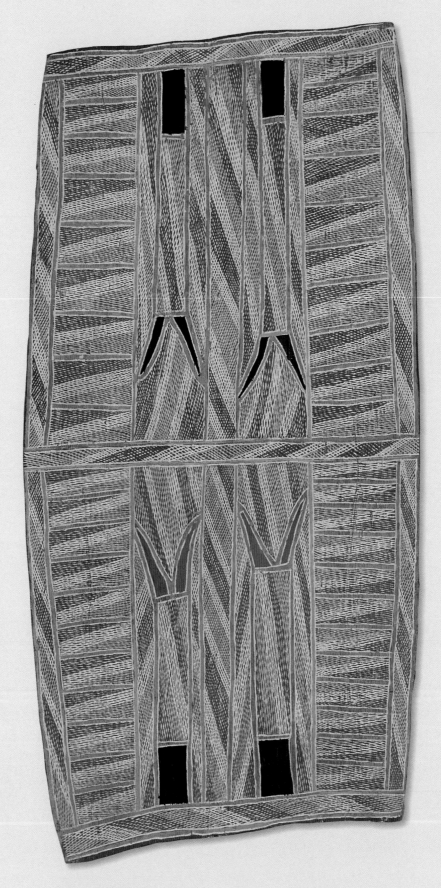

Plate 50. **Daynganggan** Daygurrgurr/Gupapuyngu *Melkiri (forked sticks)* 1957

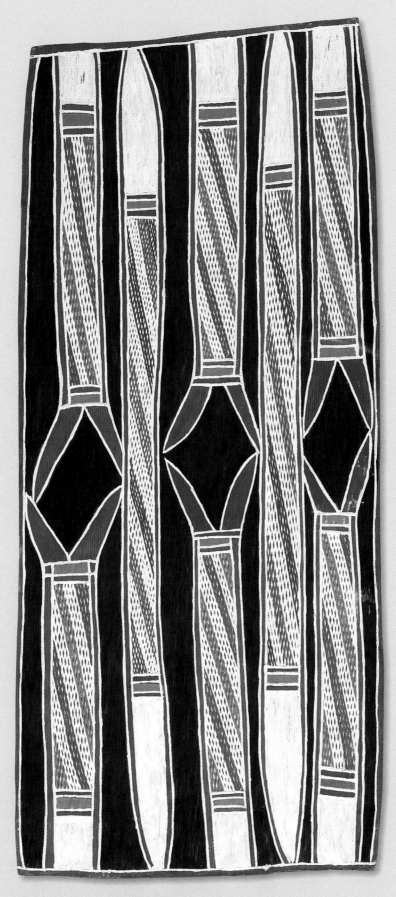

Plate 51. **Paddy Dhathangu** Liyagalawumirr/Malimali *Melkiri ga bulul (forked sticks and cross-beams)* 1975–76

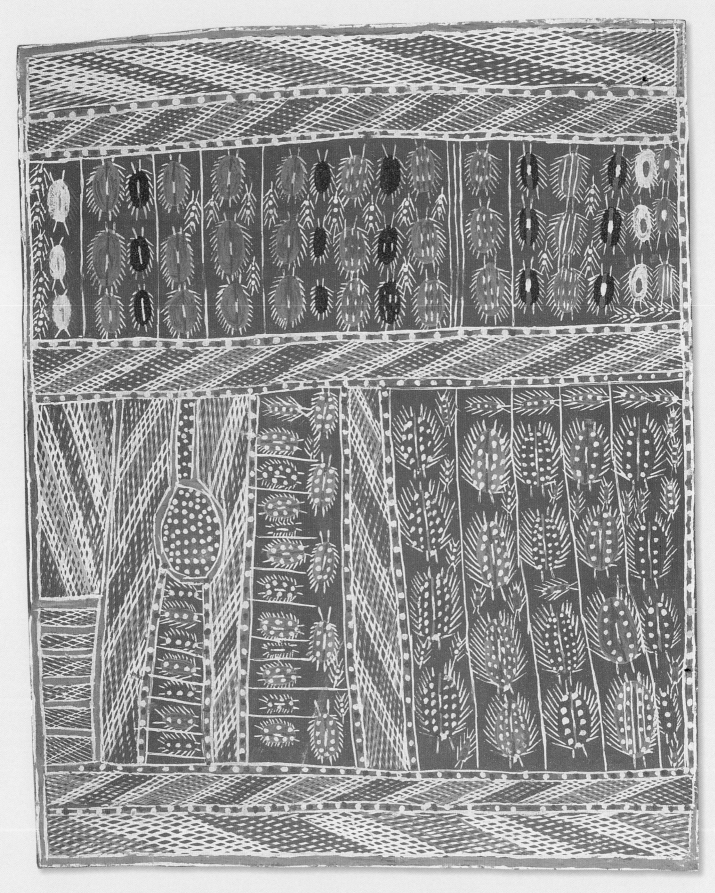

Plate 52. **Dawidi** Liyagalawumirr/Walkurwalkur *Dhapalany ga bathi (Itchy Caterpillars with nest)* 1955–56

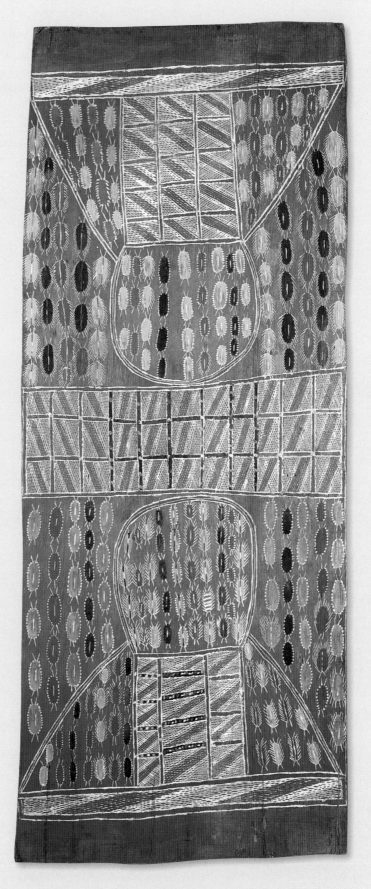

Plate 53. **Dawidi** Liyagalawumirr/Walkurwalkur *Dhapalany ga bäthi* *c.*1960

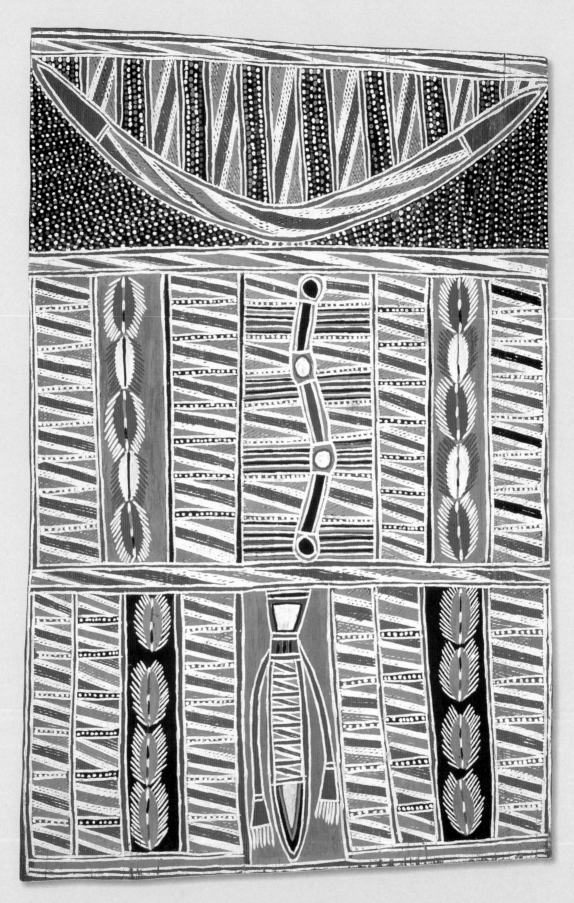

Plate 54. **Dawidi** Liyagalawumirr/Walkurwalkur *Wolma, the first thundercloud and the rain flooding the country* *c.*1969

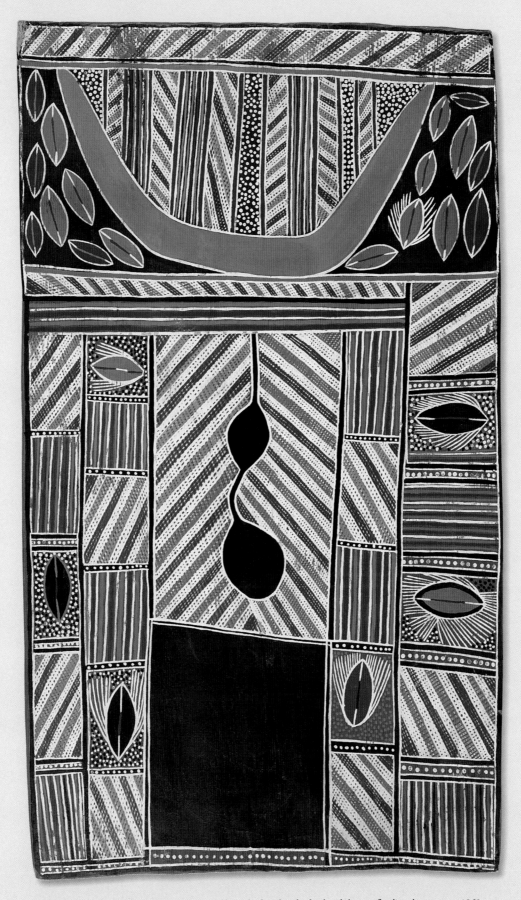

Plate 55. **Dawidi** Liyagalawumirr/Walkurwalkur *Wolma, the first thundercloud and the rain flooding the country* c.1969

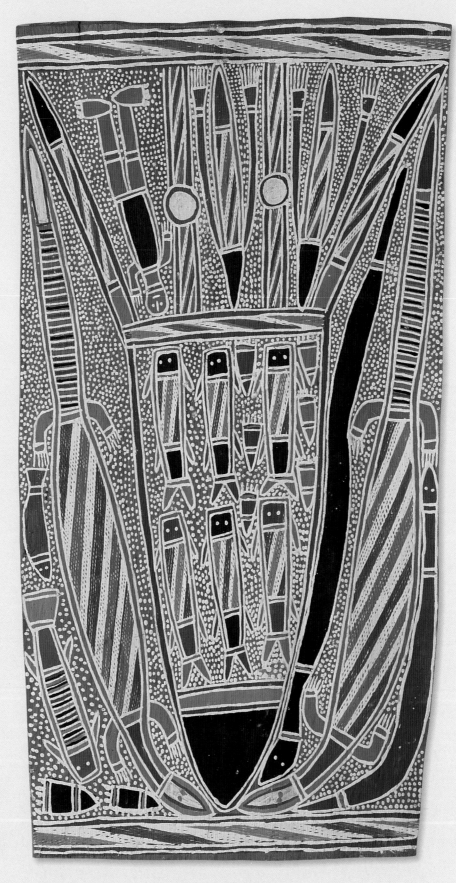

Plate 56. **Dawidi** Liyagalawumirr/Walkurwalkur *Dilly bag with fish and goannas* 1965

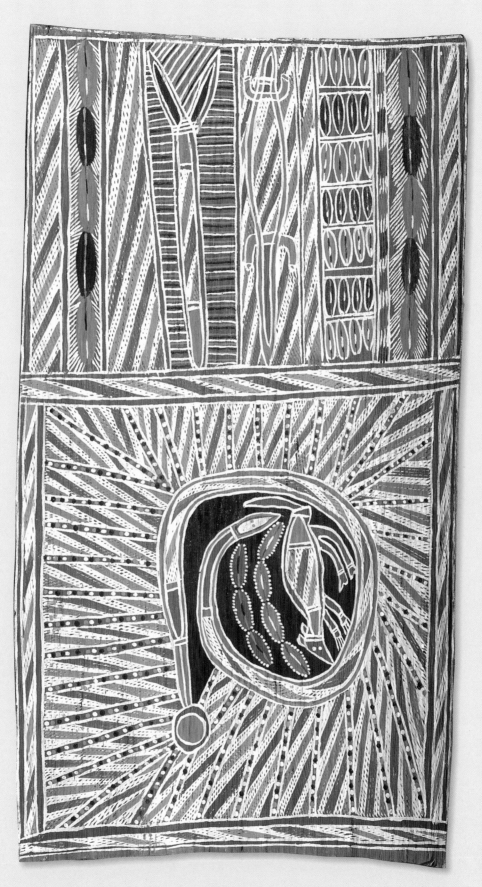

Plate 57. **Dawidi** Liyagalawumirr/Walkurwalkur *Wititj ga Warngurra' ga girri' (Wititj with Bandicoot and tools)* 1964

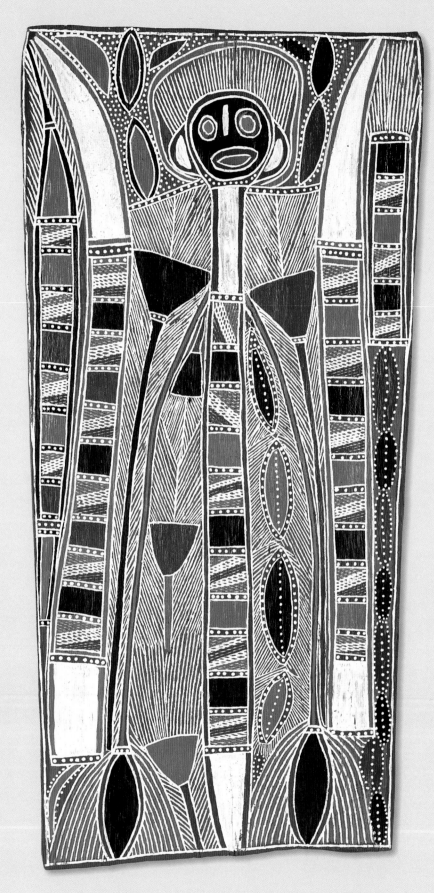

Plate 58. **Paddy Dhathangu** Liyagalawumirr/Malimali *Father totem* *c.*1969

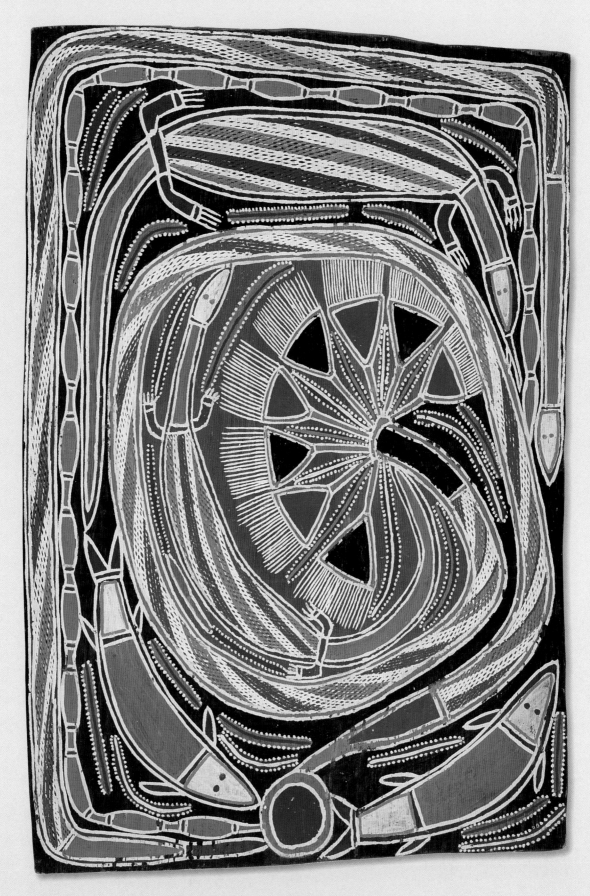

Plate 59. **Dawidi** Liyagalawumirr/Walkurwalkur *Dhalngurr* 1966

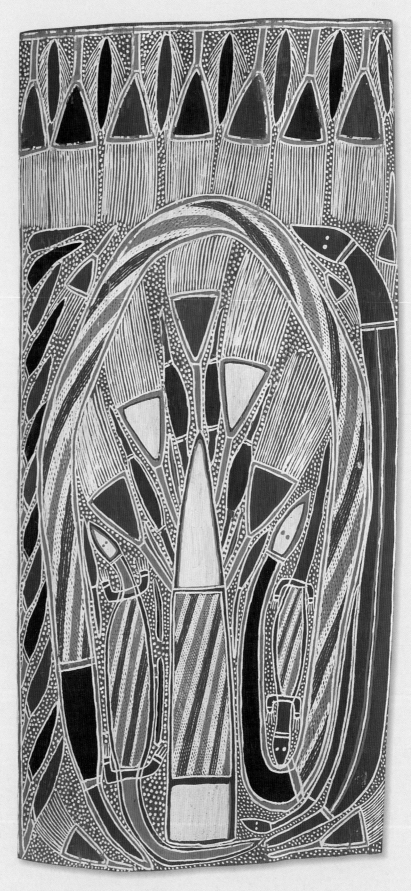

Plate 60. **Dawidi** Liyagalawumirr/Walkurwalkur *Wurrdjarra ga marrma' Wititj ga marrma' Djarrka (Sand Palm and fronds with two Snakes and two Goannas)* 1964

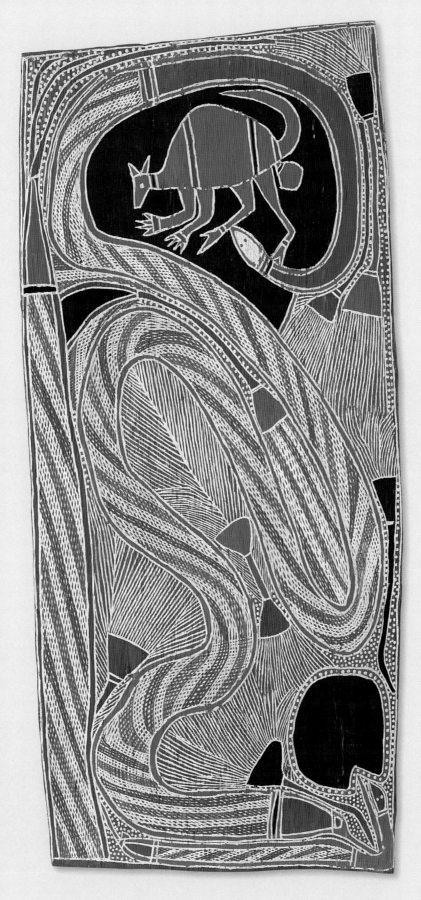

Plate 61. **Paddy Dhathangu** Liyagalawumirr/Malimali *Wititj ga Gandawul' ga Wurrdjarra (Wititj with Rock Wallaby and Sand Palm in seed)* 1967

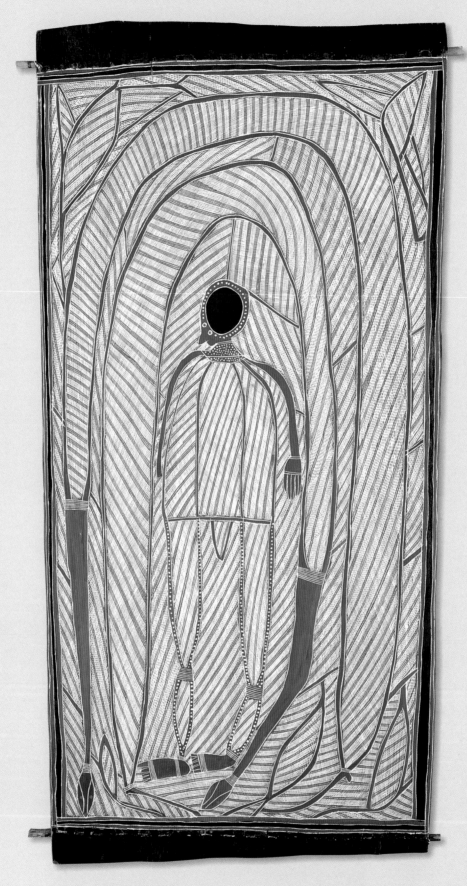

Plate 62. **Philip Gudthaykudthay** Liyagalawumirr/Walkurwalkur *Warrala Warrala* 1987

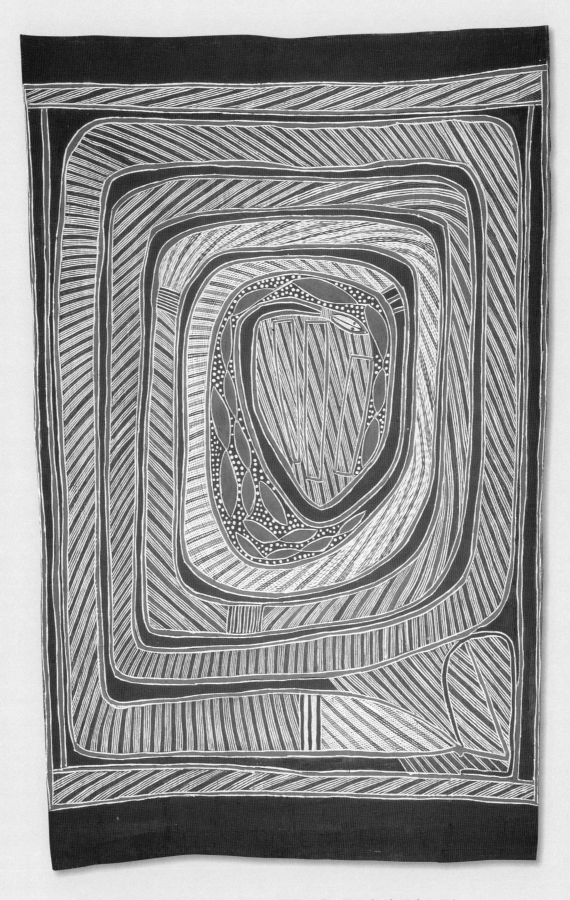

Plate 63. **Philip Gudthaykudthay** Liyagalawumirr/Walkurwalkur *Wititj the Olive Python* 1984

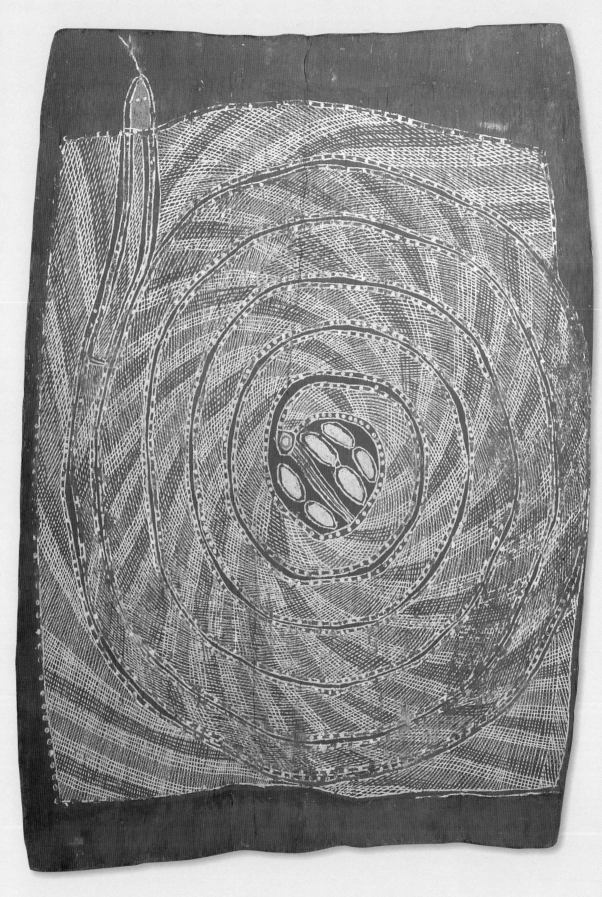

Plate 64. **Yilkari Kitani** Liyagalawumirr/Lilipiyana *Mapumirr Wititj (Wititj and eggs)* 1951

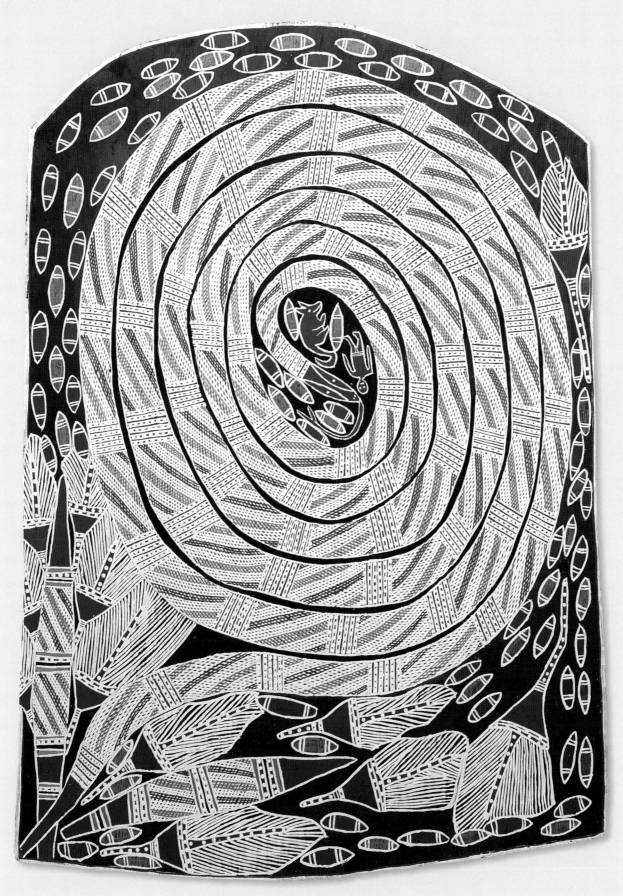

Plate 65. **Jimmy Yangganiny** Ganalbingu *Wagilag Sisters Creation Story* 1989

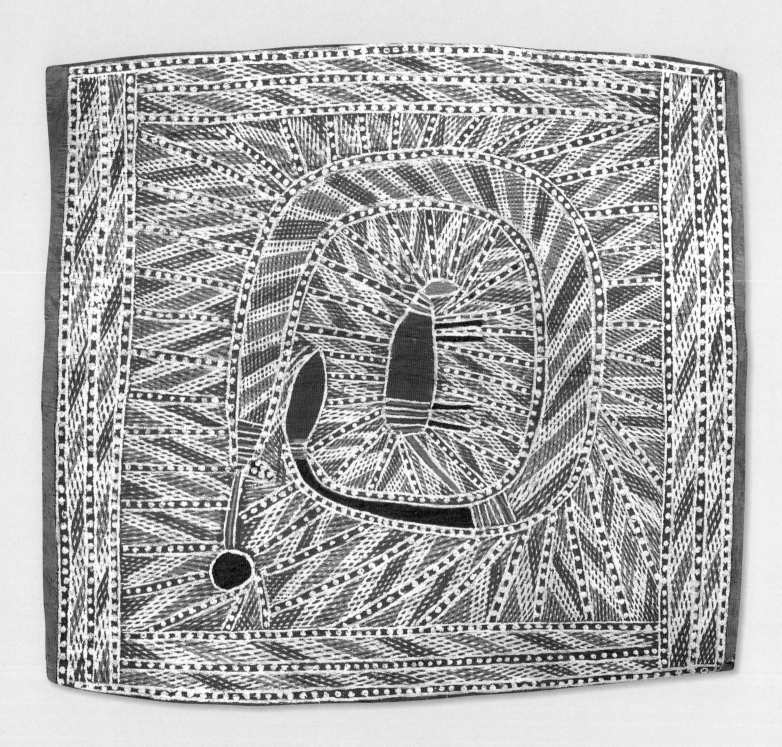

Plate 66. **Gimindjo** Mandhalpuy *Wititj and Bardipardi (Rock Wallaby) at Marwuyu* 1975–76

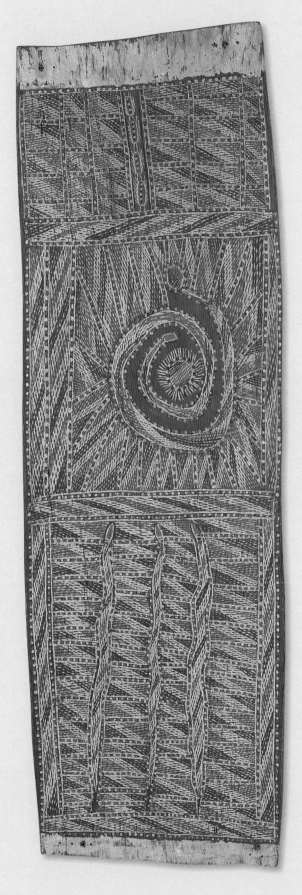

Plate 67. **Gimindjo** Mandhalpuy *Wititj at Marwuyu talks to Mirarrmina* c.1960

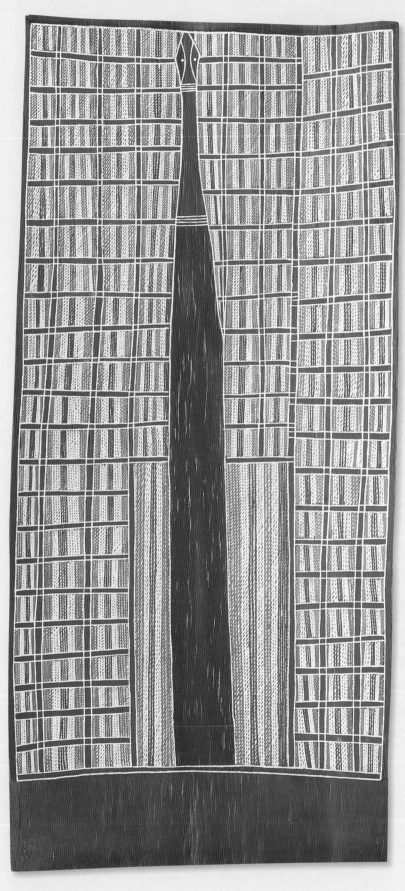

Plate 68. **Peter Minygululu** Djinba/Mandhalpuy *This Wititj lives at Milipanun, a little waterhole upstream from Marwuyu* 1995

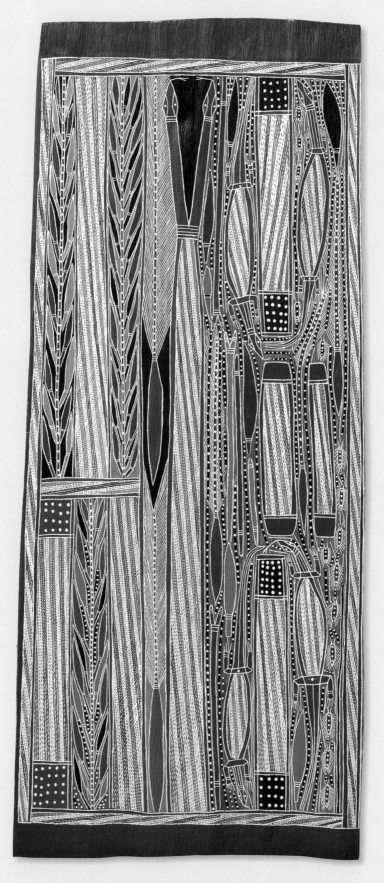

Plate 69. **Peter Minygululu** Djinba/Mandhalpuy *Mayku at Mirrngatja* 1997

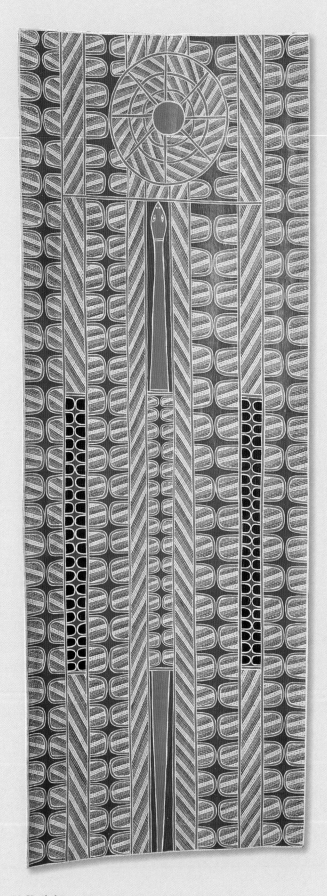

Plate 70. **Yambal Durrurrnga** Liyagalawumirr/Durrurrnga *Wititj at Guruwana* 1992

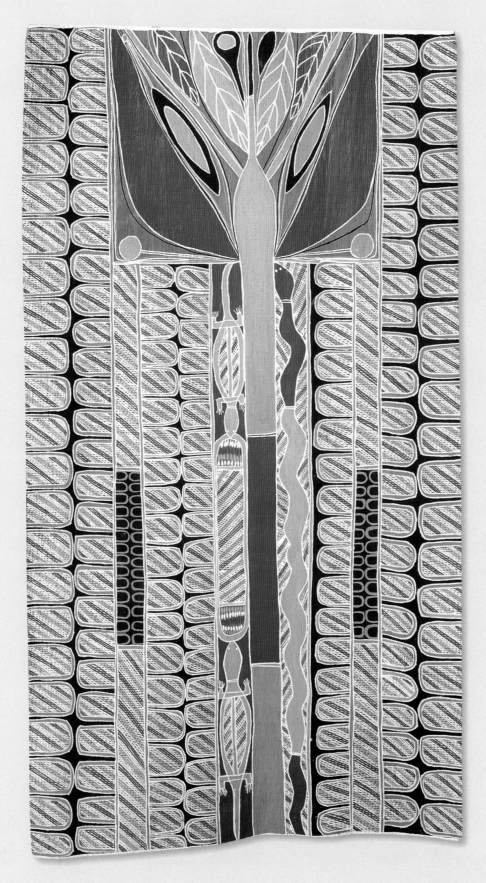

Plate 71. **Kathy Yawirr** Djambarrpuyngu *Oyster beds and Bundarrarr (Palm Tree) at Guruwana* 1990

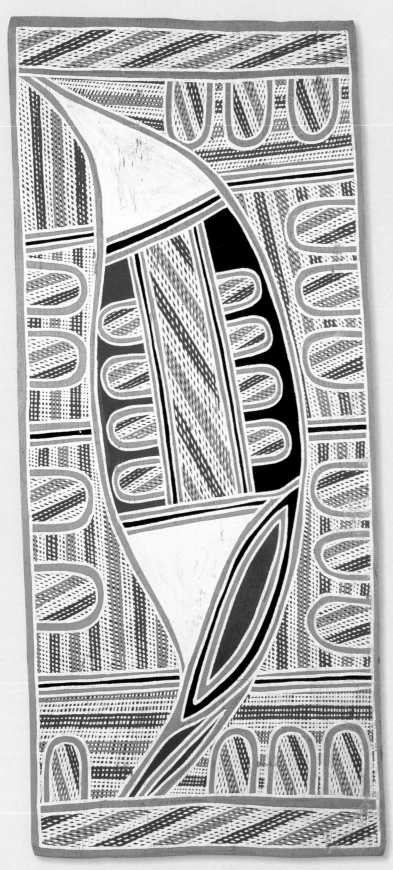

Plate 72. **Neville Nanytjawuy** Liyagalawumirr/Durrurrnga
Djunggarliwarr ga Wayanaka (Conch Shells and Oysters) 1984

Plate 73. **Neville Nanytjawuy** Liyagalawumirr/Durrurrnga
Yidaki (didjeridu) showing Wititj and Djunggarliwarr 1995

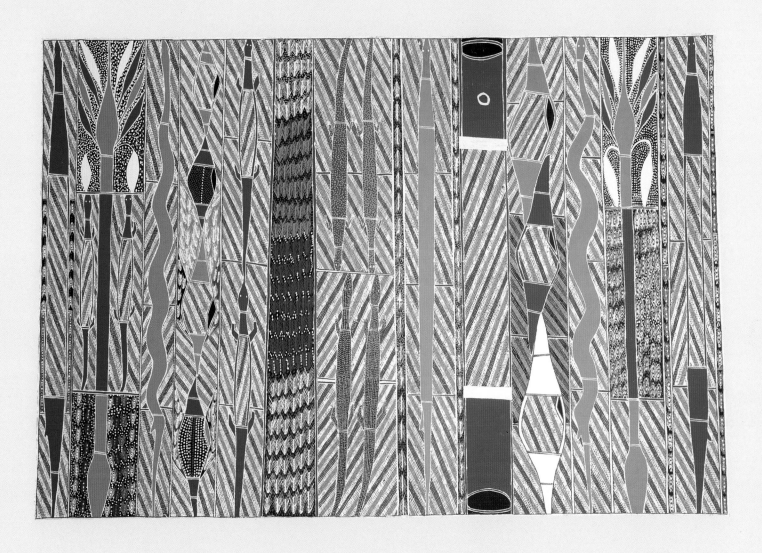

Plate 74. **Neville Nanytjawuy** Liyagalawumirr/Durrurrnga *Guruwana Story* 1995–96

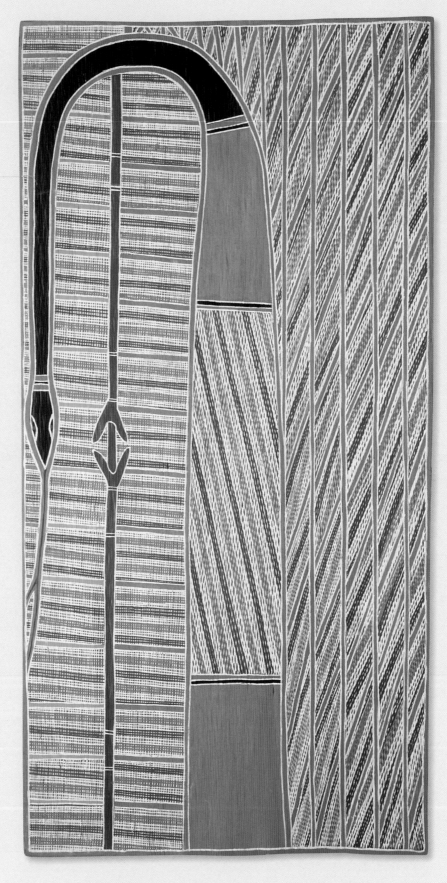

Plate 75. **Neville Nanytjawuy** Liyagalawumirr/Durrurrnga *Yambal-Matha* 1985

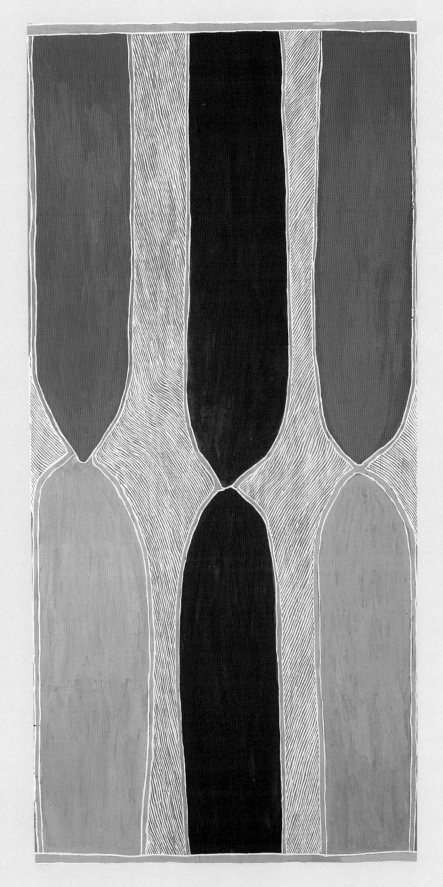

Plate 76. **Namiyal Bopirri** Liyagalawumirr/Durrurrnga *Sacred Rocks at Guruwana* 1993

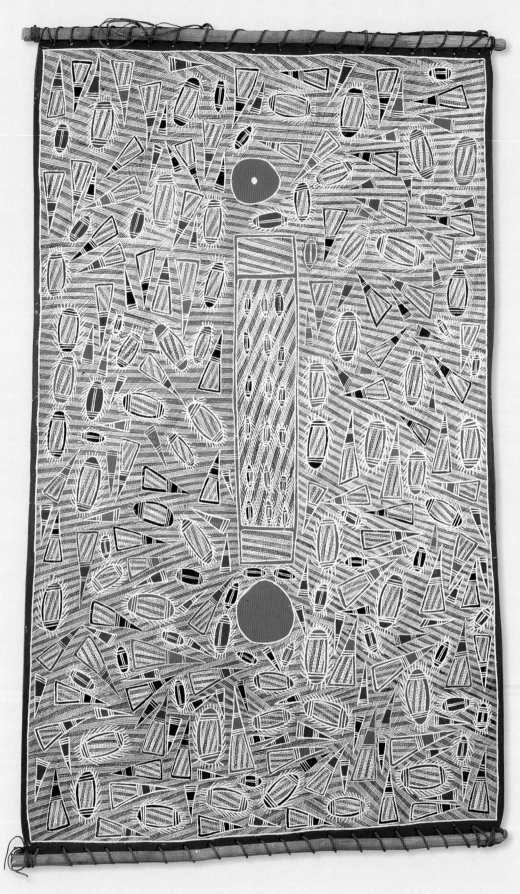

Plate 77. **Djardie Ashley** Wagilag *Ngambi, spear points, with dhapalany, caterpillars, molk, sand sculpture and waterholes c.*1984

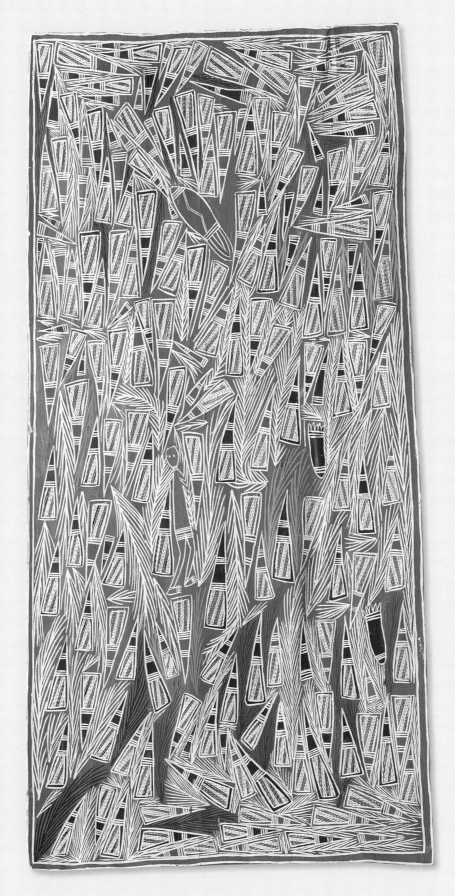

Plate 78. **Djardie Ashley** Wagilag *Ngambi, spear points* 1986

Eastern Arnhem Land

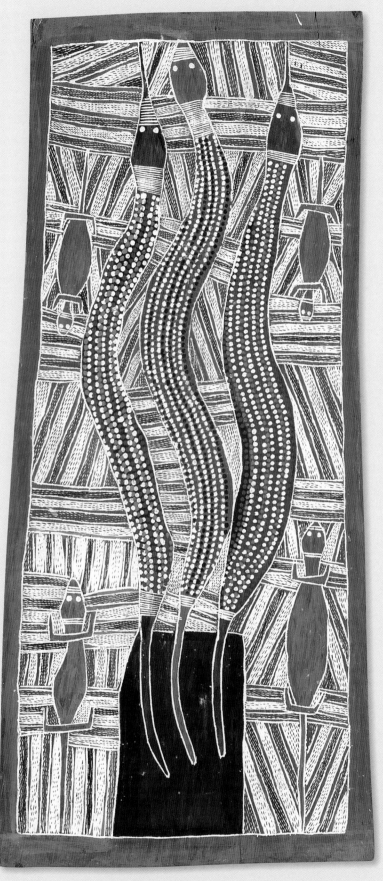

Plate 79. **Mithinarri Gurruwiwi** Gälpu *Bäpi at Ganymala* 1963

The Gälpu Story[1]

with Djalu Gurruwiwi

The ancestral travels of Wititj connect many Dhuwa moiety peoples. Djalu Gurruwiwi explains: 'Wititj looks after Gälpu people like myself, my brother and my two sisters. Wititj is also related to the story of the Wawilak Sisters and the events over Milingimbi way. Milingimbi way it is same Snake but different group of people ... This is about [those people] over there, all of the clans coming together as one — for all this to be understood by white people, this Wititj totem.'

All these clans tell 'a different story and [still the] connection is one — different background, one connection. For this [story], because the language is always changing, [when] Wititj is painted by this area it is a different language, a different background, but covering one story.' For example, 'Djarrwark, [a clan of Dhuwa people who were once living at Garngarn], Dhambuwalamirr [people living at Elcho Island] and the Gälpu are the same — [they are all] Gälpu people but [speak a] different language.[2] We are all Wititj people. All these people come together and help each other in friendship. When I go out that way, they call, "Wititj coming! Wititj, welcome home!"'

Referring to the conference of the Snakes, in which the Wititj at Mirarrmina is challenged and reprimanded for having eaten the Wawilak Sisters, Djalu, Andy Waytjuku (the eldest son of Mithinarri), and one of their *djunggaya* (custodians or managers) Don Gumana express its symbolic significance through contemporary metaphors. They stress how the communications between the different Snakes takes place according to their kin relationships.

Djalu's totem, the great Snake at Ngaypinya is angered by the Mirarrmina Wititj and his 'tricks'. 'Those two [Snakes are] talking to each other from Wessel Islands, Rarragala Island and Gunyanmi (Mirarrmina). And my totem from Ngaypinya, they listen ... talking slowly, talking:

"You've got something in there? [You've eaten something?]"

"You tell him, you both!"

"No I haven't got ... [the two Sisters inside me]."

"In your heart, you listen [you tell the truth]."

'They're listening now because *djambatj* [that clever one] from Ngaypinya [knows that] they both tricked each other.

'And he over there [the Wessell Island Snake] ate one big fish, and [the Snake on] this side [Mirarrmina] ate two Sisters. That very upset my totem [the Snake at Ngaypinya, who made] a big streak of lightning. [Djalu gestures, whipping up the lightning which knocked the Mirarrmina Wititj to the ground.] Because he's got the tricks, you know,

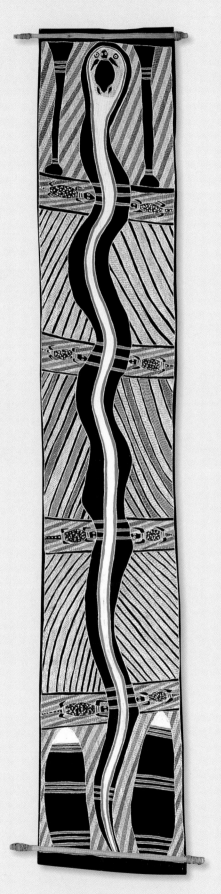

Plate 80. **Djalu Gurruwiwi** Gälpu *Wititj, Sacred Olive Python* 1994

he's got something … [to eat] … Wrong way [the Sisters are the wrong moiety]. Not honest with each other … [it's] very serious.'[3]

Don Gumana, who is one of the *djunggaya* for this story, summarises how this happened: 'People from the other parts of the area are all in one because of the totems in the story, all in one. All like telling, "You are there, I'm here, you're there, I'm here, I'm here". It's still in one, but all the dialects are different — that's part of that story, that's what he's telling you now. They're passing over each other, they're passing a way back, they're passing through one another, same way, all Wititj, they're passing a message over one another. It's like a Telecom. It's like a Telecom.'

Andy Waytjuku brings the ancestral events into the immediacy of contemporary life: 'When you see Mandawuy [a senior Yunupingu ceremonial authority and lead singer with the band Yothu Yindi], he's bridging, building the bridges and creating this one [Wititj], this is his Mother. We've got clapsticks, he's got all the new technology, all that, bridging this reconciliation. To both worlds, Aboriginal society taking it up into white society, this one, Wititj.'

1 This text is drawn from the transcripts of a number of interviews with Djalu conducted between 1994 and 1997 by Andrew Blake, of Buku Larrnggay Arts and Sophie Creighton, as well as from the video, 'Gälpu people sing Wititj *manikay* for Liyagalawumirr people', 1997, with Nigel Lendon and Sophie Creighton.
2 Djarrwark people speak Dhay'yi; Dhambuwalamirri speak Dhuwal; Gälpu speak Dhangu.
3 Djalu is speaking to the Gälpu paintings (plates 79 and 80) shown to him in the catalogue prototype for this exhibition.

The Rirratjingu Story

Dhuwarrwarr Marika

(referring to her painting *Wititj swallowing the Wawilak Sisters* 1990, plate 84)

[The painting shows] two ladies — one elder Sister, the other one young. She [the younger Sister] was pregnant. They went out to collect some bush food — goanna, lizard. They came back home to this river bank and they made a shelter for themselves to stay the night. The young girl was in labour and she gave birth that night. She did not have anything to wrap the baby in. She went out to collect paperbark for the baby. [She entered the waterhole.] The Rock Python smelled [her]. The Python rose up and the Sisters perform[ed] songs to stop the Python, but the Python swallowed the baby. The background is the paperbark. The Python went back to his home. The second Snake swallowed the young mother. The third Snake swallowed the fish. All Snakes different tribes — Rirratjingu, Gälpu. The painting and story, having birth, children, goes on today. My father [Mawalan] used to tell this story while he [was] painting it.

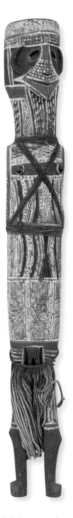

Plate 81. **Mawalan Marika** Rirratjingu *The Wawilak Sisters* 1947

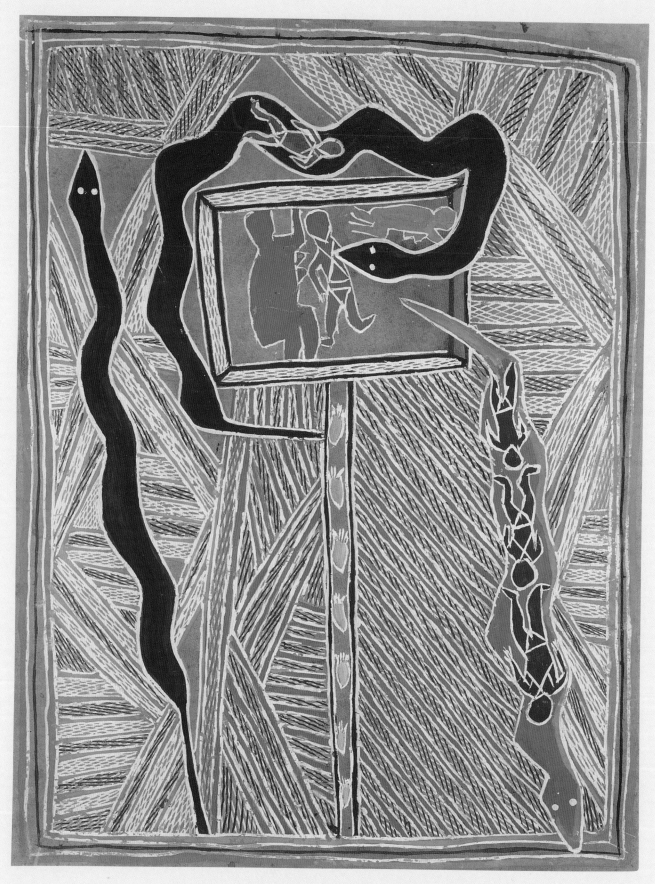

Plate 82. **Mawalan Marika** Rirratjingu *The Wawilak Sisters* 1948

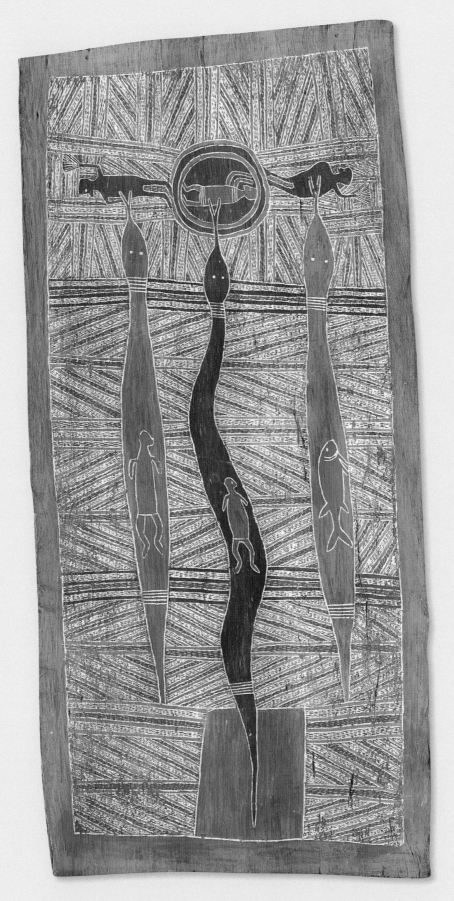

Plate 83. **Mawalan Marika** Rirratjingu *Wititj swallowing the Wawilak Sisters* c.1955

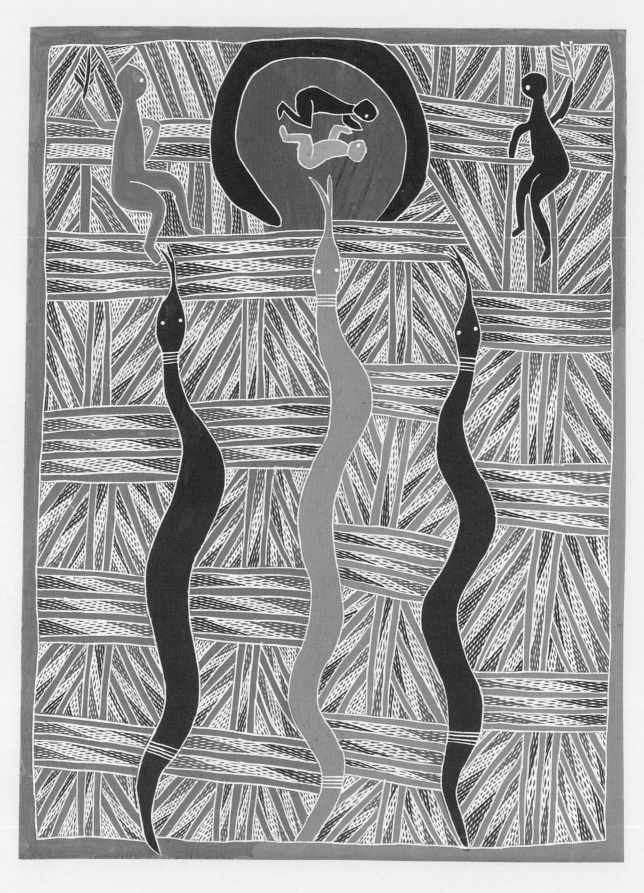

Plate 84. **Dhuwarrwarr Marika** Rirratjingu *Wititj swallowing the Wawilak Sisters* 1990

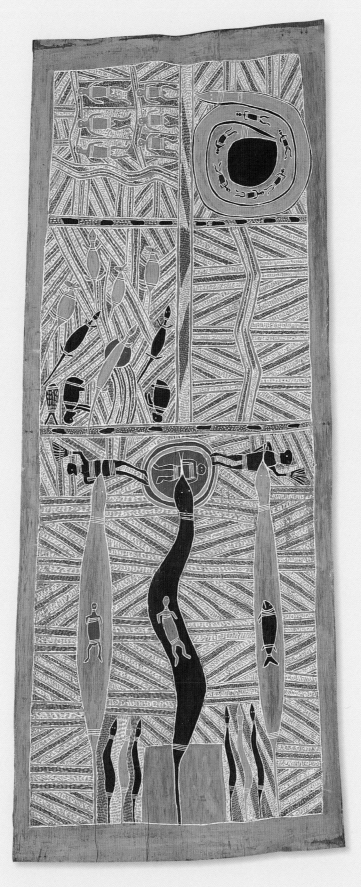

Plate 85. **Mathaman Marika** Rirratjingu *Wawilak Sisters Story* 1959

Plate 86. **Banduk Marika** Rirratjingu *Wawulak Wulay ga Wititji* 1988

Plate 87. **Banduk Marika** Rirratjingu *Wawulak Wulay* 1986

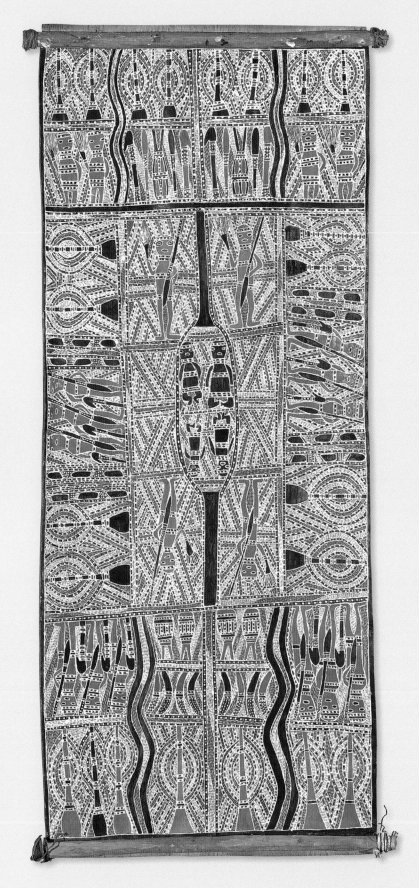

Plate 88. **Mathaman Marika** Rirratjingu *Wawilak Bunggulwuy Dhäwu (Wawilak Ceremony Story)* 1965

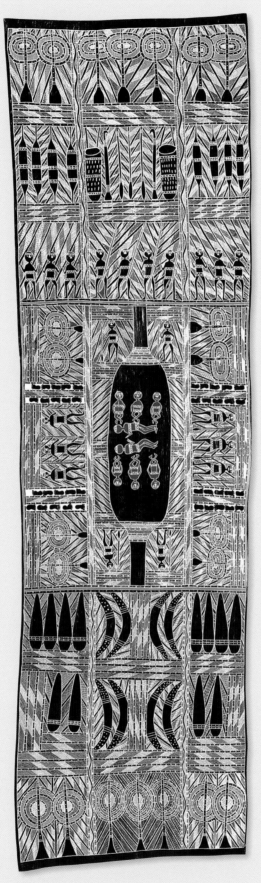

Plate 89. **Yalmay Yunupingu** Rirratjingu *Wawilak Bunggulwuy Dhäwu (Wawilak Ceremony Story)* 1996

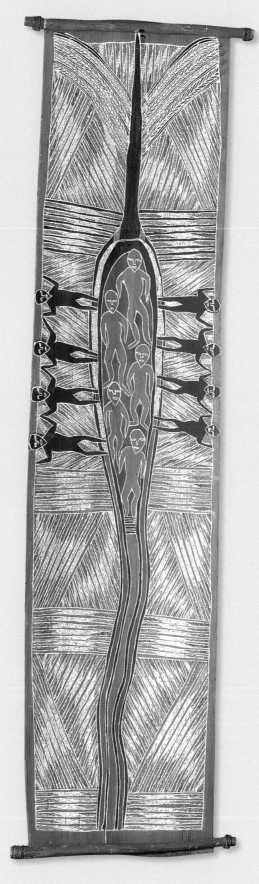

Plate 90. **Wandjuk Marika** Rirratjingu *Wawilak ritual* 1982

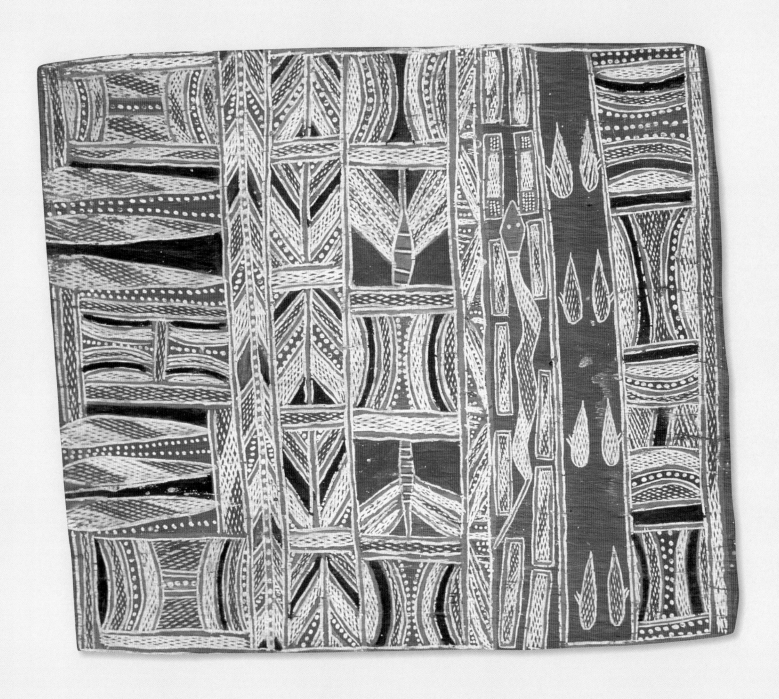

Plate 91. **Mawalan Marika** Rirratjingu *At Muruwul [Marwuyu], home of the Wititj Python* 1946

The Marrakulu Story[1]

with Gundimulk and Wolpa Wanambi, daughters of Durndiwuy Wanambi,
and Gawirrin Gumana, the senior *djunggaya* for the Marrakulu people

'Those two young women, the Marrakulu ancestors, says Gundimulk, referring to Durndiwuy Wanabi's two figures (plate 101) 'Yo this is them, the two women, this story. And this inside design, *gumurr* [on the chest] is Yanawal. These two went on that journey to Gurka'wuy, through that rocky country to Gurka' and then continued their journey all the way, Ngilipidji way. Those two went towards Ngilipidji.'

Gawirrin identifies the real names of these Marrakulu ancestors as Ngurrngurr (Nunu), the older Sister, and Wurlminawuy, who came from country called Maynbalala to the west of Gurka'wuy.

Gundimulk continues:'[The Wuyal ancestor figure] Bamabama had fallen in love with the younger Sister, so the Sisters went away and came through to Garrimala. There they made ceremonies, but changed to Djarrwark clan, and made that clan at Dhawalambar.

'Then they saw a cloud, a cloud with thunder in it, and they thought, eh, that must be good country. And they saw that *bäpi* [Snake] was there, making the thunder. Then they saw another place, and went to Ngilipidji, and then they made themselves Wawilak.

'Then they saw another cloud, raining and thunder, at another place [Mirarrmina]. "What's there?" they said, and went that way. And the younger Sister started to have baby. [When they were at that place, she] had the new baby, and all the animals came in, and they had to sing all night. That's their story, Mirarrmina people.

'We paint the goanna to represent those two women [plates 94, 95, 98, 99]. Yes, we represent the women by *djerrka*, with the log, the hollow log, to represent the two Sisters, the two young ladies. The boomerang shape represents *giyathawun* [shellfish], *maypal* [shellfish from Guyula clan], Wakuraytjpi, and where else, Guramuwuy. He got that shellfish and he came up through that hole. That's the only story that he told us, the old man. Outside story. That's why we are not allowed to do *djerrka* without the *djärrwirt* [freshwater mussel]. And only Marrakulu people can do that.'

Durndiwuy's daughters then discuss the carving of the Honey Ancestor Wuyal and Dhulaku, the kangaroo [plate 100]: 'Yo this represents what we call *gunyalili* [boomerangs],' says Gundimulk. 'This is the same Yolngu who travelled through Nhulunbuy. And this [design on the chest] is the boomerang he threw, and then he named all the places, Lömbuywuy, Gäluruwuy, Birritjimi, Dimbukawuy, naming all the places with these boomerangs *gunyalili*. [This was] Wuyal, yes, and these are the *gunyalili*. This *mokuy* [spirit figure, Wuyal], it's okay to say that name now because the person with that name died a long time ago. He went with these two *gunyalili*, threw them, and then these two boomerangs named all the places. It's a public story for this place, Nhulunbuy, because he travelled and named all these places. But its a bit complicated now …

'Dad moved into that *wänga* [bark shelter] at Gurka'wuy because all the *rangga* [sacred objects], *mardayin* [sacred business], everything is there for Marrakulu clan. Yo, ... Lilipiyana (the Wititj), he travelled from this [place] he went all the way to Ngilipidji way, all the way over to Raymingirr over there — that's what he told. Him Lilipiyana; he travelled all the way and named all the places. One *mardayin*. Making all those hills.

'This [see Mawalan, plate 91] is what is called *dhurlang*, his *miny'tji* [clan designs] for Marrakulu, [but] belonging to Lilipiyana. It is his design. Lilipiyana design. And then he went and at all [the places on] his journey there are these *gurlwirri* [Cabbage Palm]. I was told by Dad, halfway between Ngilipidji and whatsit, there is a *gurlwirri* tree like this, but it was tall, really really big and tall. So that's a part of his journey that he travelled all the way. His journey, Lilipiyana's journey, him alone.

'These paintings [here Gundimulk is referring to the painting by Mawalan, plate 83] are of when the Snake ate the two Sisters. We don't paint the part of the story with the Snake in it — when he travelled all over the country and then hit those trees, when he was doing all that work knocking the trees, *ganaywanga* trees. [But] we sing that line, that track, all the bits and pieces of *gardayka* [stringybark tree], that's the one that we sing, the bits and pieces ... We don't paint this one, because it belongs to Burarrwanga — them over there, Mirarrmina people. So we don't paint this one and I don't know the story about this one. They have to do this painting, the Rirratjingu people.'

For Gundimulk and Wolpa these ancestral connections confirm the relationship between the clans of Central and Eastern Arnhem Land: 'Marrakulu and Dhurili, that's our name ... that's our *bäpurru* [clan name]. That's where it comes from Warnapuyngu [surname], but still one line. Dhurili, Marrakulu, and there are still one more, two really big names for one [group], that we've got the same [Creation Story]. That is our clan, that is our *mayali'* [meaning]'.

Wolpa adds: 'Different bark paintings and designs but still ... one story.'

1 This text is the product of several interviews with Durndiwuy Wanambi, and later his daughters Gundimulk and Wolpa, and Gawirrin Gumana, conducted at Yirrkala and Nhulunbuy by Andrew Blake (Buku Larrnggay Arts Centre), Sophie Creighton and Nigel Lendon.

Fig.18
Durndiwuy Wanambi painting *The Sisters and their companions at their Gundimulk ceremonial ground at Gurka'wuy* (plate 95), Sydney 1977
Photo: Ian Dunlop

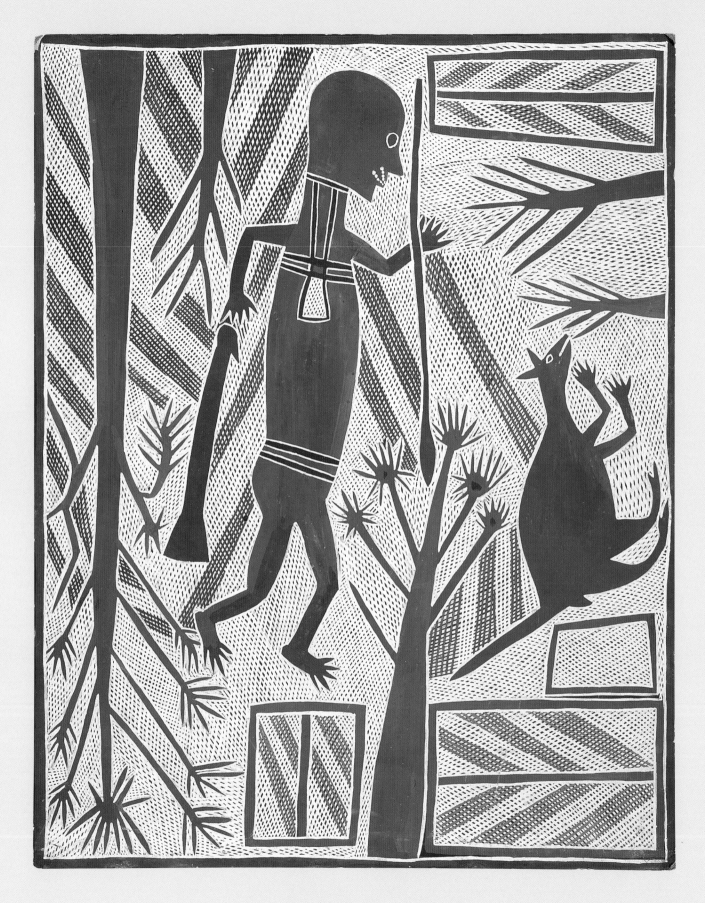

Plate 92. **Welwi Wanambi** Marrakulu *Honey man* 1973

Plate 93. **Welwi Wanambi** Marrakulu *Stone quarry* 1973

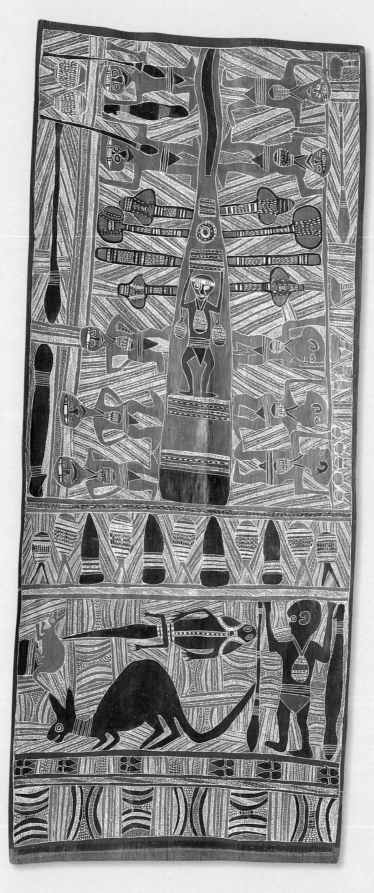

Plate 94. **Durndiwuy Wanambi** Marrakulu *Gundimulk ceremony ground with Wuyal and Dhulaku (Euro) at Yanawal* 1967

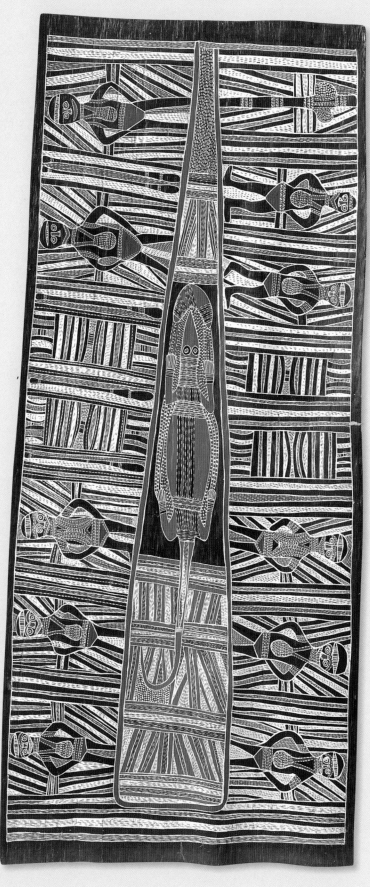

Plate 95. **Durndiwuy Wanambi** Marrakulu *The Sisters and their companions at their Gundimulk ceremonial ground at Gurka'wuy* 1976–77

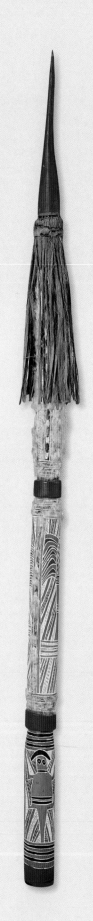

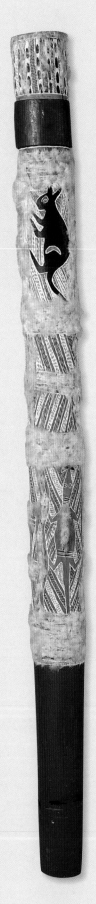

Plate 96. **Durndiwuy Wanambi** Marrakulu *Djuwany pole* 1967

Plate 97. **Durndiwuy Wanambi** Marrakulu *Djuwany pole* 1967

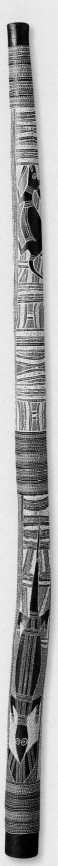

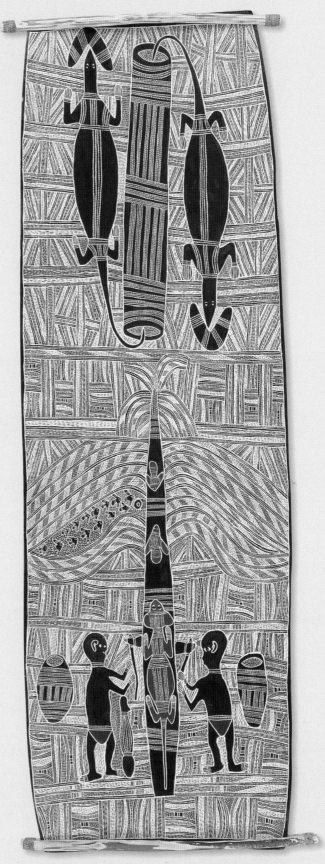

Plate 98. **Durndiwuy Wanambi** Marrakulu
*Yidaki (didjeridu) showing Djerrka and Djärrwirt
(Water Goanna and Freshwater Mussels)* 1984

Plate 99. **Durndiwuy Wanambi** Marrakulu
Wuyal Creation Story with Gundimulk ceremonial ground 1990

Plate 100. **Durndiwuy Wanambi** Marrakulu
(with Wolpa Wanambi and Motu Yunupingu)
Wuyal and Dhulaku (Euro) 1996–97

Plate 101. **Durndiwuy Wanambi** Marrakulu
(with Wolpa Wanambi and Motu Yunupingu)
Djuwany 1995–96

151

Central Arnhem Land Artists

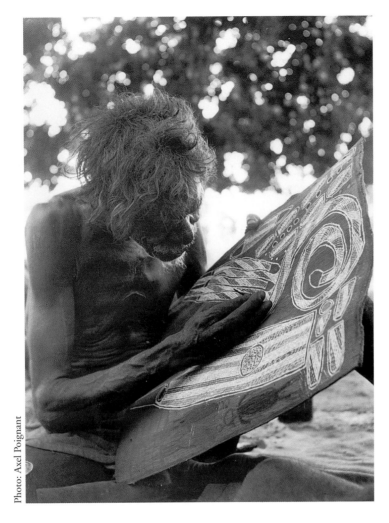

Photo: Axel Poignant

Yilkari Kitani

Told by Paddy Dhathangu, Yilkari's son, at Ramingining in 1991.

Him bin born *maku* [maybe] we country; I don't know where him bin born — I was still in the water yet, my mother didn't find me yet. He had two brothers from one Mildjingi mother. My fathers were number one singers; all three — after that I learned and now I sing.

We bin work by canoe, some young people and old people. *Yaka* [not] fish but what's that called — collecting trepang [sea cucumber]. There were Japanese and Macassan, then English people. Mission time he cut trees, cleaned up the beach and up to the Macassan Well. Plant a garden; we all worked there.

I went to school now, I grow now. I saw him paint. Him bin do alright that bark. That old fellow Dr Thomson maybe he got a bark from my father … I bin there, he never bin tell me, we sat together, I watching him [gestures painting movement with his hands] — that's the way I gotta do now. I copy — now everybody copy. I draw my [Creation Story]; Wititj [python — gestures a circling motion in the palm of one hand]. I saw first and Dawidi. Dawidi he father pass away long time ago — he watched my father and learned.

Djon Mundine, Bula'bula Arts, Ramingining

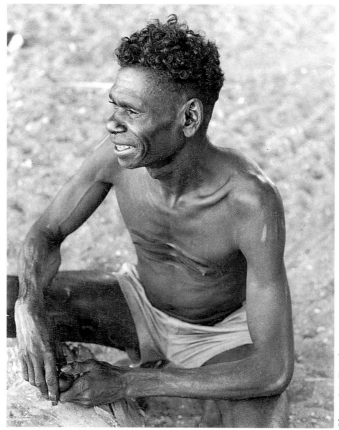

Photo: J.A. Davidson

Dawidi

Dawidi was destined to inherit his father's role as ritual leader of the Liyagalawumirr, having shown himself to possess the necessary qualities. However, when his father, Yilkari, died he was still too young to assume his full responsibilities. Dawidi's uncle, Djawa, took over the functions of ritual leader provisionally. This was the situation when Karel Kupka first visited Milingimbi in 1956. He recounts:

'When I wanted to buy a bark painted by the highest authority that recorded the Wagilag Sisters story, I had to approach [Yilkari].

'By 1960, Djulwarak [Dawidi] had assumed his responsibilities. Yet he called on Dhawadanygulili for assistance (Yilkari, Dawidi's father's brother, having died several years before) in executing this sort of bark painting for me as a mark of our friendship. He still did not consider himself capable of painting it by himself to the necessary degree of precision … It was only in 1963, when he had gained his full powers and a corresponding degree of assurance, that Djulwarak [Dawidi] sent me as a Christmas present a painting of this sort entirely painted by him. Need I add anything further to emphasise the professional integrity of a man in this position?'

Karel Kupka 1972, *Peintres aborigènes d'Australie.*
(Excerpt is a translation of the text, published in French.)

Paddy Dhathangu

Photo: Belinda Scott

I was born in the bush on the mainland near Ramingining, maybe near Yathalamarra, near the paperbark inside the bush. I was born there but my country is really Gatatangurr or Gurgangurr and Mirarrmina. That big billabong where Wititj is there. That Wititj met those two *miyalk* [women — the Wagilag Sisters] there; Wititj hunted from there. We went to Milingimbi when I was a little boy, before my *dhapi* [initiation]. There were trepangers working there then. They were white men, not Japanese or Maccassan, maybe from Darwin. We used to help them — they asked my father if they could take me on their boat to work for them, but my parents wouldn't let me go.

There was no settlement at Milingimbi then and people used to travel around by *lipalipa* [dugout canoe]. Then we saw Mr Webb [the missionary Reverend T. T. Webb] come in a big boat [in 1924]. My father came out of the bush to meet them and then all the Yolngu came out of the bush, Mildjingi, Djinang and so on, and they all went to Milingimbi. Milingimbi little town, *marrma* [two] tin [sheds], a lot of *warraw'* [lean-tos]. Rrulku, [a place on Milingimbi] there was a school and church house, and Djungulin's father [Djawa] was there then also. I went to school there and had my initiation there nearby a little after. There was a missionary there who taught me who used to use a big whip. They speared him you know — it was a Sunday when he got speared. There was a lot of trouble then and my parents took me away from Milingimbi.

After a while we went back and worked with Mr Shepherdson in the gardens they had there, mangoes, coconuts, then when the war came these two Balandas [Mr Sweeney and Bill Harney] took us, Nakarra people, Burrarra people, Blyth River people to Mataranka and Katherine. I was a corporal you know, with stripes on my shirt. I worked near Mindil Beach [in Darwin] shifting sand and in the mornings when the sirens would go off and the Japanese would come [overhead]. There was a lot of shooting and they dropped a lot of bombs and we'd all jump into the *munatha* [sand] until they'd left.

[Returning to Milingimbi after the war, Dhathangu lived on the mainland at Gätji and took part in many ceremonies. Sometime later he returned again to Milingimbi where he worked in the gardens and painted.]

My father taught me to paint. He was one of the first men [to make barks for sale through the mission] … Later, when they started a garden at Ngangalala I shifted there; this was before Ramingining was built, and did my painting there. When Ramingining was built up I shifted here.

Djon Mundine, Bula'bula Arts, Ramingining

Photo: Nigel Lendon

Daisy Manybunharrawuy

I was born and lived at Ngarrawundhu at Milingimbi … The old church was where the hospital is now. We used to go to church on Sunday — used to sing in the choir. My mother took me to a [Mardayin] ceremony at Ngarrawundhu then; my father was the *bunggawa* [boss] for this. I saw old people; women, singing and was listening and learning. Brian Yambal's grandmother was the number one singer for *miyalk bunggul* [women's ceremony].

After I left school I married to Djembangu and lived at Ngarrawundhu. I knew Joe for a long time — we were like one big family at Ngarrawundhu. I was about 17 years old then; I can read and write now. My mother used to weave baskets and mats to sell. She taught me.

I still kept going at bark painting after I married Djembangu. My father used to tell me a story from the painting. My families were happy with that — all those old people. My family support me, especially Dhathangu and Djiwada because they're beside me — we all one for like Liyagalawumirr but we got different subject — we all Liyagalawumirr but some are from Guruwana.

I use white clay from the beach; black from the tree from the bush; red and yellow from the beach. We used to use *djalkurrk* [native orchid], that bush medicine. We call it bush medicine because you chew it before you use it. Glue came really when Mr McLeay came. Alan Fidock used to use a spray — a hand spray, helping bush medicine.

I always lived at Milingimbi. Milingimbi is like my home — Milingimbi is like *momu* [grandmother].

<div align="right">Daisy Manybunharrawuy, 1992.</div>

'She can paint — many people say this is wrong because it is sacred. You heard this before? She is allowed because she is first born. She has to hand on to the next son.'

<div align="right">Henry Djirringal, Djawa's son, 1992.</div>

<div align="right">Djon Mundine, Bula'bula Arts, Ramingining</div>

Eastern Arnhem Land Artists

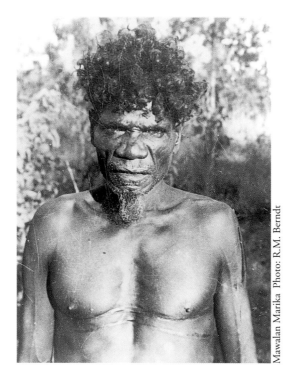

Mawalan Marika Photo: R.M. Berndt

Mawalan and Wandjuk Marika

As told by Wandjuk Marika

Painting is very important. It's the design or symbol, power of the land. First I learned to paint when I was a young man from my father, Mawalan, when he take me through the bush, teaching me where to go, where to find, what to hunt, what the special place. Then I learnt Yolngu writing, my own designs, drawing on the rock or on the sand and then putting in the hatching. I start on the bark maybe when I was about 15 years of age. But my father was still holding my hand. I used to shake my hand, but he was holding it. And he always said to me, 'Hold your brush straight, paint away from your body. Use your wrist with the brush. Just put the line there. Most important is the line; most important is the animal you draw,' he said to me …

After two months he let me go by myself; he was still watching. I sit with bark on my lap, or on the ground, and then he's holding my hand, helping me with the brush, then rest a bit so the cross-hatching can dry.

I first see the designs on my own body, paint on for a circumcision, to make me young man. But, before that, I saw some other people who painted them on other bodies when they first come to Yirrkala for special ceremonies, like Djan'kawu ceremony, or for special burial, and on special objects. That's when I learned the stories.

… I am not painting just for my pleasure; there is the meaning, knowledge and power. This is the earthly painting for the creation and for the land story. The land is not empty, the land is full of knowledge, full of story, full of goodness, full of energy, full of power. Earth is our mother, the land is not empty. There is the story I am telling you — special, sacred, important.

From *Wandjuk Marika: Life story as told to Jennifer Isaacs,* 1995

Photo: Buku Larrnggay Mulka

Durndiwuy Wanambi

See this, all behind to this, the ground — is the *gundi molk* [ceremonial ground, sand sculpture]. This is the *molk,* which is two [Sisters], was made at Maynbalala and Gurka'wuy. This is the Marrakulu [land], Marrakulu, but this not for only Marrakulu but every clan ... connected with Marrakulu ... This is the history for new generation. But I should say this strongly, please ... you can see and understand which is Yolngu culture and Aborigine culture and background; and you must be able to learn, and you must be able to learn in my culture, and therefore, I might learn in your culture a bit.

But the thing is that you're not very understanding, and you find very difficult [that] which is Aborigine, but something like that because we not taught you everything; and the same thing to me, that I cannot see clearly in your culture, because I didn't know, I haven't been in school. Well that's why I see your culture very hard.

And this is something opening the place here, the place Gurka'wuy ... I make this ceremony, put in the film for history for generation and generation. So my clan, people will, could use this same ceremony for ever and ever until we die.

From *Djungguwan at Gurka'wuy,* a film by Ian Dunlop, Film Australia Pty Ltd.

Glossary

art adviser: the coordinator or manager of the community art and craft centre who is appointed by and responsible to a committee of local artists, and who mediates on behalf of the artists in the public arena to protect their rights including copyright. The adviser organises the provision of art materials, the documentation of art works, the buying and selling of art, packing and freighting, and the organisation of exhibitions.

art centre: also known as art and craft centres, art centres act as agents for the artists in each town and its outstations; several art centres are attached to local museums where important works from the community are collected and displayed.

Balanda: the Arnhem Land term for non-Aboriginal people, introduced by the Macassans from Indonesia some centuries ago. The term is an adaptation of the Dutch word used in Indonesia for white people.

bäpi: snake.

bäpurru: clan.

bilma: clapstick.

clan: a group of people who are descended from a common ancestor.

dhapalany: stinging caterpillar.

dhapi: initiation, circumcision ceremony.

dhäwu: story, word, information.

Dhuwa: see **moiety**.

dhuway: sister's husband.

didjeridu: a drone pipe, a musical instrument.

djäma: work.

djarrka: water goanna, Merten's Water Monitor (*djerrka* in Eastern Arnhem Land).

djunggayi: custodian, guardian, manager; ceremonial authority responsible for one's mother's country and stories (opposite moiety to owner) (*djunggaya* in Eastern Arnhem Land).

dupun: one of several terms for a hollow log bone coffin.

gutharra: sister's daughter's son, grandchild of the same moiety.

manikay: songs.

Mardayin: an important ceremony.

mardayin: the sacred or holy qualities associated with places and totems; all sacred objects.

märi: paternal grandfather or his sister, maternal grandmother or her brother.

miny'tji: painted designs, clan designs.

miyalk: woman, women.

moiety: one of a pair of complementary social and religious categories; in Central and Eastern Arnhem Land these are called **Dhuwa** and **Yirritja**. All people, supernatural beings, every living thing, all inanimate objects and all phenomena are deemed to belong to one or the other moiety.

molk: ceremonial sand sculpture or design.

ngatha: food, vegetable, gathered not hunted.

ngathi: maternal grandfather.

outstation: camps or settlements established on people's traditional lands.

rärrk: cross-hatched painted design.

wäku: nephew.

yidaki: didjeridu, a musical drone pipe.

Yirritja: see **moiety**.

Yolngu: Aboriginal people in Central and Eastern Arnhem Land refer to themselves collectively as the Yolngu, a word which means human beings.

yothu: child or children.

Bibliography

Aboriginal Arts Board, *Art of Aboriginal Australia*, Rothmans of Pall Mall, Canada Ltd., 1974.

Aboriginal Arts Board, *Australian Bark Painting: From the collection of Dr Edward L. Ruhe*, Rochester: Oakland University, 1975.

Allen, Louis A., *Australian Aboriginal Art, Arnhem Land*, Chicago: Field Museum of Natural History, 1972.

Allen, Louis A., *Australian Aboriginal Art: The Louis A. Allen Collection*, San Francisco: M.H. de Young Memorial Museum and California Palace of the Legion of Honor, 1974.

Allen, Louis A., *Time Before Morning: Art and myth of the Australian Aborigines*, New York: Thomas V. Crowell, 1975, and Adelaide: Rigby, 1976.

Altman, Jon (ed.), *The Aboriginal Arts and Crafts Industry: Report of the Review Committee*, Canberra: Department of Aboriginal Affairs, Australian Government Publishing Service, 1989.

The Anthropology Museum, *The Land, the Sea and Our Culture*, Brisbane: University of Queensland, 1981.

Beier, Ulli (ed.), *Long Water, Aspect 34,* August 1986. (Wandjuk Marika, 'Painting is Very Important', p. 7.)

Bennett, Lance, *Art of the Dreamtime: The Dorothy Bennett Collection of Australian Aboriginal art,* Tokyo: Kodansha, 1969.

Berndt, Ronald M., *Love Songs of Arnhem Land*, West Melbourne: T. Nelson, 1976.

Berndt, Ronald M., 'A Living Aboriginal Art: The Changing Inside and Outside Contexts', in Loveday, P. & Cooke, P. *Aboriginal Arts and Crafts and the Market*, Darwin: Australian National University North Australia Research Unit, 1983.

Berndt, Ronald M. & Berndt, Catherine H., *Arnhem Land: Its history and its people*, Melbourne: Cheshire, 1954.

Berndt, Ronald M. & Berndt, Catherine H., *The Australian Aboriginal Art: Arnhem Land paintings on bark and carved human figures*, (introduction), Perth: Art Gallery of Western Australia, Festival of Perth Committee, 1957.

Berndt, Ronald M., Berndt, Catherine H. & Stanton, J.E., *Aboriginal Australian Art: A visual perspective*, Sydney: Methuen Australia, 1982.

Berndt, Ronald M. et al, *Australian Aboriginal Art*, Sydney: Ure Smith, 1964.

Berndt, Ronald M. & Phillips, E.S. (eds), *The Australian Aboriginal Heritage: An introduction through the arts*, Sydney: Ure Smith, 1973.

Biennale of Sydney, *European Dialogue*, Sydney: Playbill (Australia), 1979.

Butlin, Noel G., *Our Original Aggression: Aboriginal populations of Southeastern Australia 1788–1850*, Sydney: George Allen & Unwin, 1983.

Caruana, Wally, *My Country, My Story, My Painting: Recent paintings by twelve Arnhem Land artists*, Canberra: Australian National Gallery, 1986.

Caruana, Wally, *Painted Objects from Arnhem Land*, Canberra: Australian National Gallery, 1986.

Caruana, Wally, *Ancestors and Spirits: Aboriginal painting from Arnhem Land in the 1950s and 1960s*, Canberra: Australian National Gallery, 1987.

Caruana, Wally, *Australian Aboriginal Art at the Australian National Gallery*, Canberra: Australian National Gallery, 1987.

Caruana, Wally (ed.), *Windows on the Dreaming: Aboriginal paintings in the Australian National Gallery*, Canberra: Australian National Gallery, 1989.

Caruana, Wally, *Aboriginal Art*, World of Art series, London and New York: Thames and Hudson, 1993.

Chaseling, Wilbur S., *Yulengor, Nomads of Arnhem Land*, London: Epworth Press, 1957.

Cole, Keith, *The Aborigines of Arnhem Land*, Adelaide: Rigby, 1979.

Cole, Keith, *Arnhem Land: Places and people*, Adelaide: Rigby, 1980.

Cooper, C. et al, *Aboriginal Australia*, Sydney: Australian Gallery Directors Council, 1981.

Davidson, J.A., 'Mathaman: Warrior, Artist, Songman', *Bulletin* (National Gallery of Victoria), no. 29, 1989.

Day, Robert & Whitehead, Fred (eds), *Dreamtime: Remembering Ed Ruhe, 1923–1989*, Chestertown, Md.: Literary House Press, 1993.

Djoma, Billy, *Miringuy Djapaniy malanguy bumara Milingimbi [The Japanese enemies bombed Milingimbi]*, Milingimbi: Milingimbi Bilingual Centre, Milingimbi School, 1974.

Douglas, Malcolm & Oldmeadow, David, *Across the Top and Other Places*, Adelaide: Rigby, 1972.

Dussart, Françoise, *La Peinture des Aborigènes d'Australie*, Marseille: Editions Parenthèses, 1993.

Edwards, R. & Guerin, B., *Aboriginal Bark Paintings*, Adelaide: Rigby, 1965.

Elkin, A.P., Berndt, C.H. & Berndt, R.M., *Art in Arnhem Land*, Melbourne: Cheshire, 1950.

Elsasser, Albert B. & Paul, Vivian, *Australian Aboriginal Art: The Louis A. Allen Collection*, Berkeley: R.H. Lowie Museum of Anthropology, University of California, 1969.

Groger-Wurm, H.M., *Australian Bark Paintings and Their Mythological Interpretation, Volume 1 Eastern Arnhem Land*, Canberra: Australian Institute of Aboriginal Studies, 1973.

Gruhzit-Hoyt, Olga, *Aborigines of Australia*, New York: Lothrop, Lee & Shepard Co., 1969.

Harney, William E., *Taboo*, Sydney: Australasian Publishing Co., 1943. Introduction by A.P. Elkin.

Hiatt, L.R. (ed.), *Australian Aboriginal Mythology*, Canberra: Australian Institute of Aboriginal Studies, 1975.

Keen, Ian, 'Yolngu sand sculptures in context', in Ucko, Peter J.(ed.), *Form in Indigenous Art: Schematisation in the art of Aboriginal Australia and prehistoric Europe*, Canberra: Australian Institute of Aboriginal Studies, 1977.

Keen, Ian, *Knowledge and Secrecy in an Aboriginal Religion*, Oxford: Clarendon Press, 1994.

Koyama, S., *The Art of the First Australian*, Kobe: Kobe City Museum, 1986.

Kupka, Karel, *Kunst der Uraustralier*, Basel: Museum für Völkerkunde und Schweizerische Museum für Völkerkunde (Museum der Kulturen), 1958. Foreword by Alfred Bühler.

Kupka, Karel, *Un art à l'état brut, pientures et sculptures des aborigènes d'Australie*, La Guide du Livre, Lausanne, 1962. Introduction by André Breton, preface by Alfred Bühler.

Kupka, Karel, *Dawn of Art: Painting and sculpture of Australian Aborigines*, Sydney: Angus & Robertson, 1965. (English language version of *Un art à l'état brut*, 1962).

Kupka, Karel, 'Les écorces peintres d'Australie du Musée et Institut d'Ethnographie de Genève, in *Bulletin annuel du Musée et Institut d'Ethnographie de la Ville de Genève*, no. 9, 1966.

Kupka, Karel, *Australie: Osobnost Primitivniho Malire*, Prague: Napratkovo Museum, 1969.

Kupka, Karel, *Peintres aborigènes d'Australie*, Paris: Musée de l'Homme, 1972.

Kyle-Little, Syd, *Whispering Wind: Adventures in Arnhem Land*, London: Hutchinson, 1957.

Lendon, Nigel, 'Having a History: Development and Change in the Paintings of the Story of the Wagilag Sisters', in *Art Monthly Australia* supplement 'Aboriginal Art in the Public Eye', December, 1992.

Lendon, Nigel, 'Visual Evidence: Space, Place and Innovation in Bark Paintings of Central Arnhem Land', *Australian Journal of Art*, vol. 12, 1994–1995, pp. 55–73.

Lendon, Nigel, 'The Meaning of Innovation: David Malangi and the Bark Painting Tradition of Central Arnhem Land', in Kerr, J., Losche, D. & Thomas, N. (eds), *Reframing Aboriginal Art*, forthcoming.

Lüthi, Bernard (ed.), *Aratjara: Art of the First Australians: Traditional and contemporary works by Aboriginal and Torres Strait Islander artists*, Cologne: DuMont Buchverlag, 1993.

Mackay, Machmud, 'Marketing and Aboriginal Arts and Crafts: A preliminary report on the production, distribution and marketing of Aboriginal arts and crafts in Australia', Aboriginal Arts in Australia national seminar, Canberra, 1973.

Macknight, C.C., *The Voyage to Marege': Macassan trepangers in Northern Australia*, Carlton, Vic: Melbourne University Press, 1976.

Marika, Wandjuk, *Wandjuk Marika: Life Story as told to Jennifer Isaacs*, St Lucia, Qld: University of Queensland Press, 1995.

McCarthy, F.D., *Australian Aboriginal Art*, State Art Galleries of Australia, 1960.

McKenzie, Maisie, *Mission to Arnhem Land*, Adelaide: Rigby, 1976.

Milpurrurru, George et al, *The Art of George Milpurrurru*, Canberra: National Gallery of Australia, 1993.

Mirritji, Jack, *My People's Life: An Aboriginal's own story*, Milingimbi: Milingimbi Literature Centre, 1976.

Morphy, Howard, 'Yingapungapu — Ground Sculpture as Bark Painting', in Ucko, Peter J. (ed.), *Form in Indigenous Art: Schematisation in the art of Aboriginal Australia and prehistoric Europe*, Canberra: Australian Institute of Aboriginal Studies, 1977.

Morphy, Howard, 'Schematisation to Conventionalisation: A Possible Trend in Yirrkala Bark Paintings', in Ucko, Peter J. (ed.), *Form in Indigenous Art: Schematisation in the art of Aboriginal Australia and prehistoric Europe*, Canberra: Australian Institute of Aboriginal Studies, 1977.

Morphy, Howard, 'Aboriginal Fine Art — Creation of Audiences and the Marketing of Art', in Loveday, P. & Cooke, P., *Aboriginal Arts and Crafts and the Market*, Darwin: Australian National University North Australia Research Unit, 1983.

Morphy, Howard, *Journey to the Crocodile's Nest*, Canberra: Australian Institute of Aboriginal Studies, 1984.

Morphy, Howard, 'From Dull to Brilliant: The Aesthetics of Spiritual Power among the Yolngu', *Man*, vol. 24, no. 1, 1989.

Morphy, Howard, 'Myth, Totemism, and the Creation of Clans', *Oceania*, no. 60, 1990.

Morphy, Howard, *Ancestral Connections: Art and an Aboriginal system of knowledge*, Chicago: University of Chicago Press, 1991.

Mountford, Charles P., *Australia — Aboriginal Paintings — Arnhem Land*, New York: UNESCO, 1954. Introduction by Herbert Read.

Mountford, Charles P., *Records of the American–Australian Scientific Expedition to Arnhem Land*, vol. 1, *Art, Myth and Symbolism*, Melbourne: Melbourne University Press, 1956.

Mundine, John (Djon), *Objects and Representations from Ramingining*, Sydney: Power Gallery of Contemporary Art, University of Sydney, 1984.

Mundine, John (Djon), 'Ramingining Performance Group', in the Biennale of Sydney, *Origins, originality + beyond*, Sydney: Art Gallery of New South Wales, 1986.

Mundine, John (Djon), 'Ramingining Artists Community: Aboriginal Memorial', in the Biennale of Sydney, *From the Southern Cross: A View of World Art c.1940–88*, Sydney: ABC Enterprises and the Biennale of Sydney, 1988, pp. 230–233.

Mundine, John (Djon), '200 Burial Poles', *Australian Art Monthly*, March 1988.

Mundine, John (Djon), *The Aboriginal Memorial*, Ramingining: Ramingining Arts and Crafts, 1988.

Mundine, Djon, *Paintings and Sculptures from Ramingining by Jimmy Wululu and Philip Gudthaykudthay*, Canberra: University Drill Hall Gallery, 1992.

Mundine, Djon, & Murphy, Bernice (eds), *The Native Born: Objects and Representations from Ramingining*, Sydney: Museum of Contemporary Art, in press.

Murphy, Bernice, *Catalogue XVII: Bienal de São Paulo*, Sydney: Aboriginal Artists Agency, 1983.

Museum für Völkerkunde (Museum der Kulturen), *Ozeanische Kunst: Meisterwerke aus dem Museum für Völkerkunde*, Basel: Kunstmuseum, 1980.

Northern Territory of Australia, *Government Gazette, Welfare Ordinance 1953–55, Register of Wards*, 1957.

O'Ferrall, Michael A., *Keepers of the Secrets: Aboriginal art from Arnhemland in the collection of the Art Gallery of Western Australia*, Perth: Art Gallery of Western Australia, 1990.

Peterson, Nicolas, 'Notes for Archival Version of the Djungguwan', unpublished field notes, 1966.

Reser Joseph P., 'The Dwelling as Motif in Aboriginal Bark Painting', in Ucko, Peter J. (ed.), *Form in Indigenous Art: Schematisation in the art of Aboriginal Australia and prehistoric Europe*, Canberra: Australian Institute of Aboriginal Studies, 1977.

Robinson, Roland, *The Feathered Serpent*, Sydney: Edwards & Shaw, 1956.

Robinson, Roland, *Aboriginal Myths and Legends*, Melbourne: Sun Books, 1966.

Rudder, John, *Introduction to Yolngu Science*, Galiwin'ku: Galiwin'ku Adult Education Centre, 1977.

Ryan, Judith, *Spirit in Land: Bark paintings from Arnhem Land in the National Gallery of Victoria*, Melbourne: National Gallery of Victoria, 1990.

Sayers, Andrew, *Aboriginal Artists of the Nineteenth Century*, Melbourne: Oxford University Press in association with the National Gallery of Australia, 1994.

Scougall, Stuart, *Australian Aboriginal Bark Painting: A brief survey*, Australia, (s.n.), 1963.

Shepherdson, Ella, *Half a Century in Arnhem Land*, One Tree Hill, South Australia: Ella & Harold Shepherdson, 1981.

Souef, Michèle, 'Avant-propos Karel Kupka (1918–1993)' in Françoise Dussart, *La Peinture des Aborigènes d'Australie*, Marseille: Editions Parenthèses, 1993, pp.9–16.

Spencer, W. Baldwin, *Preliminary Report on the Aboriginals of the Northern Territory, Bulletin of the Northern Territory*, no. 7, July, Melbourne: Department of External Affairs, 1913.

Sutton, P., *Dreamings: The art of Aboriginal Australia*, Ringwood Vic: Viking, in association with the Asia Society Galleries, New York, 1988.

Taylor, Luke, *Seeing the Inside: Bark painting in Western Arnhem Land*, Oxford: Claredon Press, 1996.

Thomson, Donald F., *Report on Expedition to Arnhem Land, 1936–37*, Canberra: Australian Government Printer, 1939.

Thomson, Donald F., 'Arnhem Land: Explorations Among an Unknown People', *Geographical Journal*, (in three parts) vol. CXII, 1948, CXIII, CXIV, 1949.

Thomson, Donald F., *Economic Structure and the Ceremonial Exchange Cycle in Arnhem Land*, Melbourne: Macmillan, 1949.

Thomson, Donald F., *Donald Thomson in Arnhem Land*, (compiled by Nicolas Peterson), Melbourne: Currey O'Neil, 1983.

Wallace, Daphne et al, *Flash Pictures by Aboriginal and Torres Strait Islander Artists,* Canberra: National Gallery of Australia, 1991.

Warner, W. Lloyd, *A Black Civilization: A social study of an Australian tribe*, New York and London: Harper & Brothers Publishers, 1937.

Webb, Thomas Theodor, *The Aborigines of East Arnhem Land, Australia*, Melbourne: Methodist Laymans Missionary Movement, 1934. Introduction by Donald F. Thomson.

Webb, Thomas Theodor, *Spears to Spades*, Melbourne: The Book Depot, Spectator Publishing Co. Pty Ltd, 1938.

Wells, Ann E., *Milingimbi, Ten Years in the Crocodile Islands of Arnhem Land*, Sydney: Angus & Robertson, 1963.

Wells, Ann E., *This Their Dreaming*, Brisbane: University of Queensland Press, 1971.

Wells, Edgar, *Reward and Punishment in Arnhem Land 1962–1963*, Canberra: Australian Institute of Aboriginal Studies, 1982.

West, M.K.C., (ed.), *The Inspired Dream: Life as art in Aboriginal Australia*, Brisbane: Queensland Art Gallery, 1988.

Wilkins, Sir (George) Hubert, *Undiscovered Australia*, New York, London: G.P. Putnam's Sons, The Knickerbocker Press, 1929.

Williams, Don (ed.), *Discovering Aboriginal Culture: The Aboriginal Australian in North Eastern Arnhem Land*, Canberra: The Curriculum Development Centre, 1982.

Williams, Nancy M., 'Australian Aboriginal Art at Yirrkala: The Introduction and Development of Marketing', in Graburn, Nelson H. (ed.), *Ethnic and Tourist Arts: Cultural expressions from the Fourth World*, Berkeley: University of California Press, 1976, pp. 266–284.

Williams, Nancy, M., *The Yolngu and Their Land: A system of land tenure and the fight for its recognition*, Canberra: Australian Institute of Aboriginal Studies, 1986.

Wiseman, Judith Proctor, *Thomson Time: Arnhem Land in the 1930s: A photographic essay*, Melbourne: Museum of Victoria, 1996.

Zorc, R. David, *Yolngu-Matha Dictionary*, Batchelor: School of Australian Linguistics, Darwin Institute of Technology, 1986.

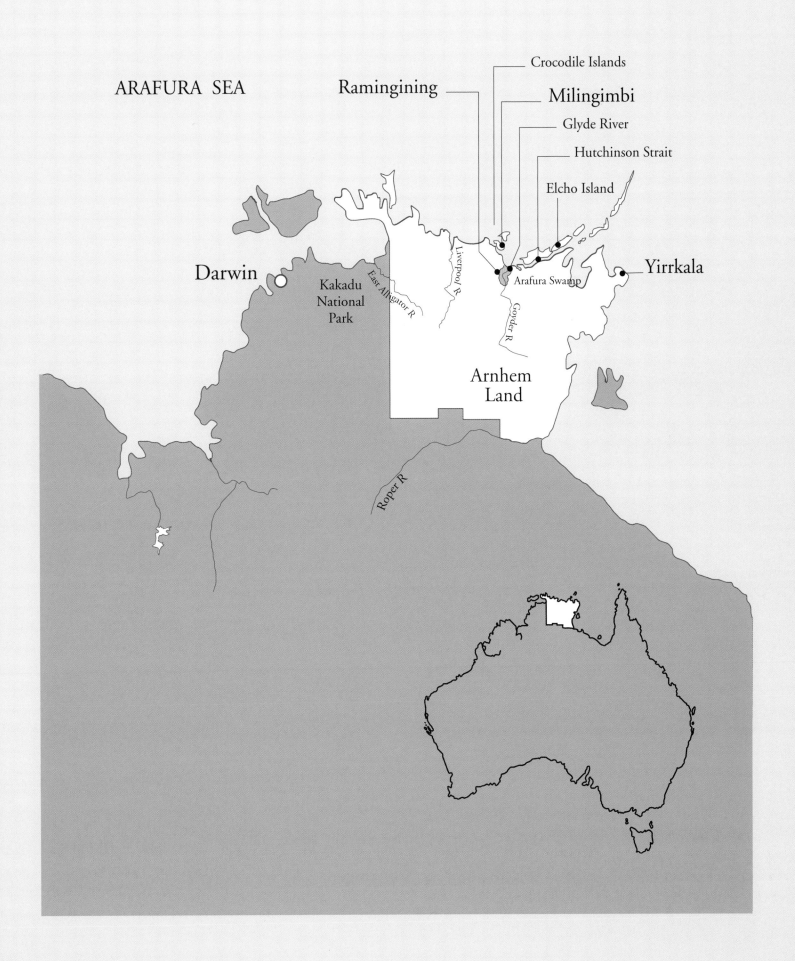

ARAFURA SEA

Crocodile Islands

Ramingining

Milingimbi

Glyde River

Hutchinson Strait

Elcho Island

Darwin

Kakadu
National
Park

Liverpool R

East Alligator R

Goyder R

Arafura Swamp

Yirrkala

Arnhem
Land

Roper R

List of Artists and Works in the Exhibition

Artists are listed by region and alphabetically by family name (refer to the artists' chart, pages 6 and 7): each artist's name is followed by his or her language and moiety, usual place of residence or work, and date of birth.

The works are listed chronologically as follows: on the advice of the current owners and custodians, each work's exhibition title is followed by the original title (in square brackets), where these differ; the place of execution where it differs from the place of residence; the medium, followed by the dimensions in centimetres (height before width) of each work; and the collection information. Unless indicated otherwise, all works belong to the National Gallery of Australia.

References and exhibition history of the work are also given; unless indicated otherwise, exhibitions were organised by the National Gallery of Australia.

Central Arnhem Land

DJARDIE ASHLEY
Wagilag, Dhuwa moiety
Ramingining and Milingimbi, born 1951

77
Ngambi, spear points, with dhapalany, caterpillars, molk, sand sculpture and waterholes c.1984
[Ngambi/Gumurr Djalk (Stone spear heads wrapped in bark)]
painted at Ramingining
natural pigments on eucalyptus bark
170.8 x 65.0 cm
Collection: Museum of Contemporary Art, Sydney. J.W. Power Bequest, purchased 1984
• exhibited: 'Objects and Representations from Ramingining, Arnhem Land', Power Gallery of Contemporary Art, University of Sydney, 1984; and 'The Native Born: Objects and Representations from Ramingining, Arnhem Land', Museum of Contemporary Art, Sydney, 1996.

78
Ngambi, spear points 1986
painted at Ramingining
natural pigments on eucalyptus bark
128.0 x 64.0 cm
Purchased from National Gallery admission charges 1987 (1987.1052)
• exhibited: 'The Continuing Tradition', 1989.

NAMIYAL BOPIRRI
Liyagalawumirr, Dhuwa moiety
Ramingining, born 1927

76
Sacred Rocks at Guruwana 1993
natural pigments on composition board
142.2 x 68.0 cm
Purchased 1994 (1994.206)

DAWIDI
Liyagalawumirr, Dhuwa moiety
Milingimbi, 1921–1970
[Dawidi is referred to as Djulwarak in Karel Kupka's writings]

52
Dhapalany ga bathi (Itchy Caterpillars with nest) 1955–56
natural pigments on eucalyptus bark
41.5 x 33.0 cm
Museum der Kulturen, Basel
Collected by Karel Kupka
• exhibited: 'Kunst der Uraustralier', Museum für Völkerkunde (Museum der Kulturen), Basel, 1958.

3
Wagilag Creation Story 1960
(painted with DHAWADANYGULILI, Gupapuyngu, Yirritja moiety, Milingimbi, 1900–1976)
natural pigments on eucalyptus bark
125.0 x 48.0 cm
Museum der Kulturen, Basel
Collected by Karel Kupka
• exhibited: 'Gemaltes Land (Painted Land)' at the Linden-Museum in Stuttgart; and the Hamburgisches Museum für Völkerkunde, 1994,
• see Kupka 1962, p. 150 and 1965, p. 144.

13
Gurrurdupun (hollow log coffin): Wagilag Creation Story with Waltjarn (rain) 1960
natural pigments on wood
78.5 x diameter 10.0 cm
Musée national des Arts d'Afrique et d'Océanie, Paris
Collected by Karel Kupka
• see Dussart 1993, p. 71.

49
Dhapalany ga melkiri (Itchy Caterpillars with forked sticks) 1960
natural pigments on eucalyptus bark
52.0 x 30.0 cm
Musée national des Arts d'Afrique et d'Océanie, Paris
Collected by Karel Kupka

53
Dhapalany ga bäthi c.1960
[The Wagilag Sisters (Narrative): The Sacred Caterpillars]
natural pigments on eucalyptus bark
105.3 x 43.6 cm
Collection of the Newcastle Region Art Gallery
• exhibited: 'Aboriginal Bark Paintings from Arnhem Land', Newcastle Regional Art Gallery, 1984.

14
Wagilag Creation Story 1963
natural pigments on eucalyptus bark
110.0 x 50.0 cm
Acquired by the Australian Government before 1970 (1900.162)
• exhibited: 'Ancestors and Spirits', 1987; and 'The Continuing Tradition', 1989,
• see Caruana 1987, p. 15; and 1989, p. 63, plate 25.

57
Wititj ga Warngurra' ga girri' (Wititj with Bandicoot and tools) 1964
natural pigments on eucalyptus bark
84.0 x 45.0 cm
Private collection
Collected by J.A. Davidson
• see Lendon 1994, p. 62, fig. 4.

60
*Wurrdjarra ga marrma' Wititj ga marrma' Djarrka
(Sand Palm and fronds with two Snakes and two
Goannas)* 1964
natural pigments on eucalyptus bark
112.5 x 52.9 cm
Collection: National Museum of Australia
Collected by J.A. Davidson

1
The Wagilag Sisters 1965
wood, natural pigments
heights: Elder Sister 93.3 cm,
Younger Sister 66.3 cm
Collection: Art Gallery of Western Australia
Previously in the Louis A. Allen Collection
• both figures exhibited 'Australian Aboriginal
Art: The Louis A. Allen Collection',
R.H. Lowie Museum of Anthropology,
University of California, Berkeley, 1969;
see Elsasser and Paul 1969, p. 4;
'Australian Aboriginal Art', Field Museum of
Natural History, Chicago, 1972; see Allen 1972;
and 'Australian Aboriginal Art: The Louis A. Allen
Collection', M.H. de Young Memorial
Museum, California Palace of the Legion of Honor, 1974;
see Allen 1974,
• Elder Sister exhibited: 'Australian Aboriginal
Art', The Art Galleries, University of California at
Santa Barbara, 1970; see Allen 1970, p. 14; and
1975, p. 145; O'Ferrall 1990, p. 74, plate 86,
• Younger Sister; see Allen 1975, p. 69.

15
*Wagilag Creation Story and the thundercloud
before the first wet season* 1965
natural pigments on eucalyptus bark
145.0 x 72.7 cm
Private collection
Collected by J.A. Davidson
• see Williams 1982, p. 63; Caruana 1993, p. 49,
plate 34; and Lendon 1992, p. 30.

20
Wadjiwadji (emu feather fans) c.1965
emu feathers, wood, natural pigments, resin
heights 87.0, 75.6 and 78.3 cm, variable
Collection: National Museum of Australia
Collected by J.A. Davidson

21
Nguja, feathered head ornament 1965
feathers, wood, resin, natural pigments
26.0 x 10.0 x 3.0 cm
Collection: National Museum of Australia
Collected by J.A. Davidson

46
Stone-headed spear 1965
stone, paperbark, wood, natural pigments, resin
166.0 x 5.0 x 4.0 cm
Collection: National Museum of Australia
Collected by J.A. Davidson

47
Wulambu' (spear thrower) c.1965
wood, natural pigments, resin, hair
98.0 x 16.0 x 6.5 cm
Collection: National Museum of Australia
Collected by J.A. Davidson

56
Dilly bag with fish and goannas 1965
[Dilly bag fish trap]
natural pigments on eucalyptus bark
89.0 x 47.5 cm
Collection: National Museum of Australia
Collected by J.A. Davidson

16
Wagilag painting (Elder Sister) 1966
natural pigments on eucalyptus bark
85.0 x 59.5 cm
Collection: National Museum of Australia
• see Groger-Wurm 1973, p. 50, plate 64.

59
Dhalngurr 1966
natural pigments on eucalyptus bark
80.0 x 53.5 cm
Groger-Wurm Collection, Museums and
Art Galleries of the Northern Territory
• see Groger-Wurm 1973, p. 40–41, plate 41;
and West p. 88, plate 67.

17
*Molk ga Yolngu ga ngambi ga wurrdjarra ga manga
ga malirri (Ground design with Yolngu, spear heads,
sand palm fronds, spears and clapsticks)* 1968
[Wagilag ceremony]
natural pigments on eucalyptus bark
86.5 x 57.0 cm
Purchased from National Gallery admission
charges 1987 (1987.195)
• exhibited: 'Ancestors and Spirits', 1987;
and 'The Continuing Tradition', 1989,
• see Caruana 1989, p. 65, plate 27.

54
*Wolma, the first thundercloud and the rain flooding
the country* c.1969
[The flood at Mirarrmina]
natural pigments on eucalyptus bark
94.0 x 46.5 cm
Purchased from National Gallery admission
charges 1987 (1987.196)
Collected by J.A. Davidson
• exhibited: 'Ancestors and Spirits', 1987;
and 'The Continuing Tradition',1989,
• see Caruana 1989, p. 64, plate 26.

55
*Wolma, the first thundercloud and the rain
flooding the country* c.1969
[Rain and water — Wawiluk story, the flood]
natural pigments on eucalyptus bark
78.0 x 45.2 cm
Collection: Art Gallery of Western Australia
Previously in the Louis A. Allen Collection
• exhibited: 'Australian Aboriginal Art', Field
Museum of Natural History,
Chicago, 1972; see Allen 1972, p. 12, fig. 26;
'Australian Aboriginal Art: The Louis A. Allen
Collection', M.H. de Young Memorial Museum,
California Palace of the Legion of Honor, 1974;
see Allen 1974,
• see Allen 1975, p. 72 (attributed to Mithinarri).

[Johnny] DAYNGANGGAN
Gupapuyngu, Yirritja moiety
Milingimbi, 1892–deceased

50
Melkiri (forked sticks) 1957
natural pigments on eucalyptus bark
85.0 x 39.0 cm
Royal Tropical Institute, Tropenmuseum,
Amsterdam
Previously in the Ethnographic Collection,
University of Melbourne

Paddy DHATHANGU
Liyagalawumirr, Dhuwa moiety
Milingimbi and Ramingining, 1915–1993

61
*Wititj ga Gandawul' ga Wurrdjarra (Wititj with
Rock Wallaby and Sand Palm in seed)* 1967
[The Gatatangurr Python]
painted at Milingimbi
natural pigments on eucalyptus bark
122.0 x 56.5 cm
Collection: National Museum of Australia
Collected by H. Groger-Wurm
• see Groger-Wurm 1973, p. 43, plate 42.

23
Wagilag Dhäwu (Wagilag Story) 1969
[The coming of the Sisters — Wawiluk Myth]
painted at Milingimbi
natural pigments on eucalyptus bark
72.4 x 43.5 cm
Collection: Art Gallery of Western Australia
Previously in the Louis A. Allen Collection
• exhibited 'Australian Aboriginal Art:
The Louis A. Allen Collection',
R.H. Lowie Museum of Anthropology,
University of California, Berkeley, 1969;
see Elsasser and Paul 1969; 'Australian Aboriginal
Art', Field Museum of Natural History, Chicago,
1972; see Allen 1972; 'Australian Aboriginal Art:
The Louis A. Allen Collection', M.H. de Young
Memorial Museum, California Palace of the
Legion of Honor, 1974; see Allen 1974,
• see Allen 1975, p. 74.

58
Father totem c.1969
painted at Milingimbi
natural pigments on eucalyptus bark
89.0 x 43.0 cm
Collection: Art Gallery of Western Australia
Previously in the Louis A. Allen Collection

51
Melkiri ga bulul (Forked sticks and cross-beams)
1975–76
painted at Ramingining
natural pigments on eucalyptus bark
95.5 x 43.0 cm
Gift of Dr Joseph Reser 1990 (1990.1079)

6
Wagilag Dhäwu (Wagilag Story) c.1980
painted at Milingimbi
natural pigments on eucalyptus bark
62.0 x 130.0 cm
Private collection

The Wagilag Sisters Story series 1983
painted at Ramingining
• the series exhibited at Collectors Gallery,
Sydney, 1983; 'My Country, My Story,
My Painting', 1986; and 'The Continuing
Tradition', 1989.

22
The Wagilag Sisters Story 1983
(with the assistance of Dorothy DJUKULUL,
Ganalbingu, Yirritja moiety, born 1942)
natural pigments on eucalyptus bark
60.0 x 133.0 cm
Purchased 1984 (1984.463.5)
• see Caruana 1987, p. 15; 1989, p. 67, plate 28;
and 1993, p. 50, plate 35; and Lendon 1992, p. 30.

24
Wäk ga Wititj (Crow and Olive Python) 1983
natural pigments on eucalyptus bark
63.0 x 26.0 cm
Purchased 1984 (1984.463.4)

25
Wäk (Crows) 1983
natural pigments on eucalyptus bark
78.0 x 54.0 cm
Purchased 1984 (1984.463.12)
• see Caruana 1989, p. 69, plate 31.

26
Wurrdjarra ga Wititj (Sand Palm and Wititj) 1983
natural pigments on eucalyptus bark
94.0 x 33.5 cm
Purchased 1984 (1984.463.11)

27
Wurrdjarra (Sand Palms) 1983
natural pigments on eucalyptus bark
102.0 x 55.0 cm
Purchased 1984 (1984.463.9)
• see Caruana 1989, p. 69, plate 30.

28
Bilma (Clapsticks) 1983
natural pigments on eucalyptus bark
57.0 x 31.0 cm
Purchased 1984 (1984.463.10)
• see Caruana 1989, p. 69, plate 32.

29
Dhapalany (Itchy Caterpillars) 1983
natural pigments on eucalyptus bark
64.5 x 28.5 cm
Purchased 1984 (1984.463.3)

30
Wititj (Olive Python) 1983
natural pigments on eucalyptus bark
87.0 x 52.0 cm
Purchased 1984 (1984.463.15)

31
Wititj (Olive Pythons) 1983
natural pigments on eucalyptus bark
57.5 x 37.0 cm
Purchased 1984 (1984.463.6)

32
Yidaki (didjeridu) 1983
natural pigments on wood
160.5 x diameter 9.0 cm
Purchased 1984 (1984.463.16)
• exhibited: 'Painted Objects from Arnhem Land',
1986.

33
Djarrka ga Wititj (Goannas and Olive Python)
natural pigments on eucalyptus bark
68.0 x 34.0 cm
Purchased 1984 (1984.463.2)

34
Djarrka (Goanna) 1983
natural pigments on eucalyptus bark
38.0 x 22.5 cm
Purchased 1984 (1984.463.8)

35
Djarrka (Goanna) 1983
natural pigments on eucalyptus bark
63.0 x 23.5 cm
Purchased 1984 (1984.463.14)

36
Djarrka (Water Goanna) 1983
natural pigments on eucalyptus bark
63.5 x 27.0 cm
Purchased 1984 (1984.463.13)

37
Dhamaling (Blue-tongue Lizards) 1983
natural pigments on eucalyptus bark
67.0 x 34.5 cm
Purchased 1984 (1984.463.7)

38
Djarrka (Goannas) 1983
natural pigments on eucalyptus bark
61.0 x 34.0 cm
Purchased 1984 (1984.463.1)
• see Caruana 1989, p. 68, plate 29.

Joe DJEMBANGU
Gupapuyngu, Yirritja moiety
Milingimbi, born c.1935

4
Wagilag Creation Story c.1980
natural pigments on eucalyptus bark
127.0 x 73.0 cm
Collection: Anthropology Museum,
University of Queensland

Albert DJIWADA
Liyagalawumirr, Dhuwa moiety
Yathalamarra, born 1938

42
Wagilag Dhäwu (Wagilag Story) 1994
natural pigments on eucalyptus bark
134.6 x 76.0 cm
Purchased 1995 (1995.297)

7
Wagilag Dhäwu (Wagilag Story) 1995
natural pigments on eucalyptus bark
113.0 x 67.0 cm
Purchased 1996 (1996.1094)

41
Liyagalawumirr Mortuary Ceremony 1995–96
natural pigments on eucalyptus bark
93.0 x 65.0 cm
Private collection

40
*Djarrka Dhäwu (Goanna Story) for Ngirrgining
people* 1996
natural pigments on eucalyptus bark
116.0 x 65.0 cm
Purchased 1996 (1996.1095)

GIMINDJO
Mandhalpuy, Dhuwa moiety
Milingimbi, 1915–deceased

67
Wititj at Marwuyu talks to Mirarrmina c.1960
[The Sacred Serpent — Wagilag Story]
natural pigments on eucalyptus bark
71.0 x 22.6 cm
Collection: Art Gallery of Western Australia
Previously in the Louis A. Allen Collection
• see O'Ferrall 1990, p. 63, plate 69 (attributed
to Djawa), and Elsasser and Paul 1969, p. 3.

66
Wititj and Bardipardi (Rock Wallaby) at Marwuyu
1975–76
natural pigments on eucalyptus bark
40.5 x 36.0 cm
Purchased 1989 (1989.1507)
Collected by Dr Joseph Reser

Philip GUDTHAYKUDTHAY
Liyagalawumirr, Dhuwa moiety
Ramingining, born 1935

63
Wititj the Olive Python 1984
natural pigments on eucalyptus bark
123.0 x 81.0 cm
Purchased 1984 (1984.1955)
• exhibited: 'The Continuing Tradition', 1989,
• see Caruana 1989, p. 89, plate 48.

62
Warrala Warrala 1987
natural pigments on eucalyptus bark
180.0 x 100.0 cm
Purchased 1987 (1987.1041)
• exhibited: 'The Continuing Tradition', 1989;
• see Caruana 1989, p. 87, plate 47;
'Aratjara: Art of the First Australians',
Kunstsammlung NordrheinWestfalen, Düsseldorf,
the Hayward Gallery, London, and the Louisiana
Museum, Denmark, 1993–94; see Lüthi 1993,
p. 171, plate 40.

43.A and 43.B
Wurrdjarra (Sand Palms) 1991
natural pigments on composition board
177.0 x 44.0 and 199.0 x 51.0 cm
Purchased 1991 (1991.1310-11)

43.C
Wagilag Sisters Story 1991
natural pigments on composition board
120.0 x 93.0 cm
Purchased 1991 (1991.1312)

44
Wititj the Olive Python and landscape 1991
natural pigments on composition board
220.0 x 100.0 cm
Purchased 1991 (1991.852)

45
The Wagilag Sisters and child 1994–95
wood, natural pigments, fibre
Elder Sister: 160.0 x 18.0 x 16.0 cm
Purchased 1995 (1995.305)
Younger Sister: 164.0 x 30.0 x 17.0 cm
Purchased 1996 (1996.608)
Child: 149.0 x 17.0 x 16.0 cm
Purchased 1995 (1995.306)

[Tjam] YILKARI KITANI
Liyagalawumirr, Dhuwa moiety
Milingimbi, 1891–1956

8
Wagilag Dhäwu (Wagilag Story) 1937
natural pigments on eucalyptus bark
126.5 x 68.5 cm
The Donald Thomson Collection on loan
to the Museum of Victoria from the University
of Melbourne
• see Caruana 1993, p. 48, plate 33;
and Lendon 1994, p. 58, fig. 3.

9
Yolngu with ceremonial objects 1948
[Serpent-men, (Wititj) and Gadjalan]
natural pigments on eucalyptus bark
111.8 x 49.0 cm
Collection: National Museum of Australia
Collected by C.P. Mountford
• see Mountford 1956, p. 388, plate 126 D.

11
Gurrurdupun 1949
wood, natural pigments
120.0 x diameter 13.0 cm
Collection: Anthropology Museum,
University of Queensland
Collected by E.A. Wells

12
Yidaki (didjeridu) showing Wititj and Djarrka
1940s
wood, natural pigments
136.9 x diameter 6.4 cm
Collection: Queensland Museum
Collected by W. Chaseling

2
Wagilag Dhäwu (Wagilag Story) 1951
natural pigments on eucalyptus bark
85.7 x 50.2 cm
Collection of the Estate of Fritz Goreau
Collected by Fritz Goreau

39
*Djarrka Dhäwu (Goanna Story) for
Liyagalawumirr people* 1951
natural pigments on eucalyptus bark
86.4 x 54.6 cm
Collection of the Estate of Fritz Goreau
Collected by Fritz Goreau

64
Mapumirr Wititj (Wititj and eggs) 1951
natural pigments on eucalyptus bark
85.0 x 57.5 cm
Collection: Anthropology Museum,
University of Queensland

10
Mardayin ceremony 1955–56
natural pigments on eucalyptus bark
39.0 x 78.0 cm
Museum der Kulturen, Basel
Collected by Karel Kupka
• exhibited: 'Kunst der Uraustralier', Museum für
Völkerkunde, Basel, 1958; and 'Ozeanische Kunst:
Meisterwerke aus dem Museum für Völkerkunde',
Basel, 1980.

48
*Mardayin Dhäwu c.*1957
natural pigments on eucalyptus bark
59.5 x 26.0 cm
Royal Tropical Institute, Tropenmuseum, Amsterdam
Previously in the Ethnographic Collection,
University of Melbourne

Daisy MANYBUNHARRAWUY
Liyagalawumirr, Dhuwa moiety
Milingimbi, born *c.*1950

5
Wagilag Creation Story 1990
natural pigments on eucalyptus bark
138.7 x 69.1 cm
Purchased from Admission Funds, 1990
National Gallery of Victoria, Melbourne
• exhibited: 'Spirit in Land', National Gallery
of Victoria, 1990; see Ryan 1990, p. 20, fig. 8;
'Aratjara: Art of the First Australians',
Kunstsammlung Nordrhein-Westfalen,
Düsseldorf, the Hayward Gallery, London,
and the Louisiana Museum, Denmark, 1993–94;
see Lüthi 1993, p. 169; 'Power of the Land:
Masterpieces of Aboriginal Art', National Gallery
of Victoria, 1994,
• see Lendon 1992, p. 14.

18
Girri' (Wagilag ceremonial emblems) 1991
natural pigments on composition board
119.0 x 54.3 cm
Purchased 1993 (1993.1920)

19
Girri' (Wagilag ceremonial emblems) 1991
natural pigments on composition board
119.0 x 60.0 cm
Purchased 1993 (1993.1919)

Peter MINYGULULU
Djinba/Mandhalpuy, Dhuwa moiety
Ramingining, born 1942

68
*This Wititj lives at Milipanun, a little waterhole
upstream from Marwuyu* 1995
natural pigments on eucalyptus bark
122.0 x 59.0 cm
Purchased 1997 (1997.1275)

69
Mayku at Mirrngatja 1997
painted at Yirrkala
natural pigments on eucalyptus bark
168.0 x 90.0 cm
Purchased 1997 (1997.1293)

Neville NANYTJAWUY
Liyagalawumirr, Dhuwa moiety
Ramingining, born 1942

75
Yambal-Matha 1985
natural pigments on eucalyptus bark
119.5 x 61.0 cm
Private collection, courtesy Hogarth Galleries,
Sydney

72
*Djunggarliwarr ga Wayanaka (Conch Shells and
Oysters)* 1984
natural pigments and synthetic polymer paint on
eucalyptus bark
83.2 x 36.5 cm
Collection: Museum of Contemporary Art,
Sydney. J.W. Power Bequest, purchased 1984
• exhibited: 'Objects and Representations from
Ramingining, Arnhem Land', Power Gallery of
Contemporary Art, University of Sydney, 1984;
and 'The Native Born: Objects and
Representations from Ramingining, Arnhem
Land', Museum of Contemporary Art,
Sydney, 1996.

73
*Yidaki (didjeridu) showing Wititj and
Djunggarliwarr* 1995
[Wititj and conch shells]
wood, natural pigments
171.5 x diameter 7.0 cm
Purchased 1997 (1997.1276)

74
Guruwana Story 1995–96
synthetic polymer paint on canvas
152.2 x 227.0 cm
Gift of Bula'bula Arts Aboriginal Corporation,
Ramingining, Central Arnhem Land 1996
(1996.1087)

UNKNOWN ARTIST

46
Stone-headed spear 1965
made at Milingimbi
stone, paperbark, wood, natural pigments, resin
54.0 x 5.0 x 2.0 cm
Collection: National Museum of Australia
Collected by J.A. Davidson

[Dick] YAMBAL DURRURRNGA
Liyagalawumirr, Dhuwa moiety
Ramingining, born 1936

70
Wititj at Guruwana 1992
natural pigments on eucalyptus bark
171.0 x 64.0 cm
Purchased 1993 (1993.165)

Kathy YAWIRR
Djambarrpuyngu, Dhuwa moiety
Ramingining, born 1955

71
*Oyster beds and Bundarrarr (Palm Tree) at
Guruwana* 1990
natural pigments on eucalyptus bark
154.0 x 85.0 cm
Moët and Chandon Fund 1991 (1991.683)

Jimmy YANGGANINY
Ganalbingu, Yirritja moiety
Ramingining, 1949–1989

65
Wagilag Sisters Creation Story 1989
natural pigments on eucalyptus bark
136.0 x 95.0 cm
The Collection of John W. Kluge

Eastern Arnhem Land

DJALU GURRUWIWI
Gälpu, Dhuwa moiety
Yirrkala, born 1931

80
Wititj, Sacred Olive Python 1994
natural pigments on eucalyptus bark
304.0 x 72.1 cm
Purchased through The Art Foundation of
Victoria with the assistance of Alcoa of Australia
Limited, Governor, 1994
National Gallery of Victoria, Melbourne

MITHINARRI GURRUWIWI
Gälpu, Dhuwa moiety
Yirrkala, c.1929–1976

79
Bäpi at Ganymala 1963
natural pigments on eucalyptus bark
78.0 x 39.5 cm
Musée national des Arts d'Afrique et d'Océanie, Paris
Collected by Karel Kupka
• see Kupka 1965, p. 112–120, 135, 144;
1966, p. 35–36, fig. 7; and 1972, p. iv;
and Dussart 1993, p. 75.

BANDUK MARIKA
Rirratjingu, Dhuwa moiety
Yirrkala, born 1954

87
Wawulak Wulay 1986
made in Sydney
linocut on paper
23.4 x 41.2 cm
Purchased 1987 (1987.1575)
• exhibited: 'The Continuing Tradition', 1989.

86
Wawulak Wulay ga Wititji 1988
made in Sydney
linocut on paper
37.4 x 60.4 cm
Gift of The Australian Legal Group 1988
(1988.1661)
• exhibited: 'The Continuing Tradition', 1989.

DHUWARRWARR MARIKA
Rirratjingu, Dhuwa moiety
Yirrkala, born c.1946

84
Wititj swallowing the Wawilak Sisters 1990
natural pigments on composition board
82.0 x 61.0 cm
Purchased 1993 (1993.1930)

MATHAMAN MARIKA
Rirratjingu, Dhuwa moiety
Yirrkala, c.1920–1970

85
Wawilak Sisters Story 1959
natural pigments on eucalyptus bark
142.2 x 54.6 cm
The Art Gallery of New South Wales
Gift of Dr Stuart Scougall 1960

88
*Wawilak Bunggulwuy Dhäwu (Wawilak Ceremony
Story)* 1965
[Arafura lagoon]
natural pigments on eucalyptus bark
152.4 x 69.0 cm
Presented through The Art Foundation of
Victoria by the Michael and Mary Buxton
Endowment, Governors, 1995
National Gallery of Victoria, Melbourne
Collected by J.A. Davidson
• exhibited: 'Spirit in Land', National Gallery
of Victoria, 1990, Ryan1990, p. 26, plate 12,
• see Davidson 1989, p. 12, fig. 5.

MAWALAN MARIKA
Rirratjingu, Dhuwa moiety
Yirrkala, c.1908–1967

91
At Muruwul [Marwuyu], home of the Wititj Python
1946
natural pigments on eucalyptus bark
52.0 x 60.0 cm
Courtesy of The University of Western Australia
Berndt Museum of Anthropology
Collected by R.M. and C.H. Berndt
• exhibited: 'Australian Aboriginal Art: Arnhem
Land Paintings on Bark and Carved Human
Figures', The Art Gallery of Western Australia,
1957,
• see Berndt and Berndt 1957, p. 13;
Berndt, C.H. 1962, 'Arts of Life', in *Westerly*,
nos 2, 3, pp. 86–87, plate 4; and Berndt et al
1982, p. 62, plate 46.

81
The Wawilak Sisters 1947
wood, natural pigments, hair
heights: Elder Sister 91.0 cm,
Younger Sister 80.0 cm
Courtesy of The University of Western Australia
Berndt Museum of Anthropology
Collected by R.M. and C.H. Berndt
• see Berndt et al 1964, p. 99–100, plate 68,
• the Elder Sister; exhibited 1955–c.1982 Institute
of Anatomy, Canberra; see *Images of Aboriginal
Australia*, no. 7, p. 16; Elkin et al, 1950,
pp. 50–51, plate 7; and *Images of Aboriginal
Australia*, no. 6, p. 15,
• the Younger Sister; exhibited 1955–c.1982
Institute of Anatomy, Canberra;
see R.M. Berndt, *Australian Aboriginal Religion*,
E.J. Brill, Leiden, Netherlands, 1974, (fascicles);
and *Images of Aboriginal Australia*, no. 6, p. 15.

82
The Wawilak Sisters 1948
(probably painted with assistance of
Wandjuk Marika)
natural pigments on paper
56.0 x 42.0 cm
The Collection of John W. Kluge
Collected by C.P. Mountford
Previously in the collection of Ainslie Roberts
• see Mountford 1956, p. 280, plate 88.A.

83
Wititj swallowing the Wawilak Sisters c.1955
natural pigments on eucalyptus bark
93.0 x 49.0 cm
Purchased 1985 (1985.406)
Collected by Dorothy Bennett
• exhibited: 'Ancestors and Spirits', 1987;
and 'The Continuing Tradition',1989;
• see Caruana 1989, p. 114, plate 68.

WANDJUK MARIKA
Rirratjingu, Dhuwa moiety
Yirrkala, c.1930–1987

90
Wawilak ritual 1982
painted at Melbourne
natural pigments on eucalyptus bark
147.5 x 36.0 cm
Purchased from National Gallery admission
charges 1983 (1983.2982)
• exhibited: 'The Continuing Tradition', 1989,
• see Wandjuk Marika 1995, p. 120.

DURNDIWUY WANAMBI
Marrakulu, Dhuwa moiety
Gurka'wuy and Yirrkala, c.1936–1996

94
Gundimulk ceremony ground with Wuyal and Dhulaku (Euro) at Yanawal 1967
painted at Yirrkala
natural pigments on eucalyptus bark
160.0 x 67.0 cm
Collection: National Museum of Australia
Collected by H. Groger-Wurm
• see Groger-Wurm 1973, p. 51, plate 68.

96
Djuwany pole 1967
[Palm post]
made at Yirrkala
wood, natural pigments, fibre
height 191.5 cm
Collection: Art Gallery of Western Australia

97
Djuwany pole 1967
[Male corner post]
made at Yirrkala
wood, natural pigments, feathers
height 164.0 cm
Collection: Art Gallery of Western Australia

95
The Sisters and their companions at their Gundimulk ceremonial ground at Gurka'wuy 1976–77
[Sisters at Gurka'wuy]
painted at Gurka'wuy and Sydney
natural pigments on eucalyptus bark
172.0 x 78.0 cm
On loan from Ian Dunlop

98
Yidaki (didjeridu) showing Djerrka and Djärrwirt (Water Goanna and Freshwater Mussels) 1984
made at Gurka'wuy
wood, natural pigments
176.0 x diameter 9.5 cm
Founding Donors' Fund 1984 (1984.796)
• exhibited: 'Painted Objects from Arnhem Land', 1986; and 'The Continuing Tradition', 1989.

99
Wuyal Creation Story with Gundimulk ceremonial ground 1990
[Wuyal, hollow log, lizards]
painted at Gurka'wuy
natural pigments on eucalyptus bark
184.1 x 70.0 cm
Purchased through The Art Foundation of Victoria with the assistance of Alcoa of Australia Limited, Governor, 1994
National Gallery of Victoria, Melbourne
• exhibited: 'Spirit in Land', National Gallery of Victoria, 1990; see Ryan 1990, plate 15; 'Power of the Land: Masterpieces of Aboriginal Art', National Gallery of Victoria, 1994,
• see Caruana 1993, p. 66, plate 50.

101
Djuwany 1995–96
(with WOLPA WANAMBI, Marrakulu, Dhuwa moiety, Gurka'wuy, born 1970, and MOTU YUNUPINGU, Gumatj, Yirritja moiety, born 1959)
made at Gurka'wuy
wood, natural pigments, feathers, hair, resin, fibres
175.0 x 20.5 x 18.0 cm, 170.0 x 20.5 x 17.8 cm
Purchased 1996 (1996.1.A.B)

100
Wuyal and Dhulaku (Euro) 1996–97
(with WOLPA WANAMBI, Marrakulu, Dhuwa moiety, Gurka'wuy, born 1970, and MOTU YUNUPINGU, Gumatj, Yirritja moiety, born 1959)
made at Gurka'wuy
wood, natural pigments
193.0 x 24.5 x 19.0 cm
Purchased 1996 (1996.1.C)

WELWI WANAMBI (WUYULWUY)
Marrakulu, Dhuwa moiety
Gurka'wuy and Yirrkala, 1935?–1974

92
Honey man 1973
painted at Yirrkala
natural pigments on board
50.0 x 65.0 cm
Private collection
• see Morphy 1991, p. 191–193, 205, fig. 9.2.

93
Stone quarry 1973
painted at Yirrkala
natural pigments on board
50.0 x 65.0 cm
Private collection
• see Cooper, C. et al 1981; and Morphy 1991, p. 206–207, fig. 9.4.

YALMAY YUNUPINGU
Rirratjingu, Dhuwa moiety
Yirrkala, born 1956

89
Wawilak Bunggulwuy Dhäwu (Wawilak Ceremony Story) 1996
natural pigments on eucalyptus bark
260.0 x 75.0 cm
The Collection of John W. Kluge

Plate Credits

Anthropology Museum, University of Queensland, Brisbane:
plates 4, 11, 64.

Art Gallery of New South Wales, Sydney:
plate 85.

Art Gallery of Western Australia, Perth:
plates 1, 23, 55, 58, 67, 96, 97.

The Estate of Fritz Goreau:
plates 2, 39.

Hogarth Galleries, Sydney and Peter Luxton:
plate 75.

The Collection of John W. Kluge:
plates 65, 82, 89.

Howard Morphy:
plates 92, 93.

Musée national des Arts d'Afrique et d'Océanie, Paris:
plates 13, 49, 79.

Museum of Contemporary Art, Sydney:
plates 72, 77.

Museum der Kulturen, Basel:
plates 3, 10, 52.

Museums and Art Galleries of the Northern Territory, Darwin:
plate 59.

National Gallery of Australia, Canberra:
plates 6, 7, 14, 15, 17, 18, 19, 22, 24, 25, 26, 27, 28, 29, 30, 31, 32, 33, 34, 35, 36, 37, 38, 40, 42, 41, 43A, 43B, 43C, 44, 45, 51, 54, 57, 62, 63, 66, 68, 69, 70, 71, 73, 74, 76, 78, 83, 84, 86, 87, 90, 95, 98, 100, 101.

National Gallery of Victoria, Melbourne:
plates 5, 80, 88, 99.

National Museum of Australia, Canberra, and Matt Kelso:
plates 9, 16, 20, 21, 46, 47, 56, 60, 61, 94.

Newcastle Region Art Gallery:
plate 53.

Queensland Museum, Brisbane:
plate 12.

Royal Tropical Institute, Tropenmuseum, Amsterdam:
plates 48, 50.

D.F. Thomson. Courtesy of Mrs D.M. Thomson:
plate 8.

The University of Western Australia Berndt Museum of Anthropology, Perth:
plates 81, 91.

Acknowledgments

The curators wish to thank all those who have assisted with the exhibition and the production of this catalogue. The following people and institutions deserve special mention:

All of the artists and their families, particularly Albert Djiwada, the late Paddy Dhathangu, Joe Djembangu, Trevor Djarrakaykay, Marrirra Marawili, Gawirrin Gumana, Dula Ngurruwutthun, Jimmy Wululu, David Malangi, Gundimulk Wanambi, Wolpa Wanambi. Bula'bula Arts, Ramingining. Buku Larrnggay Mulka, Yirrkala.

Anthropology Museum, University of Queensland, Leonn Satterthwait. Art Gallery of New South Wales, Ken Watson. Art Gallery of Western Australia. The Holmes à Court Collection, Belinda Carrigan. South Australian Museum, Christopher Anderson. Musée national des Arts d'Afrique et d'Océanie, Paris, Philippe Peltier, Roger Boulay. Museums and Art Galleries of the Northern Territory, Margaret West. Museum der Kulturen, Basel, Christian Kaufmann. Museum of Contemporary Art, Sydney. Museum of Victoria, Lindy Allen. National Gallery of Victoria, Judith Ryan, Nazareth Alfred. National Museum of Australia, Luke Taylor, Nancy Michaelis, Mark Henderson, David Kaus. Newcastle Region Art Gallery, David Bradshaw. Queensland Museum, Amanda Pagliarino. Royal Tropical Institute, Tropenmuseum, Amsterdam, H.J. Gortzak, J.H. van Brakel. University of Western Australia Berndt Museum of Anthropology, John E. Stanton. Geoffrey Bagshaw. Anthony Bourke and Hogarth Galleries. Ian Dunlop. Thomas J. Goreau. John W. Kluge, Margo Smith Boles. Howard Morphy.

Australian National University, Centre for Cross Cultural Research, Institute of the Arts, Canberra School of Art. National Library of Australia, David Andre. Mortlock Library, Adelaide, Jenny Tonkin. Darwin Performing Arts Centre. Roslyn Poignant. Anne Wells. Archives Kupka, the late Karel Kupka. The late J.A. Davidson, Rene Davidson, Malcolm Davidson. D.M. Thomson. Malcolm Douglas. Alan C. Fidock. Andrew Blake. Libby Raynor. Sophie Creighton. Ingrid Slotte. Jennifer Isaacs. Nicolas Peterson.

National Gallery staff, in particular Susan Jenkins, Avril Quaill, Hilary Hoolihan, Katherine Russell, Nina Spannari, Karen Leary, Kirsty Morrison, Kathryn Weir, Harijs Piekalns.